THE NEW FRENCH ARCHITECTURE

François Deslaugiers, study sketch for the exterior elevator of the Grand Arch, La Défense, 1987

THE NEW
FRENCH ARCHITECTURE

Wojciech Lesnikowski

Introduction by Patrice Goulet

RIZZOLI
NEW YORK

First published in the United States of America in 1990
by RIZZOLI INTERNATIONAL PUBLICATIONS, INC.
300 Park Avenue South, New York, NY 10010

Copyright © 1990 Rizzoli International Publications, Inc.

Library of Congress Cataloging-in-Publication Data

Lesnikowski, Wojciech G.
 New French Architecture/Wojciech Lesnikowski.
 Patrice Goulet
 p. cm.
 ISBN 0-8478-1224-3 — ISBN 0-8478-1265-0
(pbk.)
 1. Architecture, Modern—20th century—France.
 2. Architecture—France. I. Goulet, Patrice.
 II. Title.
 NA1048.L47 1990
 720′.944′09045—dc20 CIP
 90–35057

Designed by Paul Chevannes
Typeset by Rainsford Type, Danbury, CT
Printed and bound in Japan

Front cover: Architecture Studio, Lycée du Futur, Poi-
 tiers, 1986–87 (photo); Jourda and Perraudin, School
 of Architecture, Lyon, 1982, axonometric view from
 below (rendering).
Back cover (hardcover only): Bernard Tschumi, Parc de
 la Villette, Paris, 1982–83.

For Rebecca and Alexandra

Acknowledgments

The author wishes to express his gratitude to the following individuals for their help and assistance in preparing this volume: Carter Manny, Jr., Director of the Graham Foundation of Chicago; John Zukowsky, Curator of the Department of Architecture of The Art Institute of Chicago; Patrice Goulet, architecture critic, The French Institute of Architecture, Paris; Luciana Ravanel, director of The French Institute of Architecture; Deidi von Schaewen, architectural photographer; and the architects whose work is featured here.

Jacques Hondelatte, decoration study for Le Foyer de la Gironde Housing, Bordeaux, 1987–88

Contents

Introduction: The Magnificent Play of Iron and Glass by Patrice Goulet 10
From Historicism to the New Modernism by Wojciech Lesnikowski 12
 Historical Background 12
 Toward Modernism and the First Avant-Garde 20
 Architecture After the Second World War 32
 Technological Revolution 42
 Toward Super Modernism 44
 Conclusion 50

The Architects

 Architecture Studio 54
 Gilles Bouchez 68
 Jean Pierre Buffi 80
 François Deslaugiers 92
 Christian Hauvette 106
 Jacques Hondelatte 120
 Jourda and Perraudin 136
 Jean Nouvel 152
 Dominique Perrault 170
 Francis Soler 180
 Bernard Tschumi 194
 Claude Vasconi 202

Architects' Biographies 222
Illustration Credits 223

Architecture Studio, diagrammatic plans of the Church of the Resurrection, Paris, 1986–89

INTRODUCTION

The Magnificent Play of Iron and Glass

Patrice Goulet

DESPITE THE rapid expansion of our spheres of movement and communication, we continue to exist in a reality that is limited by our inability to step back for a clearer perspective. Similarly, the history of French architecture, as I read it, is buried under the weight of anecdotes, narrow-minded disputes and palace intrigues, and is entangled in a jumble of conventions and received ideas. Thus, any alternative view of French architecture, past or present, is welcome, and the more subjective and surprising the view the greater the chance it has of enlightening us.

It is for this reason that Wojciech Lesnikowski's work interests us. He comes from the "outside" and has no interest in our classifications, hierarchies, and prejudices; he doesn't hesitate to take unforseeable lines of thought and to make, what would be for us, impossible connections and observations.

Lesnikowski's perspectives are all the more remarkable given that he observes us from Chicago. Chicago—one of the mythical capitals of modern architecture, the city that saw the birth and proliferation of skyscrapers, and the home of Frank Lloyd Wright's beginnings—seems stricken once again by that terrible illness—the fear of the unknown. That fear decimated the Chicago School and reduced Louis Sullivan to silence. Chicago now seems to favor only neo-academicism, called post-modernism by its champions who seek to set before us a made-up old man as the inevitable future.

To compare Thomas Beeby's winning competition entry for the new Harold Washington Library in Chicago—a vertical mausoleum cut from Italian cloth—to the four scintillating towers of Dominique Perrault's winning entry for the new Library of France, is somewhat upsetting.

Lesnikowski, however, only has eyes for France. He admires our large projects and finds modernism here to be in perfect health. The evidence that he gives, or more accurately, the examples which he selects to support his arguments, will doubtless set certain teeth on edge. Yet, he looks at our buildings with the eyes of an American professional, basing his judgements on the tangible merits of built structures and not on the reputations of their

designers or their positions in the French architectural community.

Lesnikowski's optimism is contagious and incites us to temper our anxieties. After all, it is true that France's difficult period of post-war reconstruction is over and that the justification for the barbarous modes of urbanism, construction, and development that plagued this country are now gone. New generations of architects have arisen who, if simply by sheer force of numbers, include more inventive, creative, and truly professional designers. Even contractors and builders have grown in their openness and flexibility as architecture has acquired a value recognized by France's cities. Endowed with effective means, thanks to their decentralization, French cities today compete with each other by launching spectacular construction projects as proof of their dynamism. The mayors of Montpellier, Nîmes, Rézé, Hérouville-Saint-Clair, and Lille have made, or are in the process of making, their cities famous by their architectural enterprises. Here we should pay homage to the Mission Interministérielle de la Qualité des Bâtiments Publics (Interministerial Mission for the Quality of Public Buildings) which has urged these city administrations to set an example by improving the organization of competitions required for all important architectural commissions. Many architects of this new wave owe the Mission the built works that have made them famous.

It is important to note that the buildings that interest Lesnikowski, the ones he uses as examples of his faith in the progress of modernity in France, share one significant trait—they are made of metal, and this is no minor attribute. It has been sufficiently argued that the immoderate and almost exclusive use of concrete during the reconstruction was not the best way to produce architecture needed for the modern era. Not that concrete should have been excluded—far from it—but that in using it alone we deprived ourselves of the lightness and precision attainable through the use of metal.

Thus, one of the darkest periods in French architecture was the one in which champions of heavy prefabrication prevailed over those who dreamed of industrialization and of dwellings that could be produced like cars. We were led to prefer work that could be executed by unskilled labor, considering it a universal panacea, and we know today what it has cost us.

We can understand why it is not unreasonable for several of today's most active architects to affirm their work by presenting themselves as "carriage builders," in opposition to those who erect their edifices like rising dough with frosting and cream to follow. In doing so, they have rediscovered the path opened up by architects like Gustave Eiffel and Jean Prouvé, who founded what would become the French "high-tech." A path that was practically abandoned, it is now well-trod, especially since Jean Nouvel proved with his Arab World Institute that it was once again plausible. All the better, because there is no more certain source of pleasure than to take up the ideas demonstrated by Pierre Chareau in his extraordinary house on rue Saint-Guillaume—the magnificent play of iron and glass.

Paris, 1990

FROM HISTORICISM
TO THE NEW MODERNISM

Wojciech Lesnikowski

Historical Background

"All things noble are as difficult as rare."— Spinoza

IT MAY be said that the birth of all creative endeavors takes place as a challenge to established customs, manners, and methods, in the name of spiritual, creative, or scientific progress. All genuinely creative movements perform under conditions of intellectual tension and anxiety as they attempt to alter the course of history, struggling against conservative forces determined to halt their development. At the same time, truly novel approaches to many fields could not develop without the presence of a historical context against which they direct their activities, often without profiting from its experience and achievements.

This conceptual duality in every new movement, the simultaneous rejection and recognition of a historical context, is at the heart of the birth and evolution of modern French architecture. Given its remarkable historical heritage—revealed in magnificent gothic cathedrals, monasteries, towns, renaissance chateaux and their gardens, as well as nineteenth-century achievements in planning and urban renewal—it is not surprising to realize that the birth of modern French architecture was often slowed by intellectual confusion, the mistrust of untested modern ideals, and the anxiety associated with the disappearance of traditional French artistic sensibilities, which were, after all, largely responsible for the growth of French cultural influence in the world (1-15).

Since medieval times, French architects have forwarded a series of intellectually precise and dogmatic theories of architecture and urban form upon which centuries of architectural activity in France has been based. That these historical concepts of architecture were systematically enforced at the French educational institutions, usually with the support of men in the positions of political and cultural sponsorship, did not facilitate an easy transition to modernity. Indeed, most French ar-

chitectural ideals were grounded in the philosophy of the Enlightenment—the search for universal methods and rules, abstract principles, and distinct perceptions which represented the essence of the immensely influential philosophy of René Descartes. Descartes attempted to unite the sciences, philosophy, morality, and aesthetics into a unified approach based on theoretical and analytical foundations. It was Descartes who developed the method of doubt, the approach that elevated analytical and deductive thinking above traditional synthetic tendencies in thought. The method of doubt became the chief form of scientific and philosophical inquiry with which he approached the dualistic structure of the world, that is the existence of primary and secondary, or spiritual and material systems of knowledge in which Descartes deeply believed.

Descartes' influence was not limited to the realm of rational philosophy or science alone, but helped to direct French architectural thinking along the rationalist path for many decades to come. That Descartes placed greater importance upon theoretical and abstract concepts and their deductive possibilities than on experiments and empirical approaches had one important consequence from an architectural point of view—Descartes affirmed excessively geometric, scientific models of inquiry which, in the end, gave rise to architectural abstraction and typological model-making rather than designs that would derive their notions from their given or inherited context.

A century later, work was in progress on the first edition of the *Encyclopedia*, in the spirit of Diderot's claim that "Man is the sole and only limit where one must start and back to whom everything must return." The *Encyclopedia* became the symbol of French intellectual prominence in the eighteenth century and its humanistic thrust had an immense impact on the architectural thinking of the eighteenth and nineteenth centuries. The purpose of this monumental undertaking was to correlate philosophy with reason, and it proposed to examine its subjects in a Cartesian or analytical way. It was oriented toward scientific models, rational argumentation, and toward changing the traditional way of thinking. It was, therefore, a forward-looking and revolutionary endeavor. The flowers of the French intellectual movement—Diderot, Alembert, Voltaire, Rousseau, Montesquieu, Marmontel, and Holbach—cooperated to produce it. The *Encyclopedia* became the greatest document of the Age of Reason.

In consequence, French architecture responded by forwarding its own rational ways of thinking, seeing, and conceiving. The rationalist hold on French architectural creativity became so strong that the absorption of new or foreign concepts, like the English picturesque, was slow and forcefully resisted. Despite the similarities of aesthetic attitudes held by Jean Jacques Rousseau and the English philosopher Edmund Burke, the French generally viewed English architectural products, which evolved out of Burke's idea of the sublime, as vacuous and of poor taste. Burke's criteria for true beauty—delicacy, obscurity, fantasy, fancifulness, ambiguity, and arbitrariness—struck the French eighteenth-century intellect as naive. Although the English picturesque garden penetrated their culture, the French geometricised and rationalized it to such an extent that it lost much of its English free form. French gardens became more architectonic and rational than natural. The classically educated French architect preferred systematic planning to the individualistic experimentation which many English and German architects favored. Individualism in thought and action was seen as a potentially dangerous and arbitrary trend. Ultimately, this led French architecture to a serious creative problem that affected its ability to accept and absorb modern developments and demands quickly and positively. On the one hand, Cartesian and eighteenth-century rational principles of analysis produced a powerful and continuous basis for a century of architectural education and design. On the other hand, they led to a considerable ossification and conservatism of thought which the nineteenth-century École des Beaux Arts illustrated so well.

The nineteenth century's "style wars" between the neo-classicists, represented mostly by the academicians, and the neo-gothicists, composed mainly of individual mavericks, raged on despite the inevitable approach of "savage and uncertain" modern times, to borrow a phrase from Patrice Goulet. The conceptual drama that occurred between these bitterly divided architectural circles was highly intense because the conversion to modernity meant a conversion to a different socio-political composition, and a conversion to the use of industrial materials and construction methods. For architects who practiced on the basis of historical methods of design and construction, upon which all theoretical notions of beauty, harmony, stability, and longevity were established, the conversion to materials and construction methods of an industrial nature must have been equal to the collapse of a tradition of artistic refinement and taste which had placed French architecture and art in the leading position in the Western World.

The essence of French resistance to modern architectural innovation in the nineteenth century goes back to the preceding century, usually referred to as the Age of Enlightenment. From the thinkers of this period came rational models which summarized past French architectural experience. They begin with theorists such as jesuit Marc-Antoine Laugier, who published in 1753 an "Essai sur l'Architecture" in which he expounded the view that architecture should be a direct expression of functional and structural rationality. He called for the return of architecture to simplicity, clarity, and honesty in its overall expression. For Laugier, only the true classical principles of architecture could respond to such intellectual criteria. He ended his arguments by praising the 'primitive hut' in the name of common-sense simplicity as the most fundamental expression of classical rationality.

Like most of his contemporaries, Laugier reacted

1. Mont-Saint-Michel, Abbey, 1122–1521

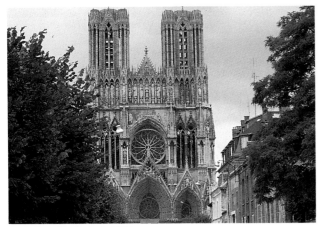

2. Reims, Cathedral, 1211

3. Chenonceau, Château, 1519–47

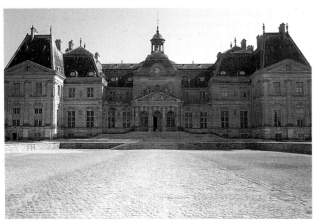

4. Jean Le Breton, Villandry, Gardens, 1536

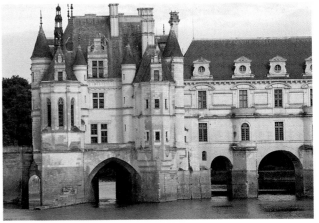

5. Louis Métezeau, Place des Vosges, 1605–12

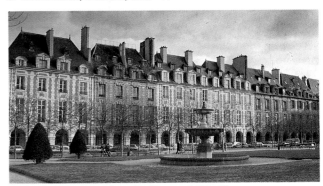

6. Louis Le Vau, Château de Vaux-le-Vicomte, 1656–61

7. Jules Hardouin Mansart, Palais de Versailles, 1678–89

8. *Ange Jacques Gabriel, Petit Trianon, Palais de Versailles,*
1761–68

9. *Claude Perrault, Palais de Louvre, Paris, 1667–74*

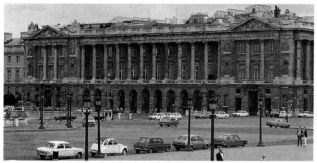

10. *Ange Jacques Gabriel, Palaces of Place de la Concorde,*
Paris, 1755

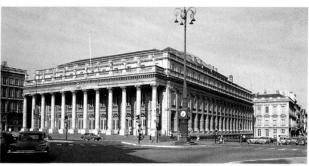

11. *Victor Louis, Grand Théâtre, Bordeaux, 1773–80*

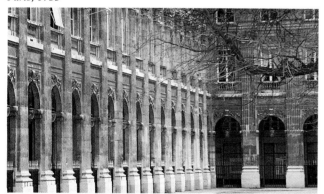

12. *Victor Louis, Colonnades of the Palais Royal, Paris, 1781–84*

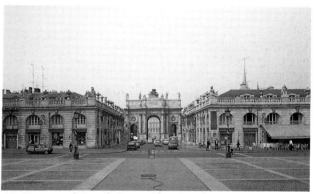

13. *Emmanuel Héré de Corny, Place Royal, Nancy, 1752–56*

14. *Pierre Fontaine and Charles Percier, Rue de Rivoli, Paris, 1811*

15. *Jacques-Germain Soufflot, Panthéon, Paris, 1755–92*

against the excess of the renaissance, particularly of its mannerist, baroque, and rococo phases, which he blamed for the decadence of taste, common judgment, and too great an individualism. Laugier's views, which centered on the search for universal, objective, and harmonious laws of architecture, corresponded well to the overall thrust of philosophical interests of the time. They combined Platonic and Cartesian philosophical and sociopolitical ideas with the intent of defining the laws of harmonious political relationships, social civility, and intellectual enlightenment, as well as proper artistic expression.

Laugier's eighteenth-century views echoed similar concerns expressed one hundred years earlier at L'Académie Royale d'Architecture. This institution was founded in 1671 by the minister of Louis XIV, Jean Baptiste Colbert, with the purpose of studying architecture to determine its cardinal rules and principles. L'Académie Royale was connected to L'Académie Française, created earlier by Cardinal Richelieu, and L'Académie de France in Rome, which Colbert organized in 1669 as a place for advanced studies in the arts. This last institution later played a pivotal role in the nineteenth-century development of eclecticism in France. All these institutions had one common goal: to connect the theoretical and practical activities of French artists and architects with the interests and views of the French ruling classes. Thus, under the government of Louis XIV, the precedent of governmental sponsorship and, at the same time, the control of architecture was established. This tradition has survived in France to the present day. The so-called "Presidential Projects" of the 1980s under President Mitterand are illustrious examples of this persisting French tradition.

Two theorists in particular distinguished themselves at L'Académie Royale: François N. Blondel (1617–86), who was its first director, and his distant relative Jacques F. Blondel (1705–74). Both proposed strictly rational and platonic views of architecture in their theoretical works *Cours d'Architecture* and *Discours sur la Nécessité de l'Étude de l'Architecture*, respectively. These were views with which Laugier later concurred. They condemned the Italian renaissance because it was not scientific and rational enough and proposed a sober, purified, classicist version of it as a key to logical, clear, and positive reasoning. Thus, a precise theoretical body of principles appeared in the eighteenth century which served as an operational design mode for most of the distinguished eighteenth-century French architectural masters, including Gabriel, Sufflot, Peyre, Chalgrin, Boullée, and Ledoux.

In fact, eighteenth-century French rationalist thinking in architecture only defined in stricter terms what had long been understood. It was the logical culmination of the gothic and renaissance traditions. If we think of the eighteenth century as a century in love with universal, logical, and worldly objectives of which the austere form of classicism was to be the messenger, we can see a fore-shadowing of these tendencies in the gothic and renaissance periods. Since the creation of the Abbey of Saint Denis by Abbot Suger and Pierre de Montreuil, which gave birth to many standards of the gothic aesthetic, French architecture has been searching for guiding ideas and concepts. The renaissance writings of Philibert De L'Orme (1500–1570) and of Jacques Androuet Du Cercau (1515–1590) already addressed the notions of monumental planning and comprehensive order. From this point on, French architecture, as seen in the works of François Mansard, Louis LeVau, Claude Perrault, Jules Hardouin-Mansart, Jacques Lemercier, and Simon de Brosse, began establishing a distinctive character within which the ideas of clarity, rationality, and monumentality reigned supreme. This first phase of the search for unified and grand architectural principles culminated in the landscapes of André Le Nôtre, upon which all future notions of grand composition and planning were founded.

Le Nôtre's garden designs united the French aesthetic and political tendencies of the time. We see in them the effects of aristocratic, governmental sponsorship determined to express itself through monumental, idealized, and symmetrical images derived from concepts in Plato's *Republic*—that is, a permanent, abstract, and universal realm within which nothing is left to whim or chance and nothing remains physically or intellectually unattended. The age of Le Nôtre was the age of great civic leaders in France whose minds and activities found their imprint in his garden compositions.

They began with Sully, minister of Henry IV. He was followed by such men as Cardinal Richelieu, Cardinal Mazarini, and finally, Le Nôtre's own sponsor, Minister Colbert. Under their direction and leadership a spectacular series of urban improvement projects like the royal plazas of Paris, Dijon, and Bordeaux were created, along with Le Nôtre's famous gardens of pleasure: Vaux-le-Vicompte, Fontainebleu, Chantilly, Saint-Cloud, Scaux and, of course, Versailles. Le Nôtre's influence remained fundamental for the next one hundred years, practically until the coming of the French Revolution.

The aristocratic Académie Royale d'Architecture was dissolved in 1789 by the revolutionary authorities who abolished all institutions formerly established by the crown or the Church. To replace it, the pragmatic School of Engineering was created under the title of L'École Polytechnique with the purpose of training students for practical building tasks. Architecture eventually became a part of this new establishment. The regime of Napoleon I, who succeeded the revolutionary government, continued to support it, but ordered the students to wear military uniforms to emphasize their service to and dependence on the state. The chief purpose of training architects in this institution was to give them practical knowledge of the building profession, which by now included a diversity of programs, functions, and tasks.

It is no wonder that the two most prominent theorists associated with this school, J.N.L. Durand (1760–

1834) and August Choisy (1841–1904), stressed in their writings rationalist and structu_alist concepts of architecture. Durand, in his famous theoretical treatise *Précis des Leçons d'Architecture données á L'École Polytechnique*, (1802–05) proposed an almost utilitarian approach to design. For Durand flexible, typological, and organizational patterns of design were infinitely more important than cultural and symbolic concerns. His lack of interest in specific historical modes was such that he can be credited with the invention of "eclecticism," which he expressed theoretically by applying various freely-treated historical styles to his typological building organizations. The free selection and adaptation of historical styles to functionalist and structuralist principles of organization became the most significant feature of his theory of modern architecture. It is astonishing to realize that Durand was a student of Étienne Louis Boullée, whose grand romantic visions of revolutionary architecture have absolutely nothing in common with the almost technocratic demeanor of Durand's beliefs. His approach became widely influential, despite many misgivings concerning the overall mechanistic dryness of his propositions.

The two volume work *L'Histoire de l'Architecture* by August Choisy was based on a structural interpretation of the history of architecture, that is the assertion that structural invention played the leading role in progressive architectural development. Choisy's work exerted a strong and positive influence on the development of modern architecture. Despite the radical change in the socio-political climate of France following the French Revolution, his principles and definitions, as well as those of Durand remained vital and significant forces for years following their advent. Thus, a characteristic of French thought and art became firmly rooted—a tendency toward rational, universal, and objective frameworks that transcend the particularities of a given socio-political context.

The restoration of the conservative Bourbon dynasty to power had a very adverse effect upon the further development of French architecture. In 1816, Louis XVIII ordered the creation of the new Académie Royale de l'Architecture which was to be called L'École Royale des Beaux Arts. Under the direction of Quatremère de Quincy, this school began to imitate the methods of the old Académie. A curious and contradictory duality resulted. On the one hand, it was open to anybody who could pass the entry examinations and was tuition-free, which again showed the enlightened governmental sponsorship of the public domain in France. On the other hand, it became the determined intellectual defender of dogmatic classicism, which de Quincy championed. As he detested the current romantic and gothic traditions, he eliminated everything that was not in tune with Blondel's and Laugier's positions. He molded the school into an instrument of the old style of Hardouin-Mansart and Colbert, who were the stylistic watchdogs of the Royal House of Louis XIV in the seventeenth century. His rigidity of thought and method led in consequence to serious

conceptual tensions, student rebellions, and ultimately to reforms, which Napoleon III attempted to force upon the institution.

The educational reforms that Napoleon III decided to implement were associated with the growing theoretical influence of two illustrious individuals whose relationships with the faculty of the Beaux Arts were uneasy from the very beginning. They were Eugène Emmanuel Viollet-le-Duc and Henri Labrouste. Viollet-le-Duc's criticisms of the goals and methods of L'École des Beaux Arts resulted from his enthusiasm for and knowledge of medieval architecture, of which he became the indisputable nineteenth-century authority. He believed that the proper understanding of this period, associated with the greatest achievements of French architecture, could redefine and redirect the meaning and creative goals of nineteenth-century architecture. The road to innovation and progress lay in the gothic period, in which he saw the essence of imaginative design and within which functional, structural, and programmatic concerns formed unified and organic structures. Viollet-le-Duc expressed his knowledge of the gothic and his views in his two principal works, *Dictionnaire Raisonné de l'Architecture Francaise du XI au XVI Siècle* and *Entretien sur l'Architecture*.

Viollet-le-Duc's determination to bring the medieval world to the attention of the French public often corresponded with other efforts of the time. Victor Hugo, the romantic writer, published his *Nôtre Dame de Paris* in 1832. It included a chapter called "Ceci Tuera Cela" or "This Will Kill That." Hugo expressed the opinion that the gothic was the greatest of all French architectural periods and that, in fact, it represented the terminal phase of architectural development in the West. He argued that the invention of the printing press by Gutenberg in the 1430s had killed architecture. From this epoch-making moment on, the world had no need of architecture to express symbolic values as ancient architecture once had. The printed word fulfilled this necessity and architecture lost forever its most important visual asset—the ability to embody and express the political, spiritual, and social concerns of a time and people. Renaissance architecture, based upon the written treatises of Vitruvius, Alberti, and Serlio, he considered hollow, superficial, and decadent in every possible respect.

Hugo expressed the deeply pessimistic view that to revive architecture in the participatory social sense from which the gothic arose was utterly impossible, because for buildings to express anything more than functional utility and stylistic embellishment they had to be expressive of overall socio-political and moral content, which was scarce in the nineteenth century. Even if architecture accidentally experienced a rebirth, it would never become a primary social art again. It would be, at its best, only a series of isolated phenomena. Masterpieces were still possible as were great architects, but only as singular events. True symbolic architecture died 400 years ago. From our present vantage, it is surprising

17

how accurate Hugo's prophesies turned out to be. Under democratic conditions, modern architecture has produced many works of genius, but they have been surrounded by a sea of appalling mediocrity and lack, on the whole, any unifying spirit.

Viollet-le-Duc, who was not as pessimistic as Hugo, tried to take his crusade on behalf of the gothic inside the Beaux Arts. In 1856 he started his own atelier which, in the face of ideological opposition, he was forced to give up after only a few months. He later became the favorite architect of the imperial couple and began enjoying strong political support for his views and activities. In 1863, during a phase of controversial education reforms, the government installed many new professors and many new courses dealing with modern sciences and engineering, and retired some of the old guard, and Viollet-le-Duc was again at work in the Beaux Arts. Yet, after only a few lectures, he hastily retired finding that violent opposition to his ideals continued. The faculty of the Beaux Arts considered the case of the gothic closed forever.

The second controversy which led to government reforms concerned Henri Labrouste. Labrouste seemed influenced by Hugo's polemics even if he never literally adhered to the gothic revival movement. Nevertheless, the rationalist arguments of Viollet-le-Duc and his own structuralist leanings, as far as classicism was concerned, led him to embrace the structuralist interpretation of architecture. He certainly preferred Choisy's history of architecture to Quatremère de Quincy's classicist pastiche. Labrouste, like Viollet-le-Duc before him, encountered similar mistrust and the rejection of his views within the walls of the Academy. He, too, eventually gave up his atelier and preferred to apply his views to reality. The Beaux Arts establishment failed to understand that both men were working toward a novel concept of architecture rather than a revival of the gothic or a specific form of structural classicism. Even if they had understood, they would not have condoned it, finding it too experimental and potentially destabilizing.

The result was a split into four competing tendencies in French architecture. Viollet-le-Duc's partisans began first as straight gothic revivalists, evolving later into modern structuralists to whom the future decidedly belonged. The movement known as art nouveau falls within this group. Labrouste's followers formed a group of "classical structuralists" whose impact on the future of French architecture was equally decisive. The fourth group was made up of individuals who opposed modern experimentation, and became synonymous with the "pompous historicism" of the nineteenth- and twentieth-century Beaux Arts. They were devoted to heavy, eclectic monumentalism and stylistic pastiches. Many well-known and important buildings, however, were produced by these architects. Among them are Pierre Fontaine's Chapelle Expiatoire in Paris of 1816 (*16*); Léon Vaudoyer's Marseille Cathedral of 1845–1893; Charles Garnier's Paris Opera House (*17*) of 1860–1875; Honoré

Daumet's Chateau de Chantilly (*18*) of 1875–1882; Léon Ginain's Musée Galliera (*19*) in Paris of 1878; and Victor Laloux's Gare d'Orsay (*20*) of 1898–1900, also in Paris.

In the end, all such divisions and differences had one essential impact on L'École des Beaux Arts—the move towards innovation and diversification in French architectural design. Julien Gaudet, the best known professor of architectural theory of the second half of the nineteenth century and a student of Viollet-le-Duc and Labrouste, proved himself to be a master of compromise. In his famous work, *Théories de l'Architecture*, he covered a wide range of issues such as history, theory, composition, construction techniques, and budgetary, contractual, and legal matters. He even briefly discussed the gothic, despite his basic dislike for this style. Thus, Gaudet represented an important transition from the dogmatic historicism, which dominated the French academic and professional scene in the first fifty years of the nineteenth century, to the last half of the nineteenth century during which modernism slowly emerged as a significant movement.

The First World War considerably slowed architectural activities, but in the 1920s new controversies shook the walls of the old Academy. Impatient with conservatism and aware of the emergence of modernism everywhere, Beaux Arts students demanded the introduction of new ideas and methods into the school's curriculum. Facing faculty resistance, they approached Le Corbusier, asking him to form an atelier. He refused, but recommended Auguste Perret, who in 1924 organized his own atelier. It was the first official instance of the penetration of twentieth-century modern architecture into the walls of the L'École des Beaux Arts.

This event, however, did not prevent the Beaux Arts from continuing its ultra-conservative historicism to the bitter end and to terminate its career on an appropriately reactionary note. Its last pre-World War II professor of theory, Georges Gromort, wrote his *Essai Sur La Théorie de l'Architecture* in the style reminiscent of the times of Quatremère de Quincy. Perhaps the rise to power of ultra-rightist political regimes in Europe, with monumental classicism as their official "word in stone," had something to do with it. Perhaps he was just another eclectic child of the Beaux Arts. In any event, the history of conceptual troubles at the Beaux Arts came to an abrupt end in 1968 when, in the midst of a new anti-establishment student rebellion, the government of Charles de Gaulle dissolved the Beaux Arts for good. It reopened a few years later in the form of a series of autonomous pedagogical units, which had a right to determine the nature of their own curriculum, ranging from traditional Beaux Arts concerns to Marxist agendas. Thus, in the end, historical and conceptual dogmatism were progressively replaced by a pluralism of views and approaches.

16. Pierre Fontaine, Chapelle Expiatoire, Paris, 1816

17. Jean-Louis-Charles Garnier, Opera House, Paris, 1860–75

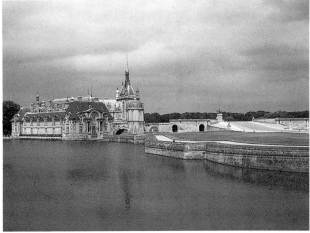

18. Honoré Daumet, Chantilly, Château, reconstructed 1875–82

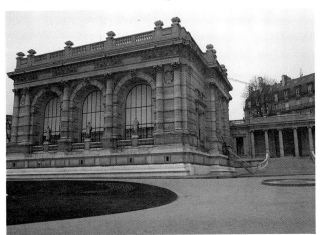

19. Paul-René-Léon Ginain, Musée Galliera, Paris, 1878

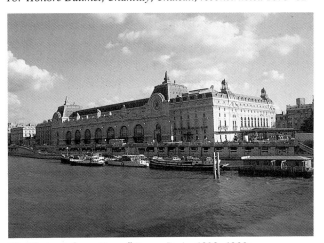

20. Victor Laloux, Gare d'Orsay, Paris, 1898–1900

Toward Modernism and the First Avant-Garde

"The first requirement of composition is to know what to do, that is, to have an idea. To express an idea one needs a set of principles and a form, that is, rules and a language." —Viollet-le-Duc

The growth of modernism in nineteenth-century France was directly associated with the theoretical events described above. Each conceptual crisis that developed within the walls of the École des Beaux Arts had a direct connection to the evolution of architectural activities outside. Each crisis resulted in a slow but unavoidable transformation of traditions and points of view. Certainly the political and social events that surrounded the academic world in the nineteenth century were ultimately responsible for such a process of change. The French revolutionary authorities and the regime of Napoleon expected architects to respond to building tasks other than the traditional palaces, aristocratic residences, and their gardens and churches alone. The growing role of the middle classes caused architecture to rapidly engage their needs and concerns. From its elite position, architecture began evolving toward a more broadly conceived and populist character. Even the restoration of the conservative Bourbon dynasty in 1818 could not halt this process. Soon architectural theory and practice had to take into account a multitude of new architectural programs which included railroad stations, public museums, public hospitals, scientific institutions, universities, schools, prisons, administrative offices, shopping arcades, department stores, warehouses, market places, factories, manufacturing facilities, and military establishments, to name a few. All of these structures had to be handled in a new aesthetic and technological manner, a combination of imaginative and technical know-how. The architectural theories of Durand, Viollet-le-Duc, and Choisy supplied ready starting points.

The radical reconstruction of Paris undertaken by Napoleon III served as a general point of departure for the creation of these new forms. This decision to renovate the city was a response to a rapidly increasing population, the growth of industry and commerce, the need for new means of transportation, new sewer systems and hygienic standards, as well as new urban spaces, including public parks and broad streets. The emperor wished to turn Paris into a more monumental, aesthetically appealing city and to make it more accessible to military troops in case of revolutionary troubles. Although the general planning methods adopted were a continuation of the "Grand Plan" approach established much earlier by Le Nôtre, the building designs addressed the multitude of new tasks in novel ways. In consequence, new building types emerged, which required innovative conceptual definitions and technological solutions suited to new materials and new methods of assembly.

The emergence of new building types is often connected with experimentation in the domain of new building materials and their use. Progress in the field of iron and steel construction in the nineteenth century allowed many new and soon-to-be-realized structures: the cast-iron spire of Rouen Cathedral by Jean-Antoine Alavoine of 1827–28; Gustave Eiffel's tower of 1889 in Paris (*21*); Les Halles Centrales in Paris (*22*) by Victor Baltard, who constructed them in cast-iron upon Napoleon's personal insistence; and Les Halles Centrales in Lyon of 1858 by Toni Desjardins. (Unfortunately, the last two have been demolished.) The experimentation with metal also extended to four new Parisian railroad terminals: La Gare de l'Est by Francois Duquesney of 1852; La Gare du Nord by Jacob Hittorf of 1861-65 (*23*); La Gare de St. Lazaire by Gustave Lisch of 1889; and La Gare d'Orsay by Victor Laloux of 1900. These stations had in common heavy, eclectic, and monumental facades with sparkling, palace-like interiors and industrial sheds made of cast-iron and glass to protect arriving and departing passengers.

Another famous building (also demolished) was the "Hall of the Machines" designed by Charles Dutert for the Paris 1900 World Exhibition. This structure featured an immense 420-by-115-meter metal and glass shed that was assembled entirely out of prefabricated components—an immense technical achievement for the time. What this structure must have felt like is suggested by a visit to another famous pavillion of 1900, the Grand Palais by Henri Deglane (*24*). It consists of an enormous, soaring metal structure in the spirit of a gothic cathedral or a huge greenhouse, enclosed by layers of eclectically handled spaces and walls as was the formal design technique of the time. Revealing industrial materials on the outside of a structure was not yet acceptable.

The application of metal construction did not stop with industrial or semi-industrial projects. The dome of the Halle au Blé (*25*) in Paris of 1808–13 by François Joseph Belanger was made of metal and glass. The courtyards of the Familistère socialist workers' housing at Guise (*26*) have a glass-enclosed industrial shed erected over them. Even the grand hall of the venerable L'École des Beaux Arts was eventually given a great glass shed supported on thin metal columns entirely exposed from within (*27*). Metal also appears as a material used for the construction of new churches. At St. Eugène of 1854 by Louis-Auguste Boileau, and St. Augustin of 1867 by Victor Baltard, exposed metal columns were used inside. The most remarkable example of the intrusion of modern materials into the ecclesiastic world of building was the church of Notre-Dame-du-Travail of 1901 by Gabriel Astruc (*28*). Here he expressed a gothic-like composition in lightweight, plain, and industrial metal.

The other source of experimentation was reinforced concrete. France quickly became a country in which this material found much sympathy and support. One might even say that reinforced concrete eventually became a sort of national building technology, even into the 1980s. The popularity of this material was associated not only with its economy, but also with its plasticity, which could

21. *Gustave Eiffel, Eiffel Tower, Paris, 1889*

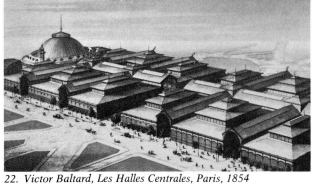

22. *Victor Baltard, Les Halles Centrales, Paris, 1854*

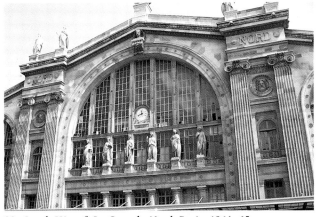

23. *Jacob Hittorf, La Gare du Nord, Paris, 1861–65*

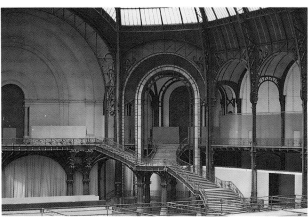

24. *Henri Deglane, Grand Palais, Paris, 1900*

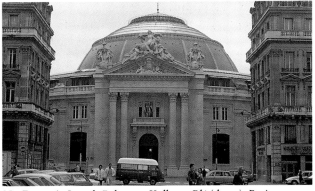

25. *François Joseph Belanger, Halle au Blé (dome), Paris, 1808–13*

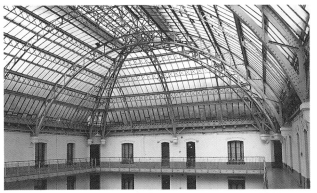

26. *Jean-Baptiste Godin, Familistère Housing, Guise, 1871*

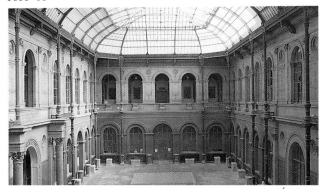

27. *Felix-Jacques Duban and Ernest-Georges Coquart, L'École des Beaux Arts (covered courtyard), Paris, 1871–74*

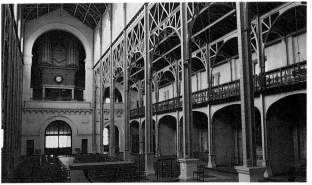

28. *Gabriel Astruc, Notre-Dame-du-Travail, Paris, 1901*

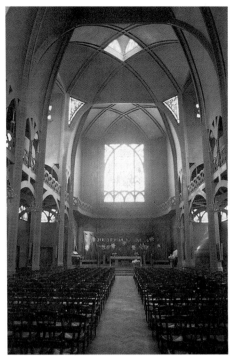

29. Anatole de Baudot, Saint-Jean de
Montmartre, Paris, 1894–1904

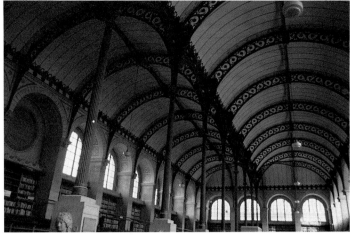

30. Henri Labrouste, Bibliothèque St. Geneviève, Paris, 1850

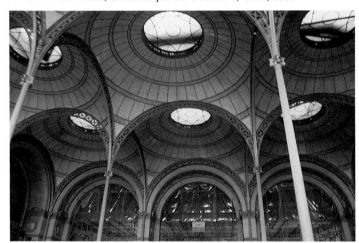

31. Henri Labrouste, Bibliothèque Nationale,
Paris, 1859–68

be compared to the architectonic features of traditional masonry. It was the builder François Hennebique who pioneered the skeletal uses of reinforced concrete in France. He built a six-story building at 1 Rue Danton in Paris in 1888 as a demonstration of this technology, which became very influential at the 1900 World Exhibition. Between 1889 and 1904 Anatole de Baudot, a former student of Viollet-le-Duc, designed and built the church of St. Jean de Montmartre (29). He expressed traditional gothic compositional parts using thin concrete shells, thereby giving historical form a novel interpretation. In sum, these people belonged to a group of pioneers determined to explore new possibilities and who saw historical traditions only as useful and general models which they could adapt for organizing their own ideas. In a way, they had Durand's approach consistently at heart, even if they rarely had any direct connection with academic theory.

Even so, their attitude was taken into account by academic theorists such as Julien Gaudet at L'École des Beaux Arts who suggested a compromise between historical models and modern technological approaches.

Gaudet must have learned the essence of this compromise from his illustrious teacher, Henri Labrouste. Labrouste's two famous Parisian libraries, St. Geneviève of 1850 (30) and Bibliothèque Nationale of 1859-68 (31), were designed to resolve the contradictory relationship between the use of industrially produced components and architecture with a monumental spirit in mind. Labrouste's conceptual dualism, which emphasized traditional monumental urbanism on the outside and structural innovation inside, helped to produce a theoretical platform for dealing with architectural changes in the second half of the nineteenth century.

This dualistic tendency, which showed itself not only in Labrouste's work, but in Parisian railroad terminals and in the Grand Palais as well, was a result of the urbanistic thinking of their authors. They maintained an image of a traditional, monumental city in which the buildings had to respond to dramatically outlined plazas, boulevards, streets, and parks. Thus, their designs may be called compositionally "contextual." Within this approach, the lightness and transparency of metal, glass, and concrete skeletal structures were often out of place.

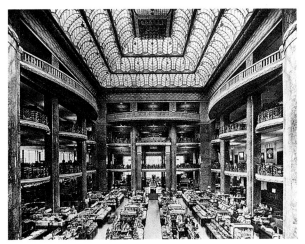

32. *Louis-Charles Boileau, Au Bon Marché, Paris, 1869*

Only a radical change in city planning could justify the general adoption of these new conditions. The architects of this period, however, did not preoccupy themselves with problems of city planning because their time had not yet come. The world had to wait for the pioneering twentieth-century work of Tony Garnier, Le Corbusier, and the functionalist architects to become seriously involved in this new, radical, and disturbing dilemma.

Among all these pioneering innovations, one particular design type made a unique and significant contribution to the development of international design typologies. This was the multi-story department store, which, perhaps more than any single type, defines the French contribution to modern architecture. Such structures or "grand magasins" as Le Printemps by Paul Sédille of 1865, La Bell Jardinière by Henri Blondel of 1869, and Au Bon Marché by Louis-Charles Boileau of 1869 (32) display the best characteristics of this new building genre. They were elegant shopping structures located along new boulevards and in tune with Napoleon III's spirit of the "belle epoche." In them, wide-span technology merged with the visual language of opulence and gaiety to create something uniquely open, accessible, and modern. In the end, the railroad terminals, grand magasins, shopping arcades, exhibition halls, and overall technological progress gradually forced architecture, by the weight of functional and technical factors, to turn away from the poetic positions of eclectic romanticism and respond to new, rational criteria with novel conceptual inventions. The rational structuralism of Viollet-le-Duc, Choisy, and Labrouste finally produced outlines of architectural philosophy to which the next three generations of architects generally adhered.

Parallel to these experiments with novel building types appeared another movement whose concern with the development of modern architectural language came from very different, non-rational sources. This movement is often referred to as art nouveau, or as it was once called in France, the 'Style of 1900s.'

Art nouveau began its existence on a platform of anti-historical, anti-pastiche, anti-imitation, and anti-academic positions. Although it developed into a strong and singular type of architecture in which an affinity with classicist principles is evident, other historical influences can easily be discovered in it. Here, too, a strong French historical heritage played an important role in its formation. Gothic, baroque, rococo, and Islamic styles were woven together into an abundance of curves, sinuous shapes, and volumes to create a flamboyant type of architectural ornamentation. The impact of organic and vegetal forms on this movement was equally strong. These influences produced architecture of a highly individualistic, personal, and often arbitrary character. But its contribution to the development of modern architecture in France and elsewhere was significant because it helped to free design from the historicism of the academies and because it experimented with new materials and technologies with great enthusiasm.

Without any doubt the greatest representative of this movement in France was Hector Guimard (1867–1942), whose most famous works include Castle Henriette at Sèvres, and Hotel Guimard (33) and Castle Béranger (34) in Paris. Others were Jules Aimé Lavirotte, whose most famous art nouveau buildings in Paris are 3 Square Rapp, the Ceramic Hotel, and the famous grand hall of the Galeries Lafayette; Georges Chedanne who built the Hotel Elysées-Palace in Paris and the Hotel Riviera in Monte Carlo; Frantz Jourdain who designed the La Samaritaine department store in Paris; and Louis-

33. *Hector Guimard, Hotel Guimard, Paris, 1910*

34. *Hector Guimard, Castle Béranger, Paris, 1894*

35. *Louis-Hippolyte Boileau, Hotel Lutetia, Paris, 1910*

Hippolyte Boileau, who designed the Hotel Lutetia in Paris (35).

Curiously enough, despite the great architectural talent Guimard demonstrated, art nouveau did not establish itself in Paris as a comprehensive movement which one could refer to as a new "Parisian" school. Instead, this new approach was called "Guimard's Style" for a long time, emphasizing its highly personal nature. Indeed, the prevailing Beaux Arts influence in Paris had much to do with this. Art nouveau lasted, in its conceptual purity, a very short time—from 1896 to about 1906. By this time, it had been absorbed into Beaux Arts compositional patterns, retaining only characteristic art nouveau ornamentation. Its short-lived history is not different from many other twentieth-century movements, like the Dutch Amsterdam school, German expressionism, or Italian futurism, which were incapable of sustaining for an extended time their initial creative and visionary energies.

But despite these positive developments and the existence of many creative individuals, the overall balance of modern French architecture at the beginning of the First World War was rather mediocre. The transition from historicism to modernism could be generally characterized as the adaptation of old compositional formulas and aesthetic principles to new needs and necessities. The enlightened compromise between the old and the new seemed to be the biggest achievement of this transitional era. However, very few professors and graduates of L'École des Beaux Arts knew how to convert old principles to new tasks, or how to replace them with radically new ones. Few had any such aspirations. The conversion to new rules meant the acceptance of new scientific, rational, and functional positions which, to a great extent, denied the spirit of lofty and painterly Beaux Arts poetics and the artistic detachment from reality. The men of the Beaux Arts, trained on idealized examples of Greek and Roman constructions, were forced to contend with the world of cast iron, industrial trusses, beams, bridges, elevators, lightweight panels, and other materials associated with the end of a culturally enlightened era.

Many architects of the time, however, opted for an "in-between" approach which was given the name "tempered modernism." The tempered modernism reflected a conceptual compromise—the desire to retain the solidity of historical formulas, and a desire to adapt them to the formal, functional, and technological spirit of the times. Among the architects belonging to this conservative movement are a few whose works are distinguished by a high level of architectural design. Henri Pacon is known for his village at Chantilly of 1928 and the Gare du Maine in Paris of 1929, and Pierre Patout for his famous building on Boulevard Victor in Paris of 1935 (36). Michel Roux-Spitz is perhaps the best-known of this group. He designed many sophisticated buildings which are distinguished by refined volumetric definitions, sophisticated geometries, and excellent concrete craftsmanship. Among his best-known buildings are the Post Office in Lyon of 1938 and the residential buildings in Paris at 115 Avenue Henri Martin (37) and 45 Boulevard Inkermann.

Another group of "tempered modernists," unlike Pacon and Roux-Spitz who could be described as progressive, were moving towards an academic and neoclassical adaptation of modernist methods. The Palais de

36. *Pierre Patout, Apartment Building, Boulevard Victor, Paris, 1935*

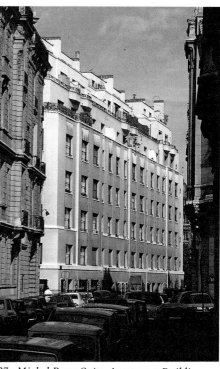

37. *Michel Roux-Spitz, Apartment Building, 115 Avenue Henri-Martin, Paris, 1931*

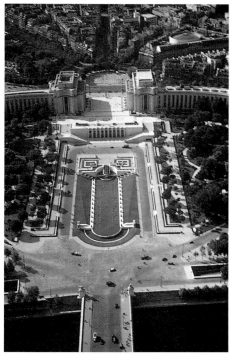

38. *Jacques Carlu, Louis-Hippolyte Boileau, and Léon Azéma, Palais de Chaillot, Paris, 1937*

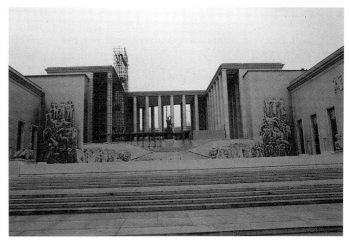

39. *Dondel, Aubert, Viard, and Dastugue, Musées d'Art Moderne, Paris, 1937*

Chaillot (38) in Paris by Jacques Carlu, Louis-Hippolyte Boileau, and Léon Azéma of 1937 and the Musées d'Art Moderne (39) in Paris by Dondel, Aubert, Viard, and Dastugue of 1937 are excellent examples of this tendency toward urban monumentality, simplified details, and heroic and ceremonial spaces. This style originated in Italy in the early-1930s to express the fascist ideology.

Very few French architects at the beginning of the twentieth century, however, dared to go beyond the limited formulas of conventional compromise. Among those few were Tony Garnier, Auguste Perret, and Henri Sauvage.

Tony Garnier (1869–1948) is known internationally for his theoretical project *Une Cité Industrielle* (40). He put his proposal together during an 1899 stay in Rome as the Rome Prize winner from L'École des Beaux Arts. After his return to Paris, he presented his ideas to the school in 1901 and met with violent rejection. Not discouraged, Garnier continued to work on his proposal until 1917. The project concerned a town of an industrial character for 35,000 inhabitants. In this project, Garnier proposed for the first time functional principles of zoning which allowed the separation of industrial centers from residential areas, taking into account modern means of

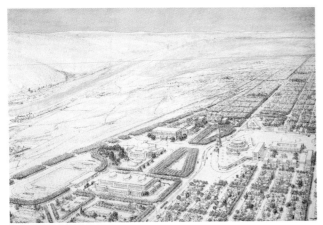

40. *Tony Garnier, Une Cité Industrielle, 1899*

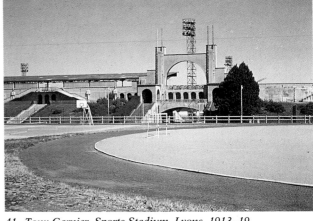

41. *Tony Garnier, Sports Stadium, Lyons, 1913–19*

42. *Auguste Perret, Apartment Building, 25b rue Franklin, Paris, 1903*

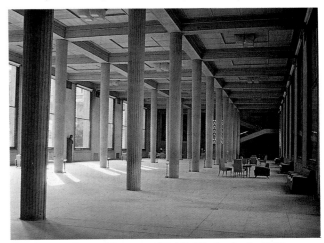

43. *Auguste Perret, Museum of Public Works, Paris, 1937*

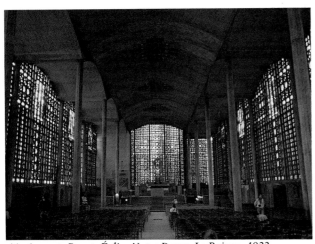

44. *Auguste Perret, Église Notre-Dame, Le Raincy, 1922*

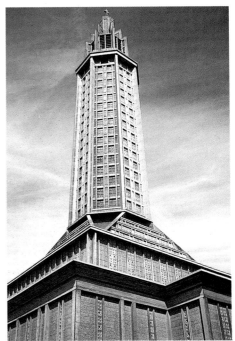

45. *Auguste Perret, Church of St. Joseph, Le Havre, 1949–56*

26

transportation and sanitary requirements. Garnier's Industrial City was also planned in a traditional French rationalist spirit—that is, in a geometric fashion with a grid plan that could be compared to the spatial compositions of Le Nôtre and the Beaux Arts tradition. At the same time, Garnier's rational tendencies were reflective of deep humanist concerns. The entire proposal is grounded in strong socialist ideas and in the writings of Émile Zola and other social reformists. The scale of the architecture is humane—no tall buildings and no violent contrasts between various urban forms. The sense of continuous communal integration is present everywhere. His programming excluded police stations, prisons, and military establishments. Garnier's architecture is simple, reductive, and cubical. The proposed materials are metal, concrete, and glass. They allowed him to achieve large-span constructions, flexible, open-floor planning, and the easy penetration of light and air. They are truly modern in their sense of openness, accessibility, and transparency. Garnier's proposal was never implemented at such a scale. He was able to demonstrate only in a limited way what he meant in his housing estate, called "Le Quartier États-Unis," in Lyon. Garnier is also remembered for several 'constructivist' projects in Lyon, like his famous sports stadium (41) of 1913–1919, the Slaughter House, as well as the design for the Stock Exchange, in all of which he used concrete as the standard material of the French architectural avant-garde.

In the end, his Industrial City proposal had a deep influence on the development of modern city planning, which Le Corbusier's Radiant City proposal and Bauhaus principles of urban planning so clearly demonstrate.

Auguste Perret (1874–1954) pioneered many of the principles that Mies van der Rohe would explore in his later work: he attempted to redefine the meaning of the classical concept of architecture from the structural position by infusing it with modern technical possibilities and, consequently, giving it a new, fresh, and personal interpretation. Perret was a pragmatic builder at heart, even if his design sensitivity was deeply ingrained in the Beaux Arts aesthetic. For Perret, the technical problems of architecture were of absolute importance, although he gradually developed more and more formal concerns. The technical problems which he attempted to resolve were associated with the use of concrete as a building material, which he tried to integrate into a system of highly rationalized planning and structural principles. A long series of his buildings—the famous apartment building at 25b rue Franklin of 1903 (42), the Théâtre des Champs-Elysées, the Museum of Public Works in Paris (43), the church of Notre Dame in Le Raincy (44), and finally the post-World War II reconstruction of the city of Le Havre, which included his famous Church of St. Joseph (45)—exemplify an unchanging classical line of design, but with a Viollet-le-Duc-like emphasis on structural and organic integrity.

Another highly original and creative architect of this period was Henri Sauvage (1873–1932), inventor of

the so-called 'hygienic' apartment buildings. His research into the domain of modern hygienic living was prompted by the often catastrophic living conditions in overcrowded Paris which led to the most dangerous public health threat of the time—tuberculosis. This illness was responsible for the emergence of new modern building types such as the sanatorium, as well as the emergence of new ideas in housing and urban planning. In spite of the early resistance of the French bourgeoisie, who always disliked novelty, new ideas of comfort, good aeration, and access to sunshine and the outdoors penetrated French twentieth-century residential architecture. Sauvage led the way with a few remarkable Parisian apartment buildings like 26 rue Vavin (46) and another on rue des Amiraux (47) which became very well known for their ziggurat-like massing, enabling the architect to form an extensive sequence of outdoor terraces. They are equally important for their use of bright, washable surface tiles which contributed to their somewhat clinical appearance. Sauvage also pioneered the use of duplex

46. *Henri Sauvage, Apartment Building, 26 rue Vavin, Paris, 1912*

47. *Henri Sauvage, Apartment Building, rue des Amiraux, Paris, 1922*

apartments, which allowed considerable penetration of sun and air into their interiors. Other, unrealized projects by Sauvage, like the famous design for Place Maillot in Paris, further explored the theme of the ziggurat-style apartment block with extensive terraces and interior swimming pools for health and hygienic reasons. In Sauvage we see an early example of the socially-oriented modern architect in whom complex and diverse public concerns led to the emergence of a characteristic and unique method of design.

It must be said that despite the interest in modern technology of architects like Garnier and Perret, the inspiration for their works was generally historical. Amidst their ranks appeared a new generation of radical reformists who, inspired by twentieth-century socio-political and scientific revolutions, wished to produce an uncompromisingly novel concept of architecture appropriate for their time. This generation looked for inspiration to the countries in which the development of modernism was more advanced than in France. The Soviet Union, for example, was the birthplace of constructivism, while in Germany the influence of the Bauhaus was on the rise, and in Holland the de Stijl movement had acquired an international reputation. Italian futurism found equal favor among the avant-garde in France, as well as the works of Frank Lloyd Wright.

In France, the works and theories of four individuals represent the most important French contributions to the development of international modernism—Le Corbusier, Robert Mallet-Stevens, André Lurçat, and Pierre Chareau. However, despite the genius of Le Corbusier their overall contribution must be judged as fairly modest at the national level when compared to the still-prevailing influence of Beaux Arts historicism. Characteristically enough, none of the three greatest French pioneers of modern architecture was born in France, although they were all of French blood. Perret and Mallet-Stevens were born in Brussels, while Le Corbusier was born in La Chaux-de-Fonds, Switzerland. Le Corbusier arrived in Paris in 1908 where he met Franz Jourdain, Henri Sauvage, Tony Garnier, and Auguste Perret, in whose atelier he worked for a few months. His first French-inspired design was the "Domino" system of prefabrication created as a solution for France's urgent housing needs immediately after the First World War. It was derived from Perret's own studies of skeletal structures and remained one of Le Corbusier's most fundamental principles of design.

His theoretical interests began to show in 1920. In this year he and the French painter Amédée Ozenfant founded the movement which they called "purism." Purism opposed cubism on the grounds of its "baroque" decorative tendencies. He also launched his review, entitled *L'Esprit Nouveau*, which he used to express his radical and provocative opinions. After 1920, Le Corbusier turned to writing, publishing, and the exhibition of his work. The goal of all these activities was to convince the French public that the time had arrived to embark upon radically different concepts of architectural thinking. His early essay, *Towards A New Architecture*, was published in 1924 and had an immediate and long-lasting impact on the international architecture community. It was Le Corbusier's first manifesto of his most cardinal beliefs and principles. It was followed by *The Radiant City* and *When the Cathedrals Were White*, equally radical and important works from a theoretical point of view. In 1933, Le Corbusier played a crucial role during CIAM's (Congrès Internationaux d'Architecture Moderne) third congress in Athens. Under his influence, the famous "Charte d'Athènes" was conceived, which, after the Second World War, became accepted as a blueprint for planning the new cities. Ironically, it turned out to become the most inflexible and ideological document of the modern movement, as dogmatic as the historicism of L'École des Beaux Arts against which it stood. It is no wonder that Le Corbusier was often called a modern academician, despite his vehement rejection of such a classification.

The period between the two world wars brought few, but significant realizations to Le Corbusier. Among his houses of this period were the Ozenfant House (*48*) of 1920–22, Villa Roche of 1923–24, Villa Stein (*49*) of 1927, Villa Baizeau of 1928, and his most famous villa before the Second World War, the Villa Savoye (*50*) of 1928–1931. During this period he also designed and built a few large residential and public structures, like the Pavilion de l'Esprit Nouveau of 1925, which was presented as the basic cell of his proposal for large scale "Immeuble Villas," Maison Clarté in Geneva, Immeuble Nungesser et Coli in Paris, the Swiss Pavilion at the Cité Universitaire in Paris (*51*), the Cité de Refuge for the Salvation Army in Paris (*52*), and the unfinished Centrosoyous in Moscow. These projects were complemented by a series of extensive and radical urban proposals for various cities—two proposals for the city of Algiers of 1930; projects for Stockholm, Anvers, and Geneva of 1933; a 1934 project for Nemours; a 1935 project for "La Ville Radieuse" or "The Radiant City," his most fundamental plan for the modern, ideal city; a 1938 project for Algiers and for Buenos Aires; and a 1938 project for St. Cloud in Paris. Of all these theoretical studies and projects, which often caused violent public reactions, only one small workers' estate at Pessac near Bordeaux (*53*) came into being. But even this project ended up in immense public controversy and general condemnation. Le Corbusier's avant-garde solutions and arguments were far too radical for the conservative-minded French. France emerged from the First World War terribly weakened, bloodied, and destroyed and was in no position to confront the large-scale conceptual *tour de force* that Le Corbusier demanded.

Most of the large urban projects of this period by other architects ended up fragmented, inconsistent, and poorly executed. Among the few exceptions were the remarkable "skyscrapers" at Villeurbanne near Lyon (*54*) of 1935 by Robert Giroud and Morice Leroux, and "La Cité de la Muette" at Drancy by Marcel Lods and Eugène

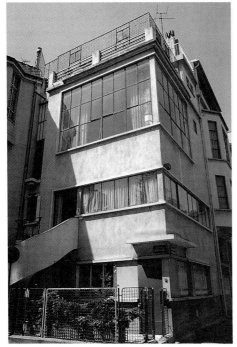

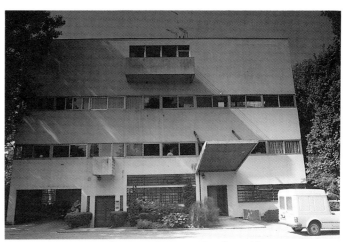

48. *Le Corbusier, Ozenfant House, Paris, 1920–22* 49. *Le Corbusier, Villa Stein, Garches, 1927*

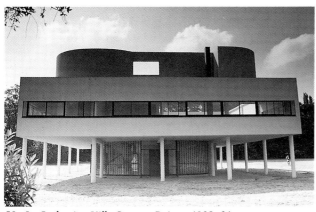

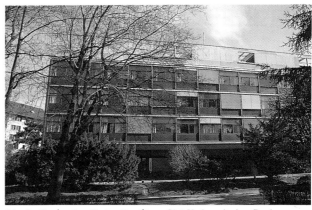

50. *Le Corbusier, Villa Savoye, Poissy, 1928–31* 51. *Le Corbusier, Swiss Pavilion, Cité Universitaire, Paris, 1930–32*

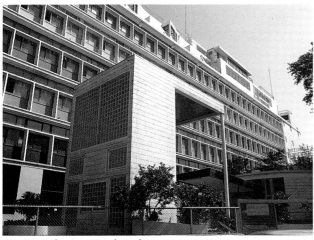

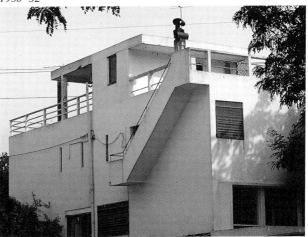

52. *Le Corbusier, Cité de Refuge, Paris, 1929* 53. *Le Corbusier, Cité Frugès, Pessac, 1925*

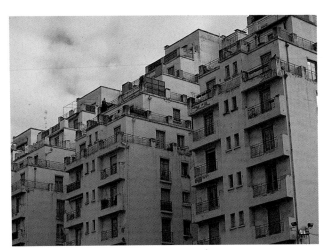

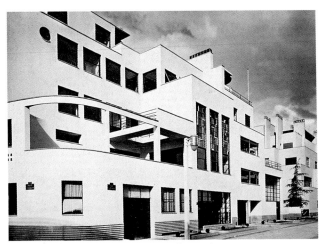

54. Robert Giroud and Morice Leroux, Housing, Villeurbanne, 1935

55. Robert Mallet-Stevens, Villa Allatini, Paris, 1926

Beaudouin of 1935. Otherwise, the best French urban planning of the time was realized in the so-called "garden cities" that were built at various suburban locations in accordance with the ideals of the British planner Ebenezer Howard. The most interesting of them were at Suresnes, built between 1919 and 1930 by Maistrasse and Quoniam, at Stain by Gonnot and Albenque, and at Châtenay-Malabry by Bassompierre, De Rutté, and Sirvin of 1932–1939, all near Paris. However, the futuristic visions of Le Corbusier—the "Modern City for Three Million Inhabitants" of 1922 and the "Radiant City" of 1930—were executed on a truly heroic scale. They were presented and instantly rejected, ridiculed as anti-French, barbarous, unreasonable, and economically and socially implausible. Le Corbusier had to wait until the second half of the 1940s to see his proposals partially realized.

Ultimately, in spite of general public condemnation, Le Corbusier's pre-World War II concept of a "machine to live in" and his urban design principles prevailed. From a broader historical perspective we realize that his creative effort was a dynamic continuation of Cartesian intellectual traditions, that is, of the spirit of rationalism which he provided with novel architectural theory. His conceptual importance transcended French borders and became truly international in scope. His analytic genius was able to synthesize a multitude of international influences and phenomena to produce a body of working principles, which, after the Second World War, became the operative mode for a generation of international architects and academicians.

The work of Robert Mallet-Stevens (1886–1945) also belongs to the movement known as the International Style, with a particular conceptual attachment to the Dutch de Stijl movement and Le Corbusier's purism. Mallet-Stevens defined architecture in 1924 as the art of geometry based upon the integration of platonic volumes (particularly cubes) with formal emphasis placed upon a system of right angles. His architecture reflected a rig-

orous expression of rational, Platonic geometry articulated externally according to internal, functional, and spatial manipulations. His style reflected purist formal concerns by using plain, white, and simple surfaces to achieve a light and transparent appearance. His most famous buildings line a small street named after him in Paris' sixteenth district, and are called Villa Allatini (55), Villa Dreyfuss, Villa Reifenberg, Villa Martel, and Villa Mallet.

André Lurçat (1894–1970) was another representative of the International Style whose theory and design work reflected socialist political concerns typical of most modernists. He spent a brief period of time in the Soviet Union in the 1930s, where he traveled and lectured. After his return to France he started working on his five volume theoretical work, *Forms, Composition and Laws of Harmony*, which was published in the 1950s. In his writings, he pointed to the necessity of producing a new type of architecture based on radically changed historical conditions. Architectural forms had to reflect the ideological and psychological content of the time. His architecture, like that of Mallet-Stevens, adhered to constructivist principles of functional expressiveness, physical lightness, transparency, linguistic simplicity, and technological efficiency. He always stressed the spatial interplay of solids and voids, as well as a preference for orthogonal forms. His greatest pre-World War II works are school designs, among which the Karl Marx School in Villejuif near Paris is his masterpiece. Other well-known buildings by Lurçat are Maison Jean Lurçat of 1924 in Paris, Maison Hefferlin at Ville d'Avray of 1931, and the Hôtel Nord-Sud at Calvi of 1930–31.

The most unusual member of this avant-garde group was certainly Pierre Chareau (1883–1950), who was trained as an interior decorator and only later found his way into architecture. His most famous architectural work, one which had a great influence on international architecture, was the Glass House of 1928–31 (56), built

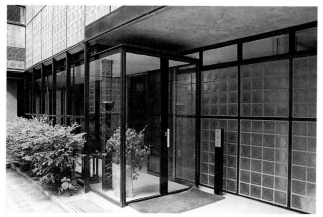

56. *Pierre Chareau, Maison de Verre (Glass House), Paris, 1928–31*

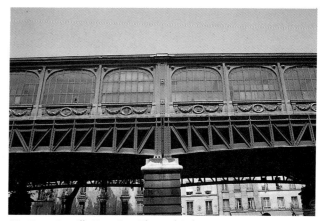

57. *Jean Camille Formigé, Elevated Subway, Paris, 1902–06*

in a nineteenth-century residential courtyard in the central portion of Paris. This three-story glass and metal house stated in a radical way design principles that the creator of the idea of the "machine to live in," Le Corbusier, was attempting to realize in his own work.

Of course, the architects of the first French avantgarde were deeply influenced by the engineering achievements of the time. The very concept of modernism in architecture was linked to an admiration for bridges, elevator silos, hangars, cranes, industrial sheds, airplanes, and ships. The visual experience many architects and artists experienced in the First World War was decisive in conceptual terms. We remember the feeling of enchantment Fernand Léger felt in the presence of the 75mm gun, Erich Mendelsohn's architectural sketches from the trenches of the Eastern front, Antonio Sant' Elia's heroic death at the Alpine front, and Le Corbusier's love of ships, airplanes and tanks. Likewise, American skyscrapers, bridges, and other constructions inspired European minds. Advanced engineering was placed on an artistic pedestal, and everything associated with imitations of the past was condemned and ridiculed.

It is no wonder a few great French engineers who appeared on the scene were hailed as pioneering giants. Gustave Eiffel, who built his famous tower in Paris in 1887 and the remarkable Truyère Bridge of 1880, was, of course, the most famous among them. But there were other constructions and their creators had an equally strong impact on the minds of architects—the exposed subway lines in Paris designed by Jean Camille Formigé between 1902 and 1906 (57), and the bridges at Auteuil (58) and Austerlitz by Louis Biette are of particular importance. Their influence explains why Georges Chedanne designed the office building at 124 rue de Réaumur (59) in such a rigorous modern manner, featuring an all-metal curtain skin, large glass panels, and strict, rational principles of geometry. Industrial designs influenced directly the formal language of architecture. Among other famous

58. *Louis Biette, Auteuil Bridge, Paris, 1906*

59. *Georges Chedanne, Office Building, 124 rue de Réaumur, Paris, 1908*

French engineers whose work deeply influenced modern French design was Eugène Freyssinet (1879–1962), the father of prestressed concrete building technology. He is remembered particularly for his two famous airship hangars at Orly airport (destroyed in 1944) which featured exceptionally elegant parabolic vaults 200-feet in height and 984-feet in length. He is also remembered for many of his bridges, among them the pioneering concrete structures of the Boutiron and Veurdre bridges on the Cher River (now destroyed). The work of Eiffel, Freyssinet, and others had a decisive influence upon the formulation of the "machine to live in" conception of architecture and urban planning. Without the engineers, modernism would not have been born.

In conclusion, however, we must emphasize that despite the creative and professional significance of men such as Le Corbusier, Mallet-Stevens, Lurçat, Chareau, and Freyssinet, to whom we refer as the first French avant-garde, the overall French position within the international development of modern architecture must be classified as fairly modest. Only Le Corbusier achieved true international significance. French architecture lacked either the creative spontaneity of movements such as German expressionism or the broader political and social agendas critical to the operative platforms of the Bauhaus, Russian constructivism, Dutch functionalism, and the romantic schools of Amsterdam and Vienna. Nor did modern French architects have at their disposal the material resources of large-scale development so readily at hand in America. Modern architecture remained the domain of a few avant-garde individuals who managed to find clients willing to take on such challenges. Unlike the socially supported German, Dutch, and Russian movements which ended up producing massive public housing developments and cultural and industrial facilities, French avant-garde modernism was limited to elitist clients and a small range of building types. Thus, modern architecture remained in French public opinion as a narrow, exclusive, and arbitrary endeavor. Ironically, public and government sponsored architecture remained largely in the hands of the Beaux Arts-trained conservatives. The Parisian housing estates located along the Boulevard Peripherique, as well as most of the institutional buildings of the 1920s and 1930s, bear witness to this situation. Only with the end of the Second World War would the architectural hierarchy in France begin to experience intense change. Until then, the force of French tradition was simply too strong to be overcome by a few radical and revolutionary individuals.

Architecture After The Second World War

"The first industrial age began a hundred years ago, and it was an age of chaos. The second industrial era will be the era of harmony and is only just beginning."
—Le Corbusier

If French architecture between 1859 and 1939 represented a period full of heroic moments and struggles between historic traditionalists and modernist pioneers, the two decades which followed World War II were, by far, less heroic. Modernism won the final victory, the eclectic Beaux Arts influence collapsed entirely, and tension between the two radically opposed ideologies ceased. The reason for this turnabout was simple—France emerged from the second war even more devastated than from the first. Many of her cities lay in ruin and her economy was seriously crippled. The public housing problem became catastrophic, due especially to rapid post-war population increases. Urgent, practical, and radical solutions were needed.

Immediately after the war, the Ministry of Reconstruction and Urbanism was created and put in charge of organizing and producing mass housing. These projects required sound planning formulas that would allow the general and efficient coordination of construction efforts. What was sought at the time was an integration of responsible designs for mass housing with industrialized construction methods and urban planning formulas to reduce costs and dramatically decrease the time of production. A quick national economic recovery (realized partially through the nationalization of chief industries) helped to achieve remarkable results in the domain of rebuilding destroyed cities and in the production of mass housing. As a result, French architecture moved from single-function designs to mass-produced commodities. It was a creative and professional revolution on a scale never before experienced. Between 1945 and 1967 almost three-and-a-half-million apartments were built, thanks to the introduction of centralized methods of planning and production. The victory of modernism signified not only the victory of advanced building technology, but also the victory of the functional "Radiant City" ideal which Le Corbusier conceived before the Second World War. Condemned then, it had resurfaced as the primary method of planning for the new housing complexes.

After ten years of massive construction, the French effort gave birth to a new urban prototype called "The Grand Ensemble," satellite dormitory communities for the major urban centers of France. The "Grand Ensemble" idea focused on two principle tasks. One was the reconstruction of destroyed cities, such as Le Havre, St. Malo, Beauvais, and Caen, which were generally successful in terms of achieving contextual integration between the surviving city and the new complexes. Another task was concerned with the building of large-scale dormitory communities, without any specific cultural or physical integration in mind. These developments became synonymous with architectural gigantism, design rigidity, coldness, and aesthetic monotony, and they ended up fostering grave social problems which continue

to plague them today. A few of the more infamous ones—all located in the vicinity of Paris—are Massy-Anthony by Sourel and Duthileul of 1960, La Courneuve (60) by Tambuté and Delacroix of 1964, and the most famous of them all, the Sarcelle (61) by Boileau and Labourdette of 1959. A few French architects, however, were able to successfully apply the "Grand Ensemble" principles. Among them, André Lurçat deserves mention for his thoughtful renovations of several Parisian districts, such as St. Denis, and his exemplary proposals for other districts like Fabien, Blanc-Mesnil, Villejuif, and Maubege. Lurçat's greatest contribution to French architecture of this period was in town planning, particularly in regard to the organization of neighborhood units for which he proposed principles radically different from those implemented in the grand ensembles.

Le Corbusier himself finally received an opportunity to put his theoretical ideas, including his Radiant City proposal, to the test in 1947. Thanks to the sponsorship of the Ministry of Construction his Unité d'Habitation in Marseille (62) was built as the first physical realization of an "Immeuble Villa," or the ultimate "machine to live in." Later, it was imitated countless times as one of the most cardinal of the modern movement's functional types. Four other Unités followed in Nantes-Rezé, Firmini-Vert, Briey-en-Fôret, and in Berlin. But, curiously enough, Le Corbusier was not given the chance to build a new town in France. Instead, he turned to India where the government of Nehru offered him a commission for a new capitol of Punjab called Chandigarh. There, several of his essential early planning ideas were finally realized. In France, he was still considered too radical to serve the realistic and speculative goals of the mass housing industry. In consequence, the pragmatists used his ideas, in the absence of any better ones, but simplified and vulgarized them to suit their production purposes and ended up with the world of the "grands ensembles."

In the meantime, Le Corbusier entered a second period of creativity in a spirit of expressionistic and intensely personal designs, which clearly put behind him his idea of a clean "machine to live in." The Second World War, his personal and often tragic experiences, and the changing world around him influenced his later buildings in a way that removed them far from the realm of the early, rational type of modernism. Among them were the Chapel of Notre-Dame du Haut at Ronchamp (63), the Convent of La Tourette (64), the Maisons Jaoul, the Secretariat, Legislative Assembly, and High Court of Chandigarh, the Museum in Ahmedabad, the Carpenter Center at Harvard, and the Maison du Brésil in Paris (65). Together they stimulated the creation of another international movement, usually referred to as brutalism, a style which took a particular hold in Germany, Switzerland, and England.

Although Le Corbusier's work and theories came under increased public criticism because of the negative influence they had on the social characteristics of mass public housing, the elemental criteria of his formal and

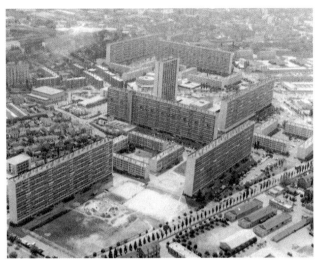

60. Tambuté and Delacroix, La Courneuve, 1964

61. Boileau and Labourdette, La Sarcelle, 1959

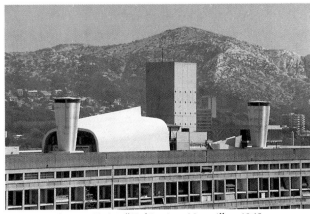

62. Le Corbusier, Unité d'Habitation, Marseilles, 1948

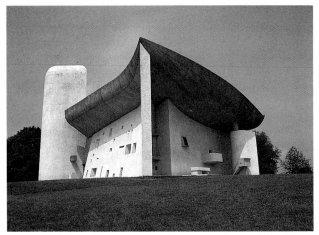

63. *Le Corbusier, Notre-Dame de Haut, Ronchamp, 1951–55*

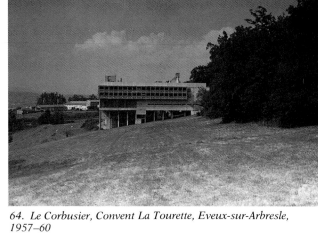

64. *Le Corbusier, Convent La Tourette, Eveux-sur-Arbresle, 1957–60*

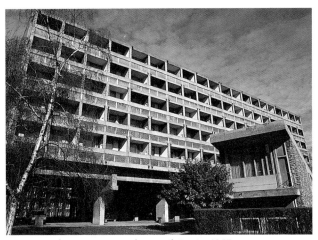

65. *Le Corbusier, Maison du Brésil, Paris, 1957*

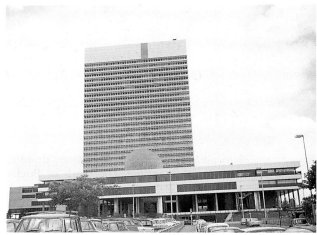

66. *André Wogenscky, Prefecture, Nanterre, 1972*

functional principles continued to exercise a deep influence on French architecture. In the 1960s and 1970s, his influence was particularly visible in the works of former collaborators like André Wogenscky, whose Prefecture at Nanterre (66), Cultural House in Grenoble, and St. Antoine Hospital in Paris followed the fundamental theories and concerns of Le Corbusier. But even in the works of a new generation of architects who opposed him on numerous issues we find many essential features of Le Corbusier's conceptual language reinterpreted. The renewed interest in Corbusier's ideas in the 1980s, therefore, is not surprising given the truly prophetic nature of his work. However, in contrast to the late 1960s and 1970s, the interest in Corbusier's thought today has been more connected with his early language, rather than with his later urban experimentations.

The late 1950s and 1960s, however, were years of critical reaction against the dogmatism of post-war architectural procedures and methods. A new generation of architects arrived on the scene, often very critical of Le Corbusier's views and the "grand ensemble" concept.

Their reaction was naturally associated with the general socio-political climate of those years. It was a time of the political contestation of America's role in the world, of corporate expansion, of conflicts in Vietnam and Algiers, of the imperial politics of General De Gaulle, and of leftist protests and demonstrations, which, among other things, led to the collapse of De Gaulle's government and to the closing of L'École des Beaux Arts, which became one of the centers of violent student demonstrations. The chief preoccupation of the time concerned the moral correctness of certain socio-political and creative outlooks, in which architecture played a significant role.

In France, the architectural debate centered on the post-war activities associated with mass housing, architectural education, the nature of governmental social programs, and the role of the private sector in social development. The general feeling was of a need for radical change. Thus, architecture became highly politicized as it was to play a crucial role in a wide range of social responsibilities—social housing, public education, health care, day care, leisure, athletics, and popular cul-

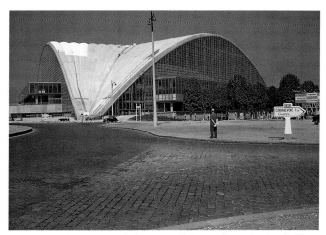

67. *Pier Luigi Nervi, Exhibition Hall, La Défense, Paris, 1955*

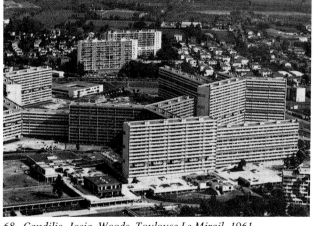

68. *Candilis, Josic, Woods, Toulouse-Le Mirail, 1961*

ture—all were to become critical areas of architectural design. As a result, new socially-oriented conceptual schemes were developed which led to a new language of architecture. Although French architecture of the 1960s produced its own characteristic vocabulary, it owed many of its concepts to the general movement of ideas in other Western countries. The architectural ideas of the time aimed at producing highly futuristic, super-modern, dynamic, mobile, and high-tech forms of architecture. These concepts challenged the post-war design heritage and continued to address socio-political issues despite their highly experimental nature. The work of Buckminster Fuller, Frei Otto, Peter Cook, Ron Herron, and Konrad Wachsmann, among others, influenced these designs. Geodesic domes, cable structures, space frames, prefabricated dwelling cells, and underground and mobile cities represented the "avant-garde" architectural thinking of the time. Although little of this work was realized, its impact on the generation of the 1980s has been crucial.

On the more pragmatic side, the work of Italian engineer Pier Luigi Nervi had a considerable impact on French architecture. His constructions of prefabricated concrete modular units corresponded well with French building tendencies. His Exhibition Hall in Torino of 1947–1949, Palazzetto dello Sport in Rome of 1957, and Palazzo de Lavoro in Torino of 1961 were acclaimed in France. Nervi was invited to France to construct the sail roof of the well-known National Center of Industry and Technology at La Défense of 1955 (67) and to collaborate on the designs of the UNESCO headquarters with Marcel Breuer. The design innovations of Matthew Nowicki's Dorton Arena at Raleigh of 1948–1953, and Eero Saarinen's TWA Terminal in New York of 1962, Dulles Airport in Chantilly, Virginia of 1958–1962, and Yale Hockey Rink in New Haven of 1958, were also welcomed in France with considerable attention. In the same spirit, Le Corbusier designed the Philips Pavilion in Brussels in 1958.

It was natural in a country which, since medieval times, had always been fascinated with engineering, to admire these products of a new structural sensibility. A number of French architects tried to work and experiment with these issues in mind. Jean Prouvé and Stéphane du Château were the foremost engineering experimentalists of the time.

One particular group of architects assumed considerable importance in connection with the evolution of architecture in the 1960s. Their work had none of the formal, experimental, or high-tech avant-garde features of their peers, but nonetheless stood for the changing ideals of post-war architectural expression. This group consisted of three architects: Georges Candilis, Alexis Josic, and Shadrach Woods. Ironically enough, none of them were French—Candilis was Greek, Josic Yugoslav, and Woods American. Candilis and Woods worked briefly for Le Corbusier and participated in the famous Aix-en-Provence anti-Le Corbusier meeting. They also prepared the dissolution of the CIAM at their meeting at Otterlo in 1959, which demonstrated their fundamental antagonism toward the ideals of Le Corbusier. In spite of their work connection with Le Corbusier, they ended up as his adversaries. Their conceptual positions were perfectly in tune with the changing spirit of the times: individual expression, functional flexibility, a wide-ranging vocabulary of architectural types, a search for regional characteristics, and a search for simple technological responses. Their philosophical beliefs were based, not upon hierarchical structures of society or concepts of planning, but, contrarily, upon the belief that modern towns and buildings should be defined by real activities and not by a search for grand ideals and abstract architectural patterns. The architectural designs which resulted from their strategies were based upon the concept of megastructural, cellular, and flexible patterns, design techniques associated particularly with the 1960s. In such a spirit they designed several large-scale projects beginning with Bagnols-sur-Cèze of 1956–1961, Caen-Herouville of 1961, Toulouse-Le Mirail of 1961 (68), the Berlin Free University of 1973, and the Ruhr University

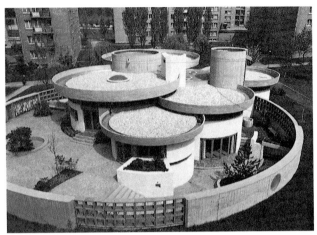

69. *Jean Renaudie, Pierre Riboulet, Gerard Thurnauer, and Jean-Louis Véret, Children's Library, Petit Clamar, 1967*

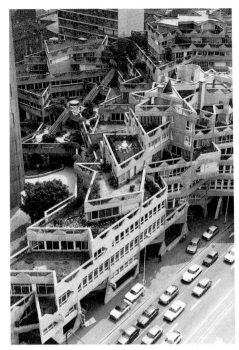

70. *Jean Renaudie and Nina Schuch, Housing, Ivry-sur-Seine, 1963–68*

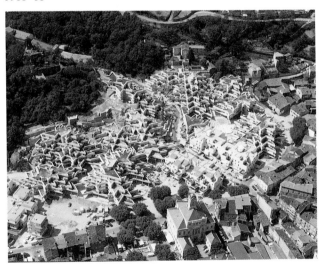

71. *Jean Renaudie and Nina Schuch, Housing, Givors, 1974–81*

in Bochum of 1962.

The team of Candilis, Josic, and Woods was only one of a few well-known French design teams of the time. Another, which produced several remarkable works, was the so-called Atelier Montrouge. Four partners—Jean Renaudie, Pierre Riboulet, Gerard Thurnauer, and Jean-Louis Véret—created some highly interesting projects like the vacation village Château Volterra at Cap Camarat, the Children's Library at Petit Clamar (69), the Electricité-France building in Paris, and many architectural studies. The atelier of Henri-Pierre Maillard and Paul Ducamp was widely recognized for its contribution to the design of sports stadiums, prefabricated housing, schools, and youth clubs. Also of interest is the work of Claude Parent and Paul Virilio whose volumes and textures were influenced by brutalism. At the same time, they demonstrated a keen interest in dynamic spatial resolutions, typical of design in the 1960s. In many ways, their diagonals and inclined surfaces are the forerunners of the present day "deconstructivist" sensibility in architecture. But the most innovative and original representative of the French generation of the 1960s was Jean Renaudie, who died prematurely in 1982. He and his collaborator, Nina Schuch, created a series of capital works—the Jeanne-Hachette and Casanova housing complexes (70) both at Ivry-sur-Seine, as well as housing in Givors (71) near Lyon and in La Viltaneuse in Paris. They demonstrated incredible geometric virtuosity in volume, mass, space, and functional arrangement. The architects searched for pronounced individuality in living conditions, for the integration of indoor and outdoor activities, and for a cohesive sense of planning which they referred to as 'organic integration.' Renaudie's leftist political convictions dictated a far-reaching rejection of isolated object-making, in which he saw the tragedy of a modern environment and a market-oriented architectural profession. He influenced many international architects at that time, many of whom continue to experiment with his approach. Nina Schuch is one of them. She recently completed the design and construction of a housing estate called Voltaire at Ivry-sur-Seine, the Einstein Primary School also at Ivry (72), and a group of houses near Grenoble.

In the late 1960s the French government made the important decision to build several satellite towns around the city of Paris. This new program was launched between 1969 and 1973, leading to the construction of five new centers: Cergy-Pontoise, Saint-Quentin-en-Yvelines, Evry, Melun-Sénart, and Marne-la-Vallée. The major reason for this decision was the rapid and chaotic

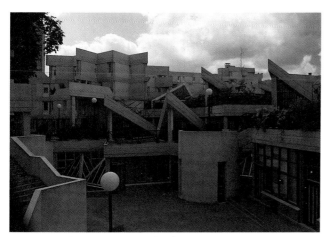

72. *Nina Schuch, Einstein School, Ivry-sur-Seine, 1985*

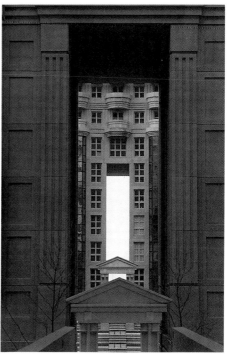

73. *Ricardo Bofill, Les Espaces d'Abraxas, Marne-la-Vallée, 1983*

growth of the city which, if left unchecked, would lead to the strangulation of the city center by making it practically inaccessible. The plan called for a series of residential and work-related subcenters located along the major transportation corridors—one along the Paris-Rouen corridor where two new towns, Cergy-Pontoise and Saint-Quentin-en-Yvelines, are located and along Paris' Nancy-Strasbourg-Reims-corridor, where three other towns, Marne-La-Vallée, Evry, and Melun-Sénart were placed. All five towns were designed as a mixture of residential, commercial, and industrial developments, as autonomous communities, in principle, even if many of their residents commute to Paris to work.

From the start, plans for the new cities called for a suburban type of organization—garden cities accessible to automobiles and other forms of transit. After two decades of negative experiences with the grands ensembles, the French turned to English urban planning principles. The new towns were provided with a character directly opposed to the single, unified, and overwhelming architectural presence of the grands ensembles. As a priority, architectural variety was sought and to a great extent achieved. But the introduction of extensive architectural diversity did not automatically make these towns examples of good urbanism. Their final built forms reveal many serious conceptual shortcomings such as loose spatial organization, weak architectural images, undefined social environments, and the absence of French cultural and architectural traditions which these cities were intended to evoke. They produced, in the end, images of laissez-faire formal planning, defined by nothing more than circulation requirements.

It is not surprising that since the birth of those cities we have witnessed a gradual retreat from their principles toward more formally defined planning considerations. Post-modernism's desire to produce formal urbanism and monumental building imagery à la Beaux Arts has had a significant impact on the recent development and growth of those cities. The post-modernist campaign to

reintroduce traditional notions of urbanism has contributed positively to the tightening of the loose fabrics of those early cities. Although limited in scale, the post-modern housing estates have introduced a sense of unity and concentrated architectural imagery into otherwise pluralistic and undefined communities. Post-modernism's challenge to inherited functionalist conditions continued throughout the 1980s, and dramatically expanded into a variety of architectural tendencies.

Thus, the new towns represent a veritable encyclopedia of French experimentation with different architectural approaches and issues. Three generations of French architects participated in their construction, and their diverse heritage is recorded in a wide range of building forms and types.

At Marne-la-Vallée are three important works from the period which favored monumentalism in public housing. They are Ricardo Bofill's Les Espaces d'Abraxas (73) and Manolo Nuñez-Yanovsky's Les Arenas de Picasso (74), both expressions of grand post-modernism, and Henri Ciriani's La Noiseraie (75), an exercise in brutalism. Among other housing projects are two interesting exercises in the 'crescent' form in architecture—one in the post-modern idiom by Christian de Portzamparc, the other a mixture of Corbusian and classicist vocabularies by Henri Ciriani. We also find ambitious exercises in the language of De Stijl in Les Residences (76) by Oliver Brenac and Xavier Gonzales.

At nearby Melun-Sénart, the least ambitious of the five towns and designed mostly as a suburban commu-

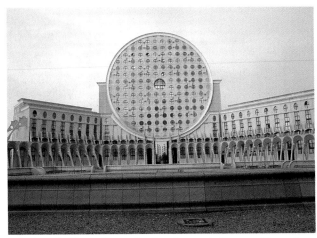

74. *Manolo Nuñez-Yanovsky, Les Arenas de Picasso, Marne-la-Vallée, 1984*

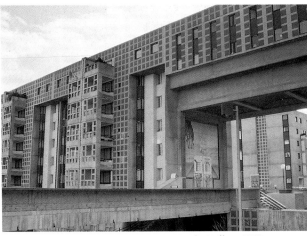

75. *Henri Ciriani, La Noiseraie, Marne-la-Vallée, 1979*

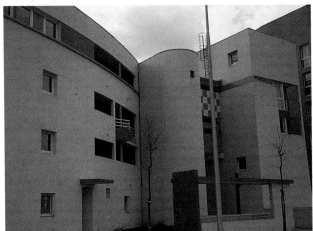

76. *Oliver Brenac and Xavier Gonzales, Les Residences, 1986*

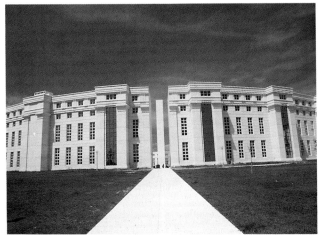

77. *Ricardo Bofill, The Green Crescent, Cergy-St-Christophe, 1983*

nity, are a few excellent examples of housing. One is the Savigny-le-Temple estate by Alain Sarfati.

In Evry the center of the town is made up of 'pyramids' which form an essential part of the plan created by Michel Andrault and Pierre Parat. Within this plan are a variety of mixed-use residential and commercial facilities. The main purpose of the plan was to create a variety of architectural functional types according to a rationally conceived geometric system. The architecture which came out of this approach consists of interpenetrating cubical masses which form a system of extensive outdoor surfaces arranged as terraces.

The urban complex of Cergy-Pontoise could be divided into two sectors from the point of view of architectural history. The original central sector of the town features the pluralistic, functional 'mess' mentioned earlier within which no visual coordination exists. Few buildings here are interesting as anything other than period pieces. However, the Saint Christophe district of Cergy-Pontoise, where a number of recent projects are concentrated, is of considerable interest. Here, planners endeavored to build according to spatial and formal coordination, resulting in groupings of housing which are, to some extent, visually connected. Each island was designed by a different architect, giving them contrasting vocabularies and scales. In the middle of Cergy-Saint Christophe we find the monumental housing estates of Ricardo Bofill (77) and Christian de Portzamparc (78). Both represent the formal and classical grandeur of the post-modern approach. Contrasting them are other residential islands which show a multitude of conceptual influences stretching from Charles Moore to late modernism.

Finally, the town of Saint-Quentin-en-Yvelines, located near Versailles, is important for two projects in particular—Ricardo Bofill's monumental housing complex consisting of Les Arcades du Lac (79) and Le Viaduct, and Kevin Roche's corporate headquarters for the Bouygues Corporation. Both earned nicknames suiting their scale and their source—"Versailles for the People" for Bofill's apartments and "Corporate Versailles" for the Bouygues headquarters. Each represents the monumen-

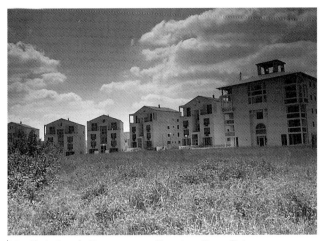

78. *Christian de Portzamparc, Housing, Cergy-Saint-Christophe, 1983*

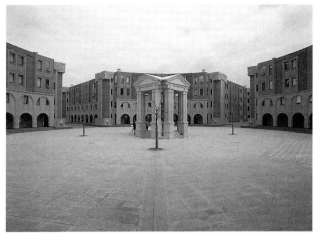

79. *Ricardo Bofill, Les Arcades du Lac, Saint-Quentin-en-Yvelines, 1974–80*

80. *Ascher, Holly, Brown-Scarda, Mikol, and Soltareff, Urban Renovations, Place d'Italie, Paris, 1966*

81. *Eugène Beaudouin and Raymond Lopez, Urban Renovation, Montparnasse, Paris, 1964*

tal, axial, symmetrical tendencies of the French Beaux Arts tradition, although each expresses its own form of classicism through different materials—Bofill through concrete, Roche through high-tech materials. But aside from these two rather controversial creations, the town is known for a multitude of excellent housing and school designs. Considering the rapidity with which all five towns have been growing, one must regard their construction as a strategic success.

Another important urban phenomenon, which preceded the building of the new towns, was the French experiment in urban renovation. In most major French cities, but particularly in Paris, urban renovation was seen as the first answer to the problem of population explosion. The solution to this problem was the replacement of several old, traditional residential districts with new, high density housing estates mixed with business and cultural services. These urban renewal operations were conducted on a vast scale with great rapidity, leading in consequence to tragic results for Paris and other smaller urban centers. In Paris, several such operations

were critical. The redevelopment of the fifteenth district, on the Seine near the Eiffel Tower, produced a series of poorly designed highrises which virtually interrupted the continuous river edge. In the Place d'Italie (*80*), compact city blocks were demolished to make room for a vast number of tall towers and high-rise apartment buildings. In the center of the city, the old district of Montparnasse gave way to a vast commercial and railroad operation dominated by an infamous fifty-story office tower, most of it designed by Eugène Beaudouin and Raymond Lopez (*81*). In other districts of Paris, particularly to the north, urban rehabilitation led to the gradual destruction of the old cohesive and continuous city districts. The most famous of these urban renovations were the changes at La Défense (*82*), which include the districts of Curbevoie and Puteaux, and at Les Halles which occurred as a part of the renovation of the first Parisian district.

In the late 1970s the problem of the 'stomach of Paris,' as the district of Les Halles was once called, became a highly-debated issue tied to the devastation which urban renewal projects had wrought upon Paris. In 1979

82. Bernard Zehrfuss, Robert Camelot, and Jean de Mailly,
Urban Renovations, La Défense, Paris, 1965

83. Ricardo Bofill, Les Echelles du Baroque, Montparnasse,
Paris, 1983

an international conference was held on the subject of how to fill the space left by the destruction of Baltard's Les Halles. This theoretical competition was created by the French Union of Architects to convince the political and public authorities that their approach to urban issues had to undergo drastic and strategic change.

The conference was organized during the height of the post-modern influence, demonstrated in the theoretical works of Colin Rowe, Leon and Rob Krier, Maurice Culot, Antoine Grumbach, Aldo Rossi, and Bernard Huet. The theory of urban design proposed by these individuals was known as the theory of contextualism, based on collage, urban fragmentation, and the juxtaposition of different urban morphologies—a view of the modern city derived primarily from the historically generated planning complexities of Rome. It is not surprising that in view of such tendencies the proposal by Steven Peterson of New York, carried out in a Roman collage style, won the competition. In this project Peterson used a collagist figure-ground technique derived from the morphology of the site and surrounding fabrics to arrive at a tight, picturesque combination of medieval and classical forms. No significant recognition was given in this project to the ideas of traditional French urban spaces or of modern functionality. In short, the offspring of the Les Halles project was entirely academic and none of the proposals were constructed. A hybrid and incoherent (but commercially successful) complex was built to replace the splendid, once exemplary modern structures of Baltard. In the end, the only good which came out of urban renewal was public outrage and criticism which put to an end the high-density and high-rise urban intrusions throughout the historical centers of France. The major building activities were shifted to safer grounds—to the new towns.

The 1970s brought a new and radical change to the further development of modern French architecture. One could argue that although France never lapsed into pastiche eclecticism as the United States did, post-modern-

ism slowed the growth of modern architectural thought there as well. Ultimately post-modernism, as a movement in both countries, was associated with economic, political, and cultural crises of the 1970s . It was a poetic and romantic reaction against pragmatic design tendencies, their historical dislocation, their detachment from Western cultural roots, and their lack of pronounced intellectual principles. But French and American post-modernism had little in common beyond similar historical sources. American post-modernism was associated with eclectic mannerism, superficial historical collages, a search for pluralistic fragmentation and contradiction, and straight historical imitation. In France, contrarily, this movement was based more upon French historical tendencies, that is, a return to grand classical principles of integrated planning, stylistic monumentality, and traditional architectural language. The French expression of this movement, which descended from the Beaux Arts legacy, produced results far different from American efforts. One could say that, in comparison to American tendencies, French post-modernism involved a modernist take on historical language.

Ricardo Bofill, a Catalonian, could be considered the most accomplished representative of this tendency in France. His extensive public housing estates evoke the grand, monumental, symmetrical, and theatrical compositions which he proposed to recapture from the Beaux Arts traditions of the French past. In contrast to the laissez-faire functionalist designs of the new towns, Bofill's strong and positive contribution to coherent urbanism cannot be denied. His early successes can be seen in his Palacio d'Abraxas at Marne-la-Vallée, in his Arcades du Lac at Saint-Quentin-en-Yvelines, and also in his housing at Montpellier. But his later projects, at Cergy-Pontoise and Montparnasse (83), lack much of his original vitality and reveal a routine and repetitive visual vocabulary.

Although French post-modernism is known particularly because of Bofill's work, it produced a number of achievements and a body of theoretical reflections and

84. *Antoine Grumbach, Housing, rue Jules Guesde, Paris, 1985*

85. *Fernando Montes, Housing, Cergy-Pontoise, Paris, 1984*

rules from some academically-inclined French architects. Among them are Bernard Huet, Antoine Grumbach, and Fernando Montes. Their efforts are expressive of urbanistic qualities descending directly from the Beaux Arts formal tradition. Bernard Huet's urban park surrounding Ledoux's famous Barriere de la Villette, and his project for a park at Quai Bercy give an excellent impression of the urbanistic and stylistic goals of their author. Antoine Grumbach, who distinguished himself first through his theoretical research and writings on urban design, created three well-known projects—a mixed housing complex at Quai de Jemmapes in Paris, housing at rue Jules Guesde in Paris (84), and the city hall at Poitiers. In each he derived the constitutive elements of his designs from the urban fabrics relative to the projects. Fernando Montes is known primarily for his monumental housing estate at Cergy-Pontoise (85).

86. *Stanislaw Fischer, Archives, Le Marais, Paris, 1988*

Within French post-modernism there is one architect whose work has more affinity with American attitudes than most others. This architect is Stanislaw Fischer, who designed and built the city Archives in the Le Marais district in Paris (86). Located in the midst of important historical structures, this building plainly demonstrates what a formal collage in architecture is really meant to be—a collection of influences from a variety of sources, whether historical, stylistic, or contextual. His assemblage of diverse influences is handled in an unusually sophisticated manner. Such a derivative attitude has been, however, exceptionally rare within the recent French architectural panorama.

In addition to these individuals and their projects, two exceptionally talented architects deserve mention. Their work, although not historicized, belongs to the totality of post-modern concerns, particularly as they relate to urbanistic issues. At the same time their creative achievements exceed, by the force of their personalities, the standards of mainstream post-modernism. They are Henri Gaudin and Christian de Portzamparc. Gaudin is an architect profoundly influenced by medieval forms of urbanism—their individuality and complexity on one hand, and their overall cohesion and unity on the other. Gaudin cares deeply about the quality of urban spaces, "empty spaces" which he considers to be crucial to the social and cultural activities of urban dwellers. He considers urban spaces the primary constitutive element of any city structure, with architectural solidity serving only as a matter of background. He subscribes to a story concerning the origin of architecture which tells of two simple houses and a space contained between them, rather than the traditional notion of one free-standing, isolated, and primitive object. He sees well-developed spatial relationships among urban objects as essential for the existence of a well-balanced, harmonious, and integrated urban environment. His designs are 'carved out of' or contextually 'derived from' their physical context. One could portray him as a city builder in the tradition of Camillo Sitte, that is, someone who deeply believes in the necessity of compositional planning over individual architectural designs. Gaudin is a master of

41

87. *Henri Gaudin, College Tandou, Paris, 1986*

88. *Henri Gaudin, Housing, Arceuil, 1987*

89. *Christian de Portzamparc, Hautes Formes Apartments, Paris, 1980*

90. *Christian de Portzamparc, School of Dance, Nanterre, 1988*

contextual design. Among his remarkable works are the College Tandou in Paris (*87*), an apartment complex in Arceuil near Paris (*88*), apartment estates in Evry, an addition to the Rodin Museum in Paris, and a recent addition to the city hall in St. Denis.

Christian de Portzamparc is recognized for the sophisticated plastic quality and the poetics of his building designs, which include many examples of housing and other public works. The best known of his projects include an early apartment complex called Hautes Formes in Paris (*89*), which is associated with early post-modern experimentation in urban planning; housing estates at Marne-la-Vallée and Cergy-Pontoise, which take into account sophisticated building typologies; and two artistic centers—the School of Dance at Nanterre (*90*) and the Music Center at La Villette, one of the "Presidential Projects" and perhaps his most complex and accomplished project to date. Portzamparc is a master of urbanistic, contextually-conceived architecture in which the balance between spatial and formal concerns has been carefully considered, controlled, and executed.

Despite the many illustrious examples of architecture mentioned above, we ought to conclude this

brief review by saying that the overall legacy of the post-modern phase in French architecture was episodic and even regressive given the continuous French post-war interest in technological innovation, and, therefore, modernism. One of the most unfortunate features of post-modern design in France is its reliance on historically derived forms which, in the end, depend on a building technology that only precast concrete can fulfill. Thus, if we look at post-modernism from this particular point of view, we realize to what degree it failed to respond to the rapidly changing realm of modern building technology.

Technological Revolution

"The first principle of architectural aesthetics should be the determination of the essential form of a monument by its adaptation to its function."—Gustave Eiffel

The development of modern architecture was directly associated with the invention of new materials, new

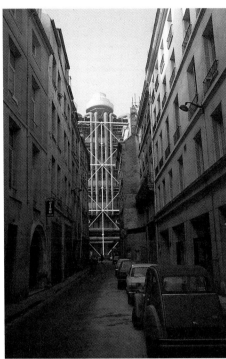

91. *Renzo Piano and Richard Rogers, Pompidou Center, Paris, 1974*

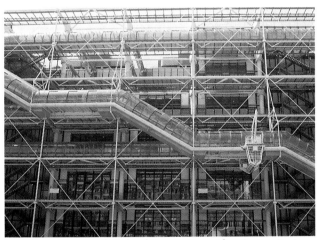

92. *Renzo Piano and Richard Rogers, Pompidou Center, Paris, 1974*

structural systems, and therefore, with inventive engineering. The emergence of structural and functional concerns in modern design reflects a tradition that, although ever present in the history of architecture, exploded with unusual force at the end of the nineteenth century. There is a great parallel between the first industrial revolution during which dramatic architectural changes occurred and the present period of architectural creativity.

The architecture of the 1980s started to align itself more and more with a concern for sophisticated construction methods and materials. New building tasks demanded structures that were economical, lightweight, naturally lit, flexible, accessible, and transparent—the type of architecture that we usually associate with industrial needs. Research on the subject of lightweight metal construction helped to reactivate interest in the utilization of glass, which in turn permitted research into the effects of natural lighting and energy savings. New innovations in the domain of metal and plastic construction, joints, and sealants allowed French architects to design in a streamlined style. More and more we witness refined architectural studies involving innovative joints and supports, and we cannot help but recall nineteenth-century engineers dealing with the requirements of cast-iron construction. A new aesthetic language of architecture borrowed from industrial precedents has been born—architecture of glass, aluminum, composite panels, trusses, cables, space frames, aircraft wings, exposed mechanical equipment, bright colors, and effective signage. Light, flexible, and demountable materials are replacing heavy reinforced concrete, up to now the primary building material in France. This does not mean that significant progress has not been made in this domain either. Concrete structures have undergone many qualitative changes to become more precise and aesthetically refined. But the 1980s stand primarily for industrial, high-tech, and constructivist architectural explorations. We see in this development an ideological agenda—the rejection of post-modernism's formal and derivative designs and monumental imagery.

During the 1970s, one particular design had a seminal influence on the present generation of French architects—the Pompidou or Beaubourg Center in Paris (*91, 92*), designed by the Italian-English team of Renzo Piano and Richard Rogers and completed in 1975. This structure represents the high patronage of the French government—it is a presidential monument, an architectural vision of the twentieth century, a "cultural machine," and an imaginative experiment in architectural expressionism connected to the use of advanced technology. The building surpassed all other post-war projects in its futuristic ambitions and could be compared in its influence to Sir Joseph Paxton's Crystal Palace in England of 1851. No matter how controversial this design has been, it has had a decisive impact on the subsequent evolution of French architecture. It demonstrated the imaginative and fanciful use of advanced technology. Although it represented a wave of high-tech designs already underway in Great Britain, it must be classified as a seminal effort in a long series of French experiments in technological design. Among them are Raymond Lopez's Caisse d'Allocations Familiales in Paris, Edouard Albert's Air France offices at Orly Airport of 1960 and library at the University of Nanterre of 1969, and Michel Andrault and Pierre Parat's Havas Agency in Paris (*93*) of 1973. Although they did not achieve the same level of originality and notoriety, the French experiments nevertheless emphasized a consistent and determined interest in advanced technology and experimental languages of design.

Since the end of the Second World War, French

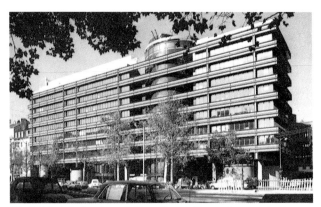

93. Michel Andrault and Pierre Parat, Havas Agency, Paris, 1973

94. Adrien Fainsilber, Center for Science and Industry, La Villette, Paris, 1979

architects have constantly wrestled with the realm of technology as a driving force in architectural conceptualization. In the 1960s, for instance, there was a strong revival of structural theories for the evolution of architecture which corresponded to an increase in French political and economic power in the Western world. Michel Ragon wrote two influential books in 1963 and in 1968 called *Ou Vivrons-Nous Demain?* and *La Cité de l'An 2000*. In both works he spoke of futuristic technologies, futuristic cities, and architecture which would address the needs of an expanding population and diminishing natural resources. Such theorizing was not exceptional for a nation which, since the time of the gothic cathedrals, was preoccupied with grandeur and which was on the verge of realizing the Concorde jet, Mirage fighters, the most extensive nuclear energy program in the world, and high-speed trains.

The Pompidou Center seemed a radical fulfillment of France's technological destiny. How popular and influential the Pompidou Center has become since its completion is proven by the following fact. In April 1986, the French architectural review *AMC* published the results of a poll taken among ninety-nine French architects on the subject of the three most important French and foreign buildings since 1950, as well as the three most important French and foreign architects. The Pompidou Center finished as the most important design on the national list and its creators, Piano and Rogers, second after Le Corbusier on the national architects list. The fact that modernists like James Stirling, Norman Foster, and Richard Meier scored very high on the foreign list of architects aptly explains the modernist influence in current conceptual trends. The triumphant showing of Piano and Rogers' landmark design demonstrates to what extent rationalist and constructivist themes became the core concepts of the 1970s and 1980s in French architecture. In fact, if we asked ourselves how the modern concept of French architecture could be characterized in its totality, we find that the answer, in spite of the existence of a great number of alternatives, is rather simple—French designers have always demonstrated tendencies

towards a universal, rational system of design applicable in all circumstances. We see this tendency, which originated in the late-eighteenth century, flourishing throughout the birth and development of modern French design. Perret, Garnier, Mallet-Stevens, Le Corbusier, Lurçat, the Beaux Arts-tempered 'modernists,' the planners and architects of the grands ensembles, the structural architects of the 1960s, the post-modern historicists, and the high-tech "avant-garde" of the 1980s share the same essential characteristics—a love of method, of rationally conceived concepts and vocabularies, and, therefore, of a Cartesian belief in clarity and conceptual definition.

The Pompidou Center put a new confidence into the architects who admired technologically-inspired architecture and showed a way it could be redeemed. As a result of the Pompidou Center's influence, new ideas and projects surged. Its presence stimulated the design of two architectural structures of primary importance in France—François Deslaugier's Regional Information Center in Nemours of 1975 and Adrien Fainsilber's Center for Science and Industry at La Villette in Paris (94) of 1981–86. All three buildings laid the groundwork for a wave of high-tech designs in the 1980s.

Toward Super-Modernism

"Beauty stimulates curiosity, responding to a need of the heart and the spirit. It both teaches us and stimulates us. My wish is that the major projects help us to understand our roots and our history; that they will permit us to foresee the future and to conquer it."—François Mitterand

To understand the spirit of the 1980s in French architecture, one must familiarize oneself with the so-called "Presidential Projects" in Paris. They were begun under the presidency of Valéry Giscard d'Estaing and are continued today by the "president-builder," as he is often called, François Mitterand. These projects belong to a long tradition of French government patronage in the

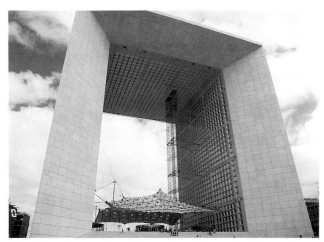

95. *Johan Otto von Spreckelsen, Grand Arch, La Défense, Paris, 1983*

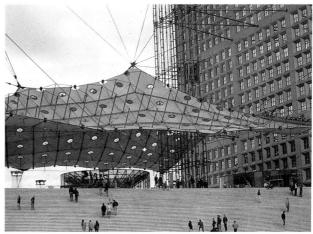

96. *Johan Otto von Spreckelsen, Grand Arch, La Défense, Paris, 1983*

domain of culture which existed in the renaissance and has been continued throughout France's history by the various royal, imperial, and republican governments which followed. The architectural program which President Mitterand presented in 1982 stemmed from a desire to create a series of important public structures in Paris that would establish a new basis for cultural and social interaction in the city and which would also stimulate French architecture to undertake new visionary and creative efforts. Through a series of international and national competitions, the presidential projects did indeed generate highly innovative architectonic and technological solutions which have had a profound impact on the present development and direction of French architecture.

The principal buildings which resulted from the program are the Grand Arch of La Défense, the Grand Louvre, the Orsay Museum, the Arab World Institute, the Bastille Opera, the Ministry of Finances, the Center for Science and Industry at La Villette, the Park of La Villette, the Music Center at La Villette, and most recently, the proposed "Grand Library" project. Additional projects were included in the original agreement of March 9, 1982, between President Mitterand and the mayor of the city of Paris, Jacques Chirac. However, most of these projects were cancelled due to various circumstances.

The Paris projects, in turn, quickly led to similar undertakings in other French towns, like Montpellier, Nîmes, Lille, and Lyon, as a method of stimulating local urban growth and commercial and cultural activity. As in the past, ambitious undertakings in Paris set the stage for developments throughout the French provinces.

Perhaps the most visible of all the presidential projects in Paris is the Grand Arch of La Défense (95, 96), which was the subject of an international competition in 1982 established by President Mitterand. The winning design, by the Danish architect Johan Otto von Spreckelsen, represents the final effort in a long series of competitions beginning in 1932 to determine how to continue or terminate the world's most famous urban axis—the avenue running from the Louvre to the Arc de Triomphe and out into modern La Défense. The site for the structure is located at the western edge of La Défense, an office and commercial development designed by Bernard Zehrfuss in the 1950s. The development was intended to promote the growth of commercial buildings on top of a huge artificial platform, under which numerous transportation networks are located. His plan ran counter to the established Radiant City formula for a highly ordered and geometricized urban fabric by introducing capitalist-inspired laissez-faire spatial organization. It soon came under intense public criticism for its lack of order, excessive height (which changed the Parisian skyline dramatically), and general architectural mediocrity. From the first of the competitions, two tendencies prevailed—one which would terminate the axis with a sense of closure, and another which would continue that axis infinitely. I.M. Pei, for instance, proposed two office towers in 1972 that formed a V-shaped opening between them, a sort of triumphal gate to be erected on the present site (97). This solution allowed the axis to continue infinitely. At the same time, Emile Aillaud designed a finish to the axis—two mirrored, concave-shaped office buildings inspired by the solar generator in the Odeillo Valley in the Pyrenees (98). In 1973, Aillaud modified his proposal by turning the two building-mirrors into a single structure. This project came very close to being realized. In 1980, however, a new competition under the patronage of the President Giscard d'Estaing was organized, and it attracted many post-modern proposals featuring monumental closings of the axis, formal symmetries, courtyards, and arcades. In 1981, four months before the presidential elections (which he lost to François Mitterand), President Giscard d'Estaing decided on another mirror project by architect Jean Willerval that featured a series of low buildings arranged as mirrors that allowed the axis to continue. Because of the change in government, nothing came of this plan either.

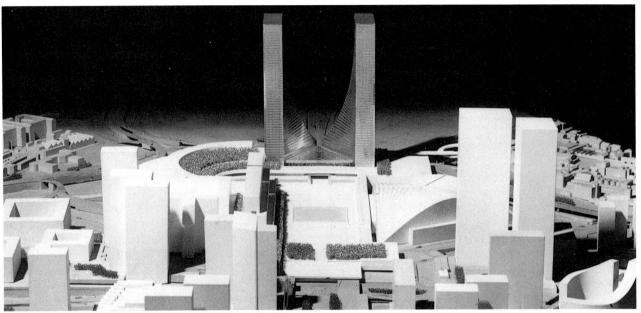

97. *I.M. Pei, Project, La Défense, 1972*

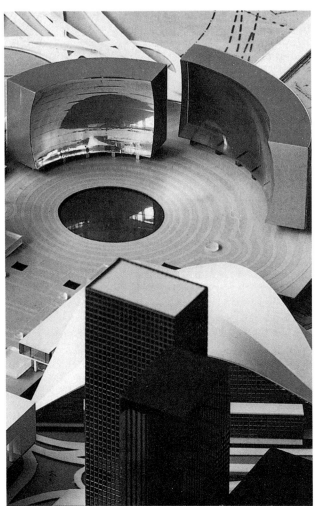

98. *Emile Aillaud, Project, La Défense, 1973*

The winner of the last international competition for the site, in 1988, and the project which was finally built, was Johan Otto von Spreckelsen's Grand Arch. The immense open cube, or "window of the world," as it is often called, serves as a double solution—it closes the axis through its sheer volume, and allows it to continue through its expansive opening. The size of the cube is immense—344 feet by 344 feet in plan, it is elevated above a complex underground network of transportation on twelve huge pillars supporting a bold, three-dimensional megastructure. Within the central opening of the Grand Arch floats the high-tech "cloud"— a plexiglass canopy—and a free-standing elevator shaft which takes visitors to the roof of the structure where exhibition spaces and viewing platforms are located. In this building, as in the Pompidou Center, the French acquired a truly original and unique building.

The second and most significant of the presidential projects is the expansion of the Grand Louvre museum (99) undertaken by the New York architect I.M. Pei, known for, among other works, his modern wing of the National Gallery of Art in Washington, D.C. The project called for two principle phases—the relocation of the Ministry of Finances from the Louvre to a new headquarters on the Quai de Bercy, and the dedication of the entire complex to artistic purposes. The renovation of the museum itself required the construction of a new main entrance, new galleries, offices, research facilities, and reception areas below the Grand Plaza of the museum. The latter move, capped by the now-famous great glass pyramid, has caused the most controversy. Two issues revolve around the pyramid's construction—the placement of such an ultra-modern structure in the midst of a revered historical landmark, and the "corporate" character of the new spaces below it. Despite initial criticisms,

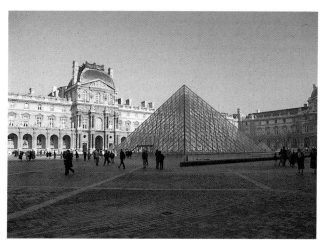

99. I.M. Pei, The Grand Louvre, Paris, 1989

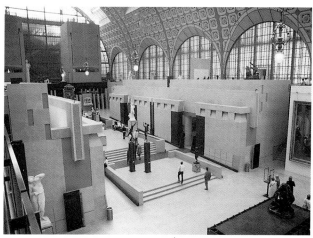

100. Bardon, Colbox, Phillipon, and Aulenti, La Musée d'Orsay, Paris, 1988

the design has truly given the Louvre a new and brilliant image, remaking the old palace in a spirit of modernity and vitality.

The Musée d'Orsay is an excellent example of the adaptation of an old building to new purposes, and the invention of a new type of museum (100). The Orsay Railroad Station and its hotel were condemned for demolition fifteen years ago. Before this, Le Corbusier had proposed to replace this Beaux Arts complex with a modern skyscraper. But in 1978, due partially to public criticism of the demolition of Baltard's Les Halles, President Giscard d'Estaing declared it a national monument and revealed plans to convert it into a museum of nineteenth-century art. The architects for the conversion were Renaud Bardon, Pierre Colboc, and Jean-Paul Phillippon. The interiors were commissioned from the Italian architect Gae Aulenti.

The outcome of the design has been heavily debated from an aesthetic point of view. The combination of the train station's nineteenth-century industrial elegance and the rather heavy post-modern ornamentation in the museum's interior is considered somewhat controversial. More importantly, the museum's rich interior has been criticized as a visual rival to the works it contains. Nevertheless, the museum continues to attract a huge number of visitors and remains a vital presence on the banks of the Seine.

The project for the relocation of the Ministry of Finances to the Quai de Bercy was an impetus for the general redevelopment of the area (101). Also planned are a sports center, a public park, and a vast residential complex. The national competition for the project was won by the well-respected team of Paul Chemetov and Borja Huidobro, who designed a technically and compositionally sophisticated building resembling a gigantic bridge or aquaduct running towards the Seine.

Launched in 1983, the competition for the Bastille Opera attracted over 750 entries. The program called for a new opera house for Paris with the most advanced stage

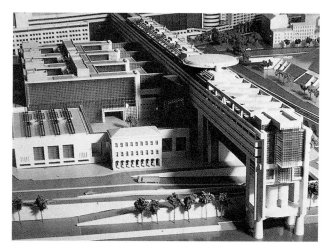

101. Paul Chemetov and Borja Huidobro, Ministry of Finances, Paris, 1989

and acoustic technology available. It was to be widely accessible to the public in a spirit of openness and participation befitting its site, the Place de la Bastille, considered to be the populist heart of Paris.

Six projects were chosen by the jury and presented to President Mitterand for his review. The design by Canadian architect Carlos Ott was chosen from the finalists because of its urban character and the way it filled the difficult, narrow, and irregular site (102). Ott's design, however, has attracted much well-deserved criticism. The finished building is a confusing mixture of post-modern volumetric standards and high-tech expressionism. In the end, it lacks any pronounced or original features which a structure of such cultural significance should display.

The extensive complex of La Villette—which consists of the Center for Science and Industry by Adrien Fainsilber, the Center of Music by Christian de Portzamparc, and the Park of La Villette by Bernard Tschumi—could be rated as the most unique of the pres-

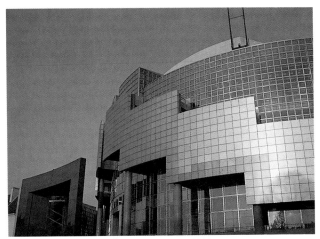

102. *Carlos Ott, Bastille Opera, Paris, 1989*

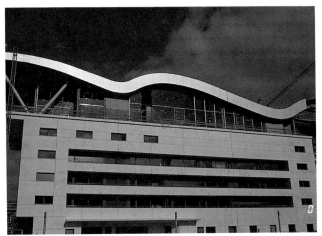

103. *Christian de Portzamparc, Center of Music, La Villette, Paris, 1989*

idential projects. Here, an entire urban district is being renovated by lacing it with ambitious programs and structures. It was started in 1979 by President Giscard d'Estaing who wished to transform the unfinished Auction Hall of the La Villette stockyards into the National Museum of Science and Industry. In the hands of its architect, this project became a high-tech 'tour de force' rivaling the Pompidou Center. The new museum involved a brilliant adaptation of the existing structure through the use of high technology. This construction served as an extraordinary experimental opportunity for the French building industry. With this building, French architecture moved decisively from the realm of reinforced concrete to a vocabulary of metal, synthetic material, and high technology.

It was President Mitterand who, in 1982, decided to elaborate the La Villette project by imposing an overall programmatic and urbanistic plan which would help to revitalize this decaying industrial district of Paris. A national design competition for a new Center of Music was held, and the well-known architect Christian de Portzamparc was chosen as the architect. The center serves several purposes—as the National Music Conservatory, a concert hall, an instrument museum, the Institute of Music Education, and student dormitory (*103*). Portzamparc's symbolic solution evokes an architecture of movement, of dynamic lines and volumes, and of dramatic interactions between solids and voids—an effect that reminds the viewer of the nature of music itself. In contrast to most of the presidential projects, which indulged in futuristic technology, this project comes across as a personal, humanistic, and poetic statement.

The Center for Music aroused intense public interest, but the Park of La Villette by Bernard Tschumi won most of the international attention and acclaim. Tschumi's prize-winning design (*104*) addressed the so-called 'urban park,' within which an overall sense of urbanism and formality gives rise to a spirit of informal public relaxation and enjoyment. It was planned to accommo-

104. *Bernard Tschumi, Parc de la Villette, Paris, 1989*

date a large number of cultural facilities, and features an 'open plan' layout which allows a flexible distribution of activities according to changing site characteristics. This design is by far the most 'academic' of the presidential projects, and is based on principles of design now called 'deconstructivist,' which Tschumi believes to be the future of architectural design.

The Arab World Institute (*105*), sited on the Seine river opposite the Île St. Louis, is the fruit of a 1974 French-Arab agreement to pursue cooperation in the domain of culture and education. It is also the result of a joint French-Arab financial investment in which many Arab countries participated. The competition for this structure was won in 1981 by Jean Nouvel, Pierre Soria, Gilbert Lezénes, and Architecture Studio (consisting of Martin Robain, Jean-François Galmiche, Jean-François Bonne, and Rodo Tisnado). Of all the presidential projects, this design, although the most modest in dimension, is the most interesting architecturally. Its extraordinary

105. Jean Nouvel and Architecture Studio, Arab World Institute, Paris, 1988

106. Dominique Perrault, Bibliothèque de France (winning competition entry), Paris, 1989

sophistication is connected to several factors—its exceptionally good fit on a difficult, demanding, and constraining site; its elegant volumetric massing; and its interesting use of metal to express traditional Islamic architectural and ornamental themes. The designers of this project proved that modern technology can be used in innovative ways for the fulfillment of highly spiritual themes and needs. Unlike the Pompidou Center's brutal and imposing experiment with technology, this project applied modern materials in a quiet, reflective, and poetic manner. It is a true masterpiece of contemporary architecture.

The most recent building project initiated by President Mitterand, the Bibliothèque de France, is probably the largest and most significant of his public undertakings. The chief purpose of the program is to make up for much lost ground in France's antiquated library system, and to give the country the most modern research facilities available. The project is of enormous scale. Located on a seventeen-acre site on the Seine, just across from the new Ministry of Finances, it will house twelve million books and serve as a facility for six thousand researchers. The building's surface will total 2.3 million square feet and will cost about $650 million. To find an architectural solution, the French government consulted 244 international architectural firms and selected twenty international teams for the final competition. Among them were James Stirling and Jan Kaplicky of England, Rem Koolhaas and Herman Hertzberger of Holland, Mario Botta of Switzerland, and Richard Meier and Arquitectonica of the United States. Among the French were Henri Gaudin, Jean Nouvel, Bernard Tschumi, Henri Ciriani, Bernard Huet, Paul Chaix and Jean Pierre Morel, Francis Soler, and Dominique Perrault. The jury, with I.M. Pei presiding, unanimously awarded the first prize to Perrault.

The winning project (*106*) is astonishingly brilliant in its simplicity. It consists of an enormous horizontal building platform approximately the size of the Place de la Concorde and four L-shaped corner towers, each 328 feet tall, within which the books will be stored. The horizontal building includes a central atrium the size of the garden at the Palais Royal, conceived in the image of an enormous monastic courtyard full of trees which will be crossed by several parallels enclosed in glass. This garden will be composed in a natural, informal manner. In fact, Perrault will choose a portion of a forest somewhere on the Île de France to be transplanted to this courtyard. Around the court the reading rooms and public spaces of the library will be concentrated. The overall architectural language is characteristically Perrault—metal, glass, and a spirit of luminosity and transparency will reign supreme here and achieve an overall effect of physical dematerialization. The architecture of the library relies on poetically outlined relationships between its physical transparency and its monastic-like sense of calm which, when built, should give this building a unique spiritual and civic presence. As Jacques Lang, the French Minister of Culture, has said, it is more a place than a building.

In conclusion, we can say that the Presidential Projects, through their conceptual significance, scale, functional complexity, and technical requirements, have stimulated architectural activities all over France. The fact that many of these projects were the subject of international competitions helped to raise the exchange of views and ideas to an international level. The presidential initiatives in France have also had a significant impact on planning for other European urban centers. It is safe to assume that without the Grand Projects, today's French avant-garde in architecture would be nowhere near the level of sophistication and technological maturity to which it has risen in recent years.

Conclusion

"All the surplus poetical force that still exists in modern humanity, but is not used under our conditions of life, should without any deduction be devoted to a definite goal—not depicting the present nor reviving and summarizing the past, but to pointing the way to the future."
—Nietzsche

If the first European avant-garde could be described as an explosion of original and creative intensity in the face of socio-political strife, international wars, and revolutions, what could allow us to call the 1980s in French architecture a second avant-garde? How can we compare both periods—one rich in powerful events, dramatic struggles, and socially committed individuals, the other an embodiment of the general decline of creativity, mass production, profit orientation, and the dominance of computerization?

To answer this, the French architectural movement of the 1980s must be seen from a different angle as it is extremely important to understand in what context it has been taking place. It is taking place at an extraordinary point in European history. The 1980s have been the formative years of a united Europe. This event is as revolutionary for all Europeans as the tumultuous events of the French Revolution once were, but achieved in a peaceful and cooperative manner. Western Europe is on the verge of becoming a parliamentary republic. The political landscape of Europe has changed dramatically. Purist ideological rivalry between communism, fascism, and capitalism does not really exist anymore. Fascism perished in 1945 and its revival is not a serious factor today. Communism is in the process of disintegration and its intellectual influence is waning. A new, middle-of-the-road European political order has emerged—a combination of socialist organizations and capitalist initiatives which have proven to be incredibly successful. As a result, architectural conceptualization today has not taken up visionary, political, or cultural platforms or sought the destruction of old orders. One is witnessing, however, the almost renaissance-like competition between different Western European cities which compete for commerce, industry, culture, and tourism using architecture as its most remarkable and visible language of attraction.

At the same time, architecture has become very professional and scientific, and is preoccupied with the newest technological possibilities. Technology is more accessible than ever, extremely flexible, and so rich in creative potential that it has become possible to use it as a personal and expressive material which can be given non-technological meaning, fulfilling spiritual and aesthetic agendas rather than purely technological needs. This philosophical goal, so much the target of the early twentieth-century modernists, is finally being reached as many French and European designs demonstrate today. This is the achievement of architects whose imaginations are bold and precise enough to allow us to define them as the second avant-garde. Its profile and character may be different from the first one, but its achievements are by no means inferior.

In order to illustrate the nature of the second avant-garde, we have assembled examples of the work of twelve French architects. To assemble such a group was not an easy task, especially when considering the many other architects in France today who deserve to be included. These twelve, however, represent a movement of similar ideas which can be defined in broad and comprehensive theoretical terms. Although there is a great variety in the conceptual approaches and attitudes included in this group, there is no doubt that they all accept an industrially generated aesthetic as a determining factor in their designs. Their positive and powerful response to advanced technology is also revealing in the sense that they treat technology as an art, rather than a functional or pragmatic necessity alone. The results are conceptually bold. Unlike most of the established ways of approaching design and technology today, we witness technology becoming a personal material for these architects. In truth, we can see in these architects the creative ability to translate pragmatics into poetics in the best of the French architectural tradition.

François Deslaugiers, study sketch for the Congress Center, Toulouse, 1989

T H E
ARCHITECTS

ARCHITECTURE STUDIO

Lycée du Futur • Poitiers • 1986–87

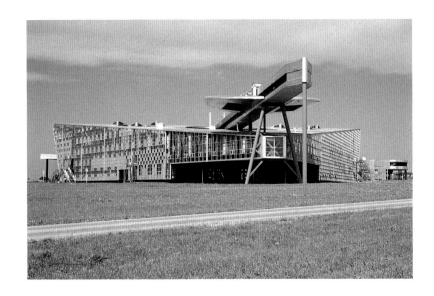

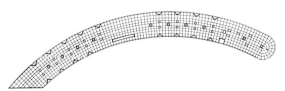

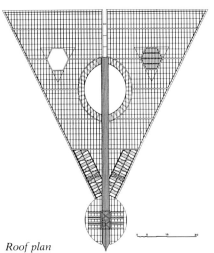

Roof plan

Architecture Studio has been consistently active in competitions, exhibitions, publications, seminars, and conferences. The best known of their many competition entries is their winning design for the Arab World Institute, conceived with Jean Nouvel. They also received second prize for their proposal, with Nouvel, for a termination to the axis at La Défense.

The members of Architecture Studio see their design work as contextually defined. They understand contextuality as a process of creating linkages between the morphological and geographical conditions of the site and the architectonic characteristics of their design products. This process of linkages is extremely complex today as architecture has practically ceased to use the organic building materials which once allowed co-existence between architecture and its sites. Architecture today arises from industrially-produced materials and industrial assembly techniques, resulting in architecture which is itself another industrial and artificial product. Yet, the members of Architecture Studio see technology as the principle symbol of our civilization and, therefore, the critical element of modern design. In the beginning

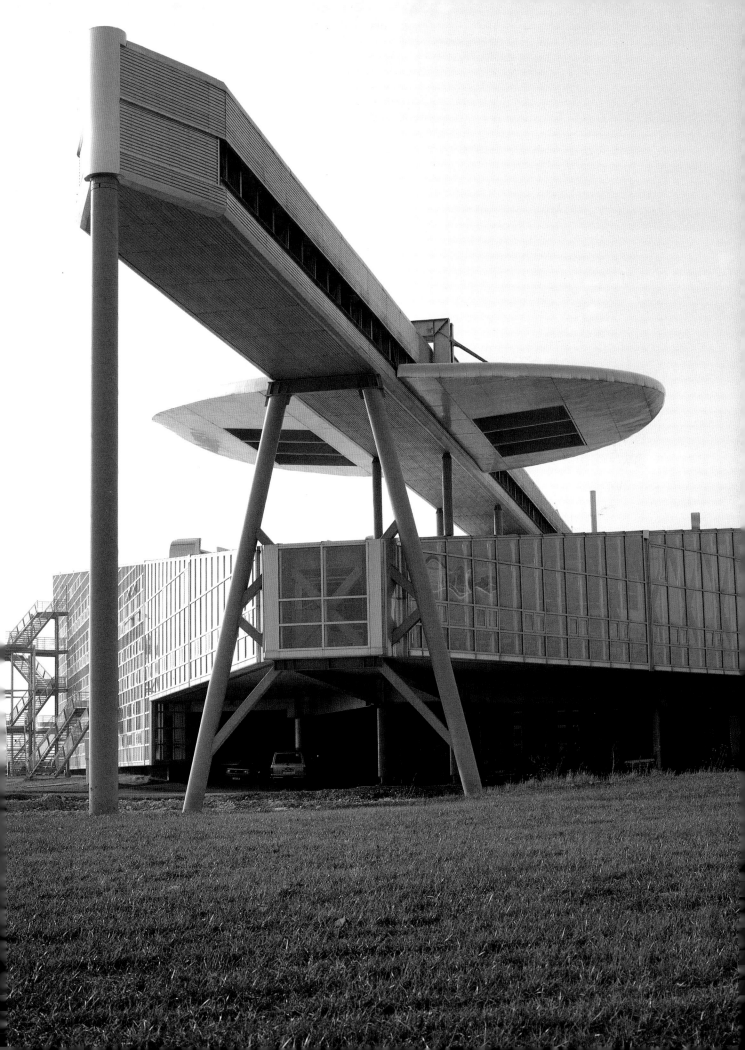

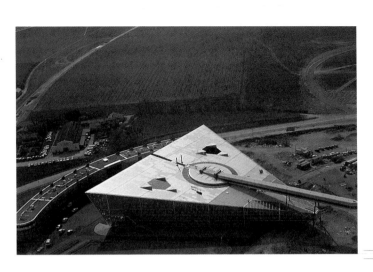

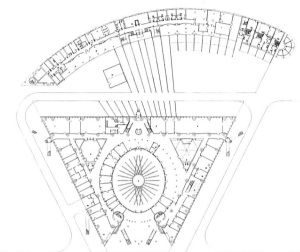

First floor plan

Second floor plan

Interior cut-away axonometric

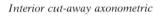

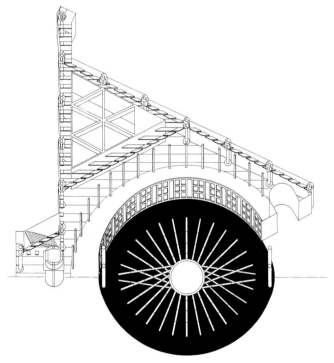

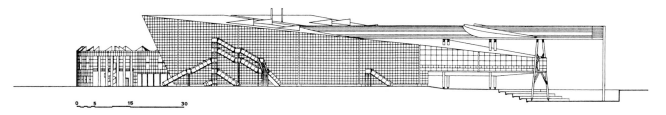

Elevation

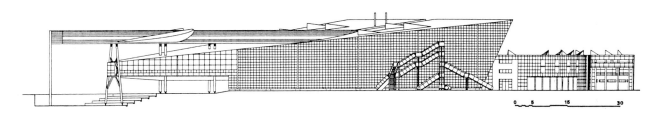

Elevation

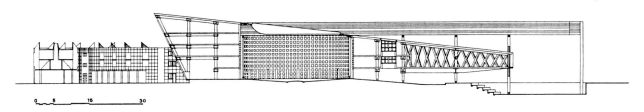

Section

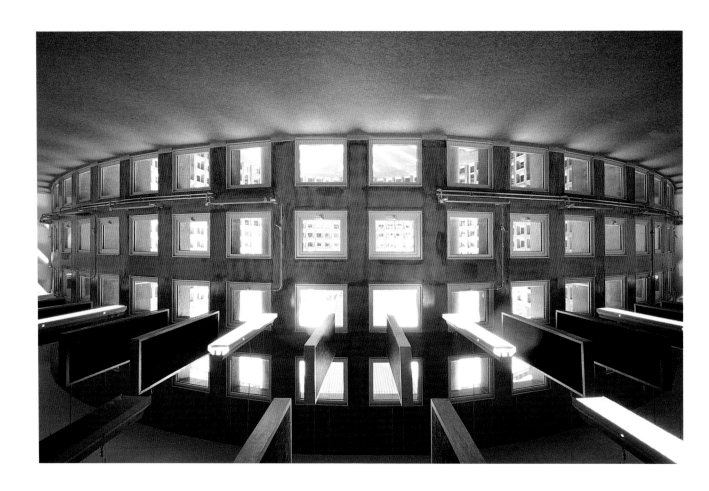

of this century, applying modern technology to architecture was to embrace the values of the avant-garde. Today, this is no longer the case because high technology represents our everyday condition, and using it to generate building concepts is a common-sense approach.

Yet, this technological dimension to building design results in serious difficulties as far as site integration is concerned. Modern architects must mediate their industrial products and their historic or organic contexts. Architecture Studio exploits those contradictions. They explain their work as an architecture of duality, designed to produce structures of a strong and stimulating presence.

The traditional modernist concerns with the truthful expression of structural systems and consistency between architectural forms and their functions are not valid for Architecture Studio. Architecture in its complexity has progressed beyond the early modernist desire to preach moral truth. Movement and visual exploration in architecture are more important than didactic moral criteria. By decomposing static architectural spaces into a series of planes or layers and then recomposing them in a manner which assures transparency and depth, they attempt to capture kinetic events and structure them architecturally. An almost cinematic form of visual communication prevails in

their work. Technology is applied as a means to make certain that architecture corresponds to the overall patterns of thought and behavior in society today.

Often, Architecture Studio's own clients have seen the need to design buildings with sophisticated technological symbols and language. This was the case in the Lycée du Futur near Poitiers. The regional counsel president wished to build a "building that was avant-garde today and would be still in thirty years." These expectations influenced the design of the building whose futuristic, airplane-like imagery combines dynamic and abstract forms and shapes with ultra-modern materials.

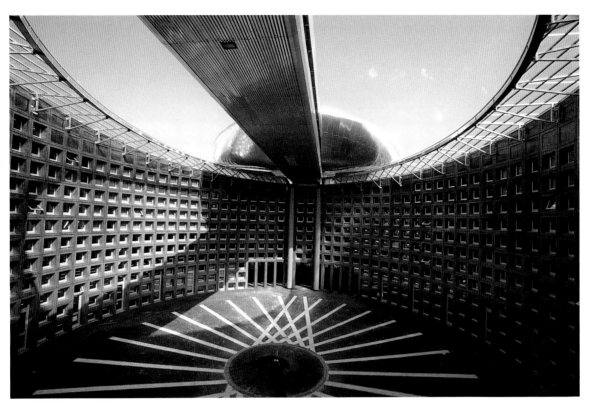

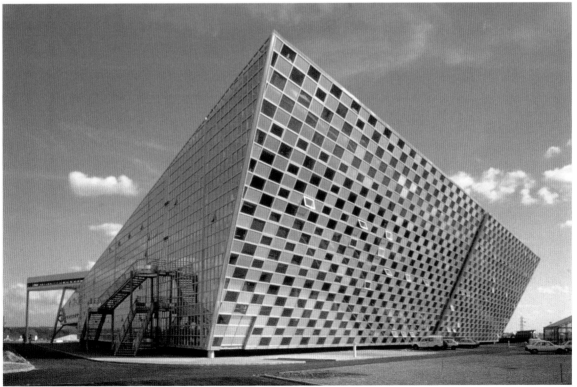

Château des Rentiers • Paris • 1985–86

Difficult conditions arose in the residential structure known as Château des Rentiers in Paris, where the plot was so narrow and small that it was not possible to use an ordinary crane for the building assemblage. Architecture Studio developed an imaginative crane which later became a permanent part of the structural frame of the building.

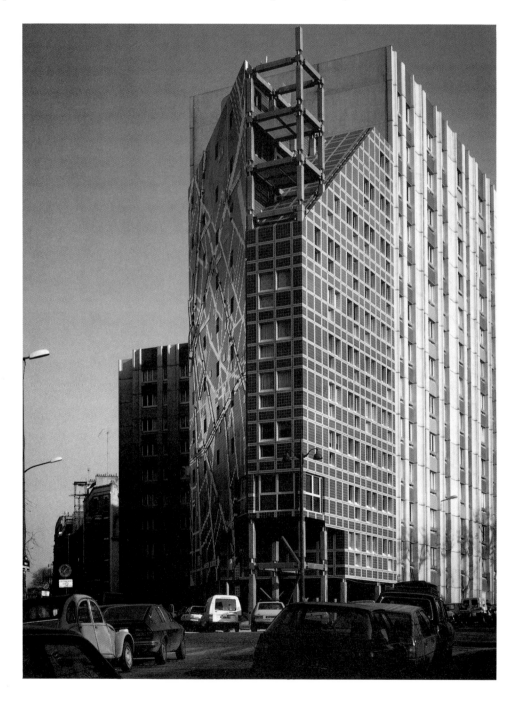

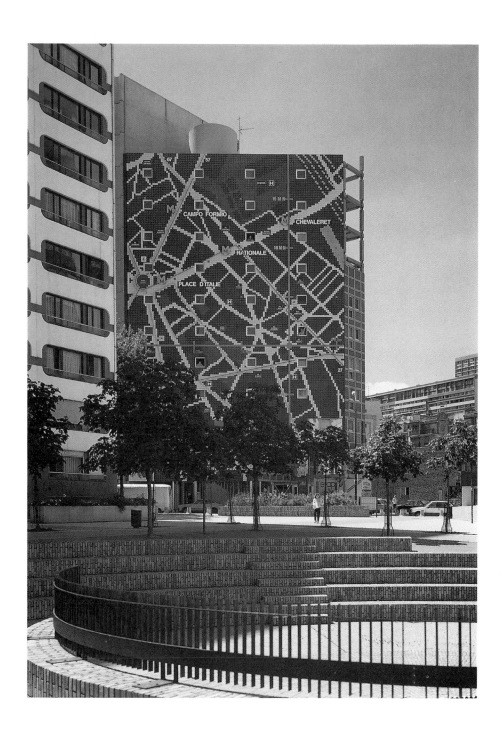

Church of the Resurrection • Paris • 1986–89

The Church of the Resurrection will be built in the fifteenth district of Paris. This project demonstrates splendidly that modern technology and materials can be used creatively for spiritual themes and concerns. Here the exposed space frame, aluminum cladding, glass panels, and the use of laser canons inside of the structure to create grids of light for a spiritual effect come together to build a powerful architectonic totality, rigorously modern, and yet moving and poetic.

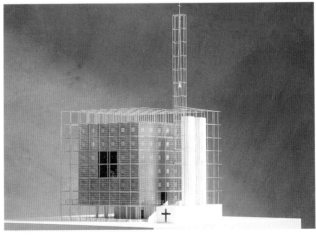

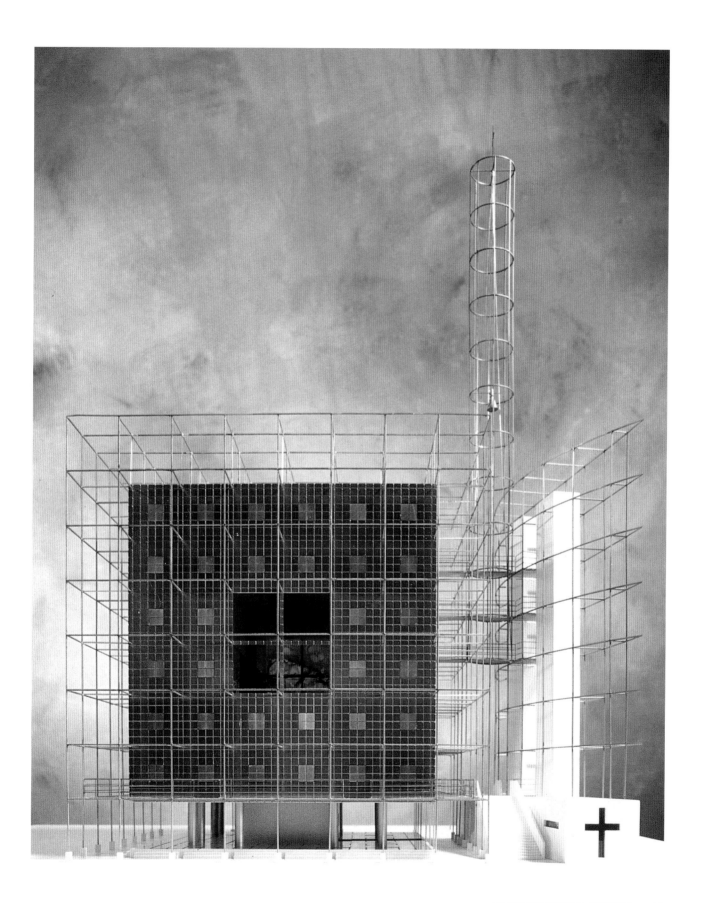

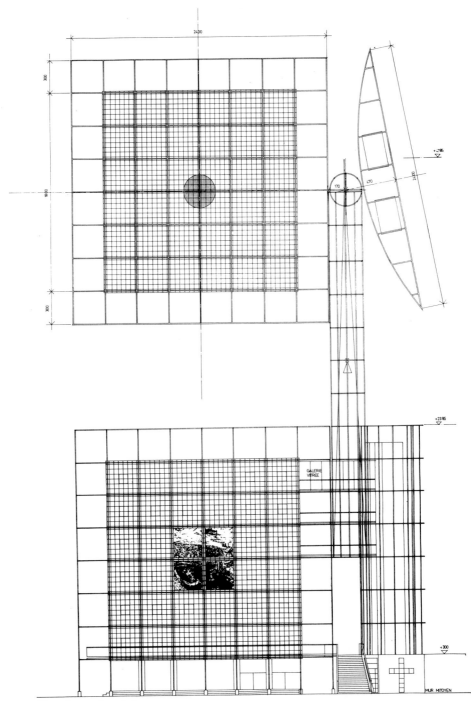

Elevation and roof plan

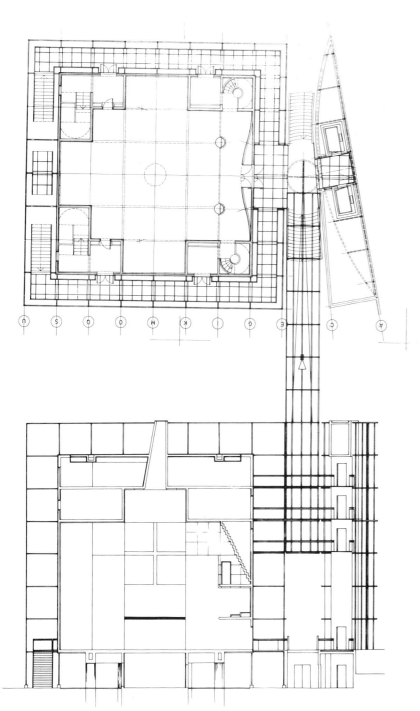

Section and first floor plan

National Institute of Judo · Paris · 1988–89

One recent project provides the best understanding of what Architecture Studio means by duality, contradiction, ruptures, and juxtapositions in their designs. The National Institute of Judo is located on a difficult triangular site. Architecture Studio's competition-winning solution proposed to divide the site into two essential volumes: a long arm to contain offices, and a circular domed building to contain sports facilities. These two components, however, have not been designed as pure volumes, but as volumes which penetrate each other and collide with each other at many points. The dome itself is also fragmented around the side of its perimeter which intersects the edge of the site. This volumetric, hybrid impurity is intended to destroy the sense of platonic and aesthetic integrity that isolated masses generate, and to achieve playful and dynamic effects which Architectural Studio believes are essential to a modern design sensibility.

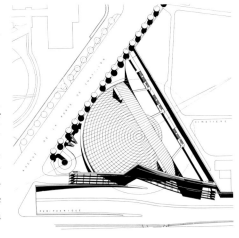

Site plan

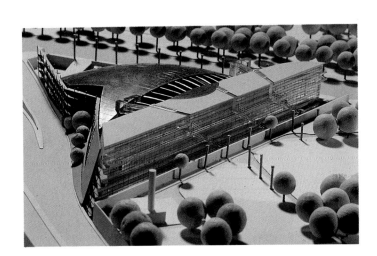

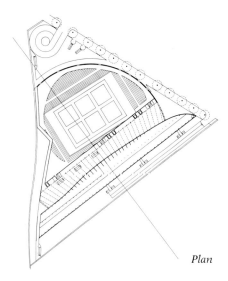

Plan

Section

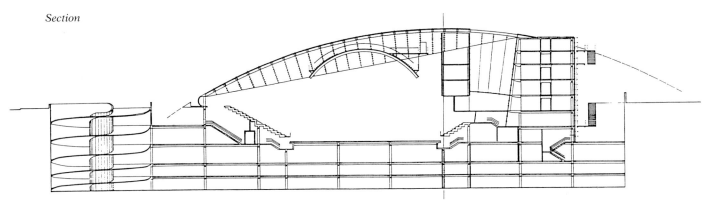

University Center • Dunquerque • 1987–89

The project for the University Center at Dunquerque employs conceptual devices similar to those used in the National Institute of Judo. It was conceived as a rehabilitation of harbor docklands, on a site which included a former tobacco warehouse. Architecture Studio proposed hollowing out the building's core, retaining only its structure, and applying a vast, wave-like canopy roof projected in smooth sheets of aluminum. Under this roof, which partially engulfs the warehouse, a variety of the university functions would be located. The roof imposes a forceful expression of unity upon a plurality of forms and functions. The work embodies an essential tenet of Architecture Studio's philosophy—that in a world of endless pluralism one still has an essential duty to perform as an architect—to stabilize and harmonize, because without harmony their can be no civilized architecture.

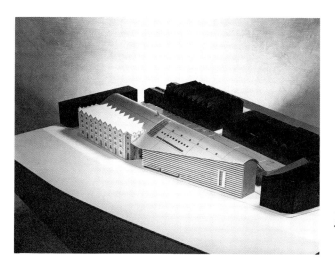

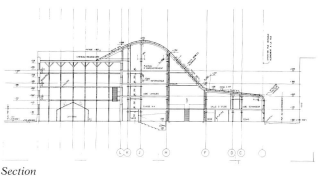

Section

Lycée des Arènes • Toulouse • 1990

The principles of dualism and contradiction have been explicitly represented in Architecture Studio's latest project, the Lycée des Arènes in Toulouse. Here the architects preserved half of an existing arena and reconstructed the other half as a new educational facility. The resulting composition forms an image of playful duality tied to the tension that exists between the old structure and the new addition, yet wonderfully harmonized within the overall oval shape of the stadium.

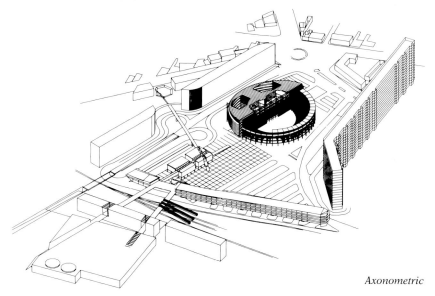

Axonometric

GILLES BOUCHEZ

Hall of Popular Music or Rock Opera • Paris • 1983

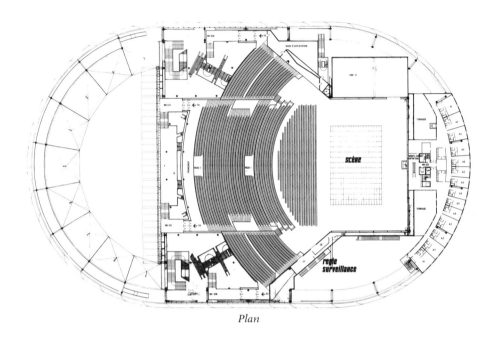

Plan

Gilles Bouchez's approach to design reflects his varied and often contradictory academic and professional experiences. He studied at L'École des Beaux Arts early in his career with Eugène Beaudoin in the still-surviving academic style, and later worked in the atelier of Georges Candilis, which exposed him to drastically different ways of thinking about architecture. After his graduation, he worked in England for Ernö Goldfinger, who was once a student of Auguste Perret, and who worked with modern technology by "personalizing" it. During his stay in England, Bouchez met the English engineer Peter Rice who is responsible for many high-tech designs in France. He returned to France very influenced by the high-tech movement which continues to manifest itself in his projects. Bouchez's competition entry for the Hall of Popular Music or Rock Opera at Bagnolet (a cancelled presidential project) utilizes a hovercraft-like steel super-structure which was to float above a chaotic site filled with roads and motorway intersections. The project was quickly labeled a product of English high-tech because its features very much resemble the designs of Ron Herron and Peter Cook from the 1960s.

On the other hand, Bouchez is capable of generating an incredible variety of conceptual responses which rarely resemble each other. He derives his architecture not so much from projected programs (which he prefers not to study until he forms a general design image) as from the site characteristics and conditions. "Only on site do we really come to grips with a project," he says. Specific locations provide him with specific responses. Yet, he believes that contextual design does not mean "stealing" the site's features but creatively transforming the site characteristics to the reality of the building

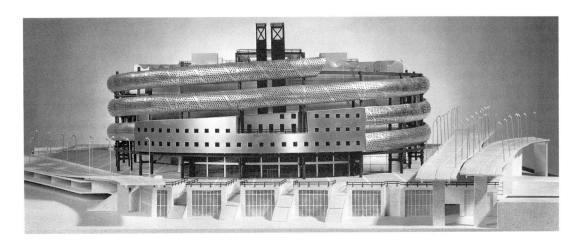

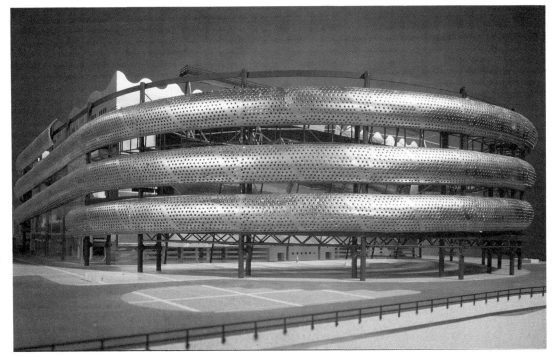

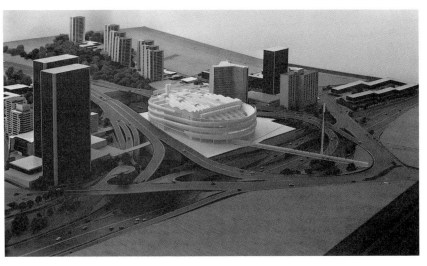

program. Since his architectural language is largely based upon technological imagery, the problem of the reconciliation between it and the site condition (particularly if it is historical in nature) remains the principle challenge.

Center for Professional Training • Marne-la-Vallée • 1985

Bouchez's project for the Center for Professional Training, located in the wooded industrial park of Cité Descartes at Marne-la-Vallée, represented multiple morphological difficulties. Bouchez designed a compact volume which he divided into two masses—one tall volume which faces the School of Engineering by Dominique Perrault, and another in the form of gigantic steps corresponding to the more dispersed edge conditions. The volumes are brought together with a diagonally positioned spine that opens in the direction of the Descartes Complex. The result is characteristic of Bouchez's multidirectional responses to a site's physical characteristics.

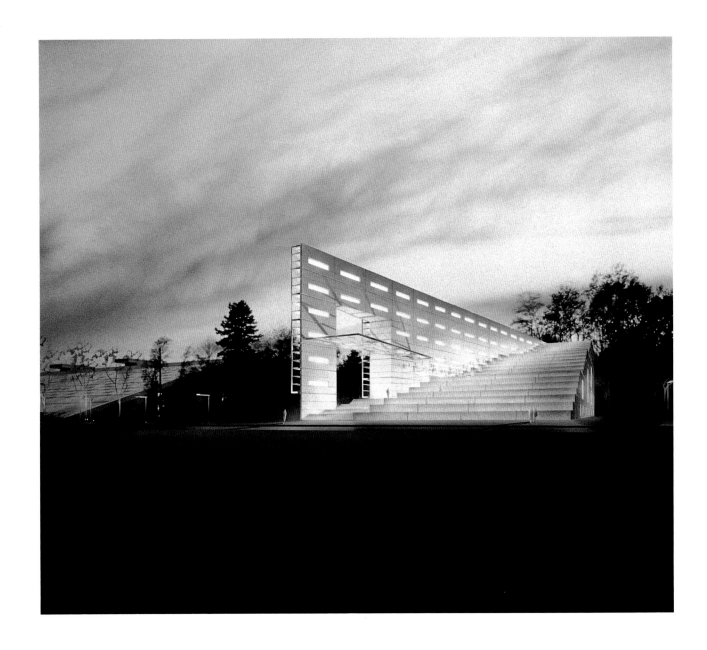

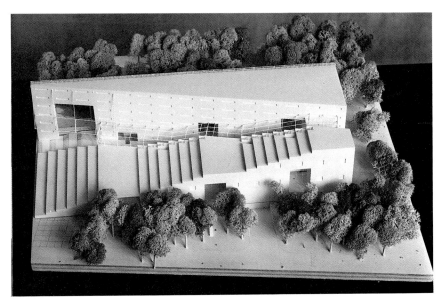

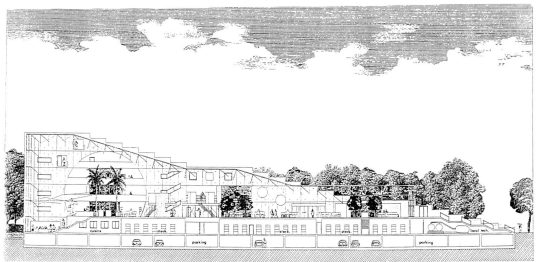

Section

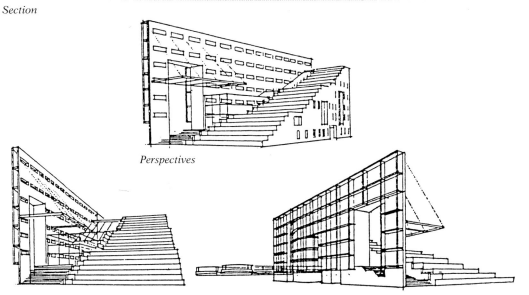

Perspectives

French Embassy • Nairobi • 1988

Bouchez has applied his industrial vocabulary to a variety of building types. A good example is his competition project for the French Embassy in Kenya. The proposed structure features a tall, compact form with a tall light court in its center. The building is wrapped in an aluminum skin which gives it a dynamic, technologically-conceived image serving, however, a distinct cultural and political purpose.

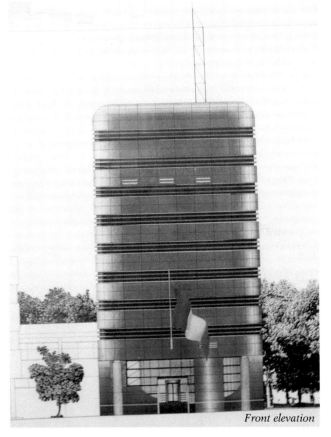

Front elevation

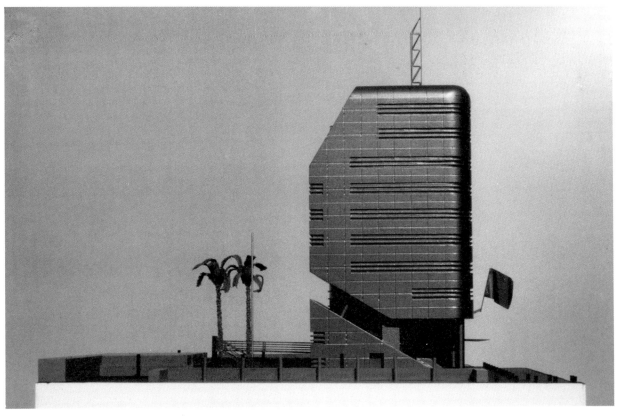

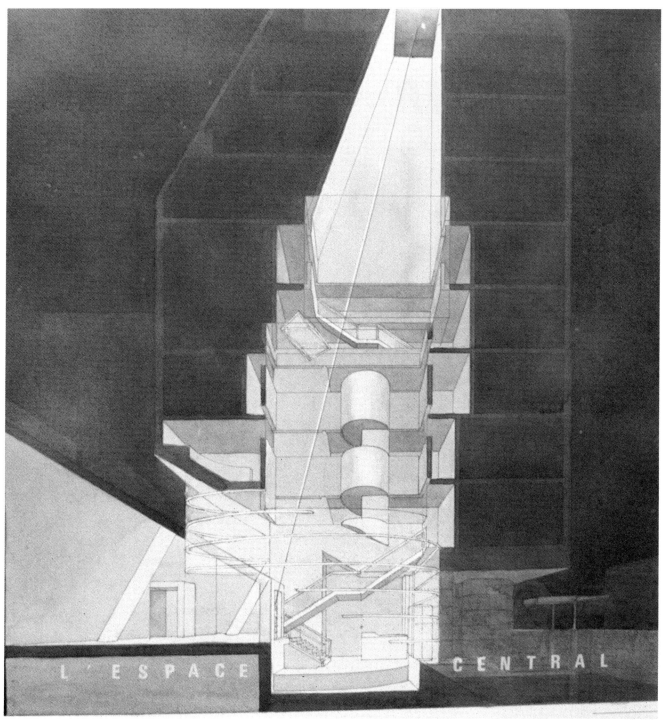

Section

Gymnasium • Guyancourt • 1987

Bouchez's Gymnasium in Guyancourt demonstrates his sophisticated ability to evolve simple but distinct forms from industrialized technology. The building reveals a strong simplicity in its basic composition, and at the same time expresses an understated elegance in its volumetric elevations and details. The imaginative treatment of its corners, entrances, lighting, and signage prove that aesthetic minimalism in architecture, if combined with architectural rigour and sophistication, is perfectly capable of producing buildings full of life, feeling, and a strong formal presence.

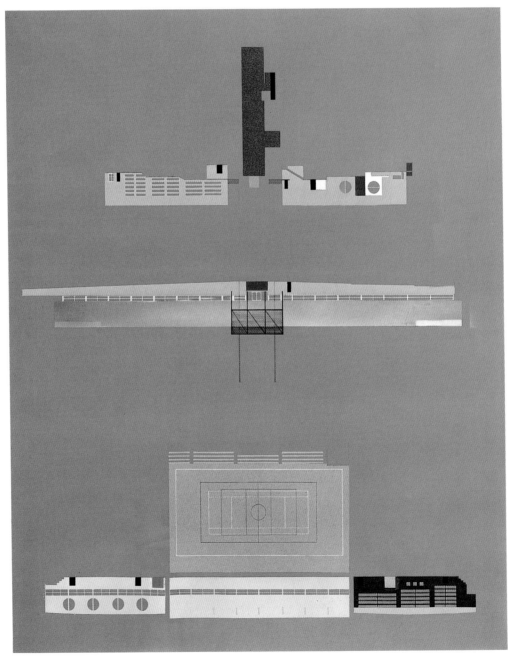

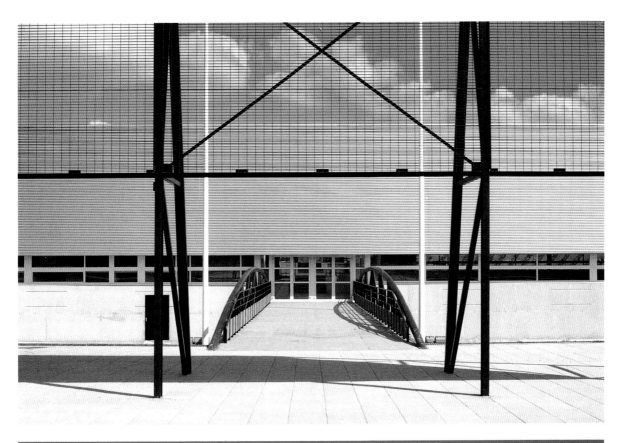

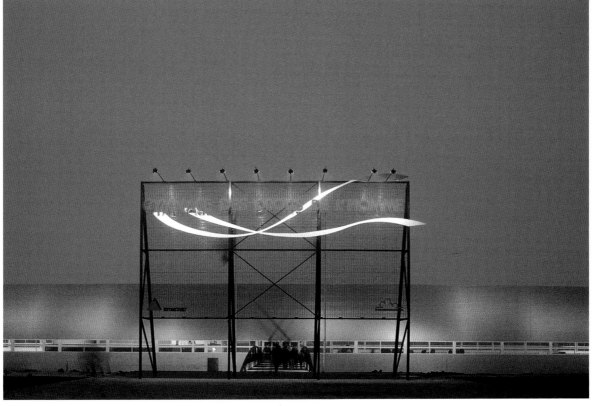

Public Housing • Avenue Phillipe Auguste • Paris • 1983

Bouchez has been involved in designing a range of public and private housing. As with other building types, he is capable of evolving an incredible variety of architectural responses related to specific site conditions. His housing complex at Avenue Philippe Auguste in Paris is a good example. On the front elevations of the complex Bouchez refers to the surrounding buildings, while on the rear garden side he develops a complex system of smaller volumes and articulations.

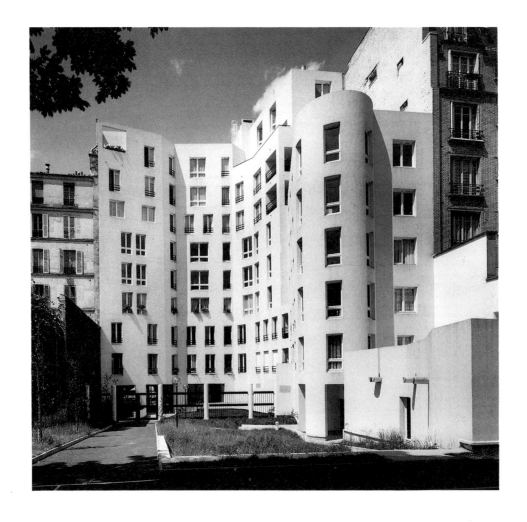

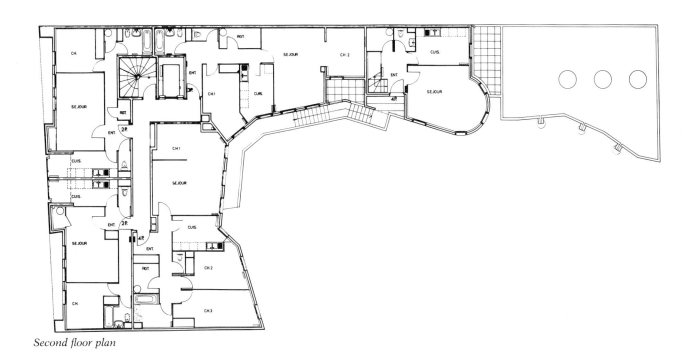

Second floor plan

First floor plan

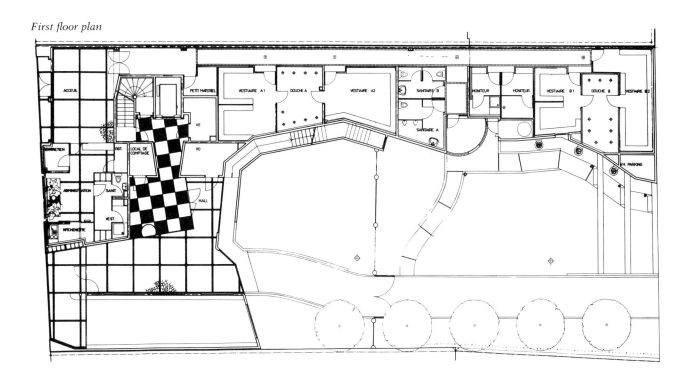

Peclers House • Garches • 1988

Bouchez's diverse architectural interests and abilities come to light in his house for Dominique Peclers in Garches. The house takes up the basic themes of Cubism, and its relationship to Le Corbusier's nearby Villa Stein is perhaps not accidental. Executed in concrete, the house features a dynamic series of spatial transformations on the theme of the cube which result in a pronounced sense of physical transparency and openness.

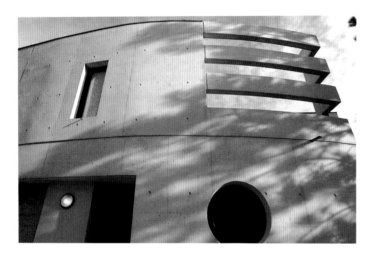

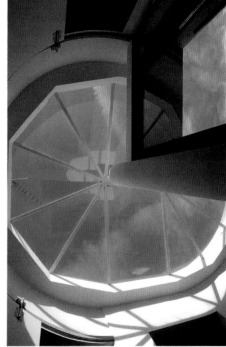

Second floor plan

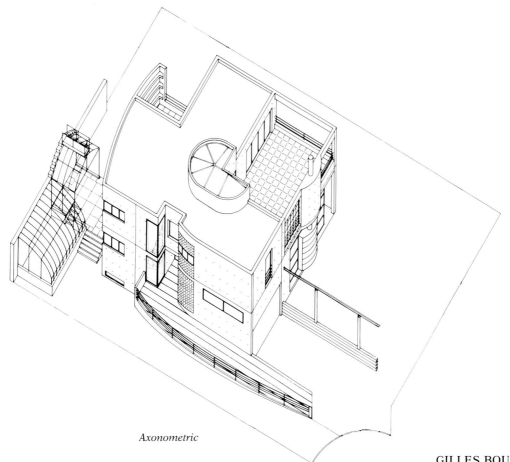

Axonometric

JEAN PIERRE BUFFI

Collines Nord et Sud • Tête Défense • Paris • 1986–90

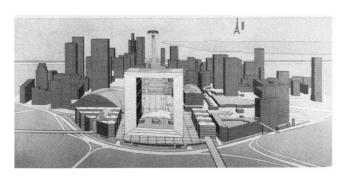

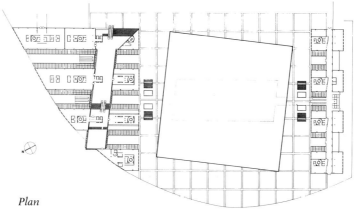

Plan

Jean Pierre Buffi began his practice in France in the Paris office of Jean Prouvé, who exerted a major influence on the direction of his future work. Despite the technological direction of Prouvé's designs, building technology did not become a conceptual passion or methodology for Buffi. He sees technology as only one dimension, albeit important, of all architectural construction. Technology allows an architect to be inventive and forward original design concepts. Therefore, without good technical knowledge one cannot become a competent and creative designer. The materials and technology used by

Buffi in his IBM buildings, for instance, help to express the technological character of the place. Yet, despite important contributions which technology can make, it should never be seen as an end in itself. There is always the danger that a too-liberal use of technology leads to superficial, high-tech designs lacking any deeper intellectual meaning. All of this depends, of course, on how one conceives the relationship between architectural expression and building technology. Buffi's answer lies in conceptual austerity, modesty, and restraint, which have always been for him a great source of architectural

inspiration.

His architecture utilizes simple, elemental forms which can be identified easily and understood on their own. He is preoccupied with architectural minimalism, or, as he puts it, with essential aesthetic emotions. Buffi's main preoccupation has always been with the proper fit of architectural objects within their context. Careful attention to site problems is evident in all his designs.

Buffi's most important architectural project is now being completed. The Collines Nord and Sud form an office complex immediately adjacent to the

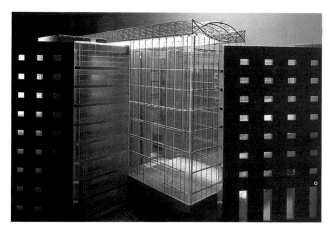
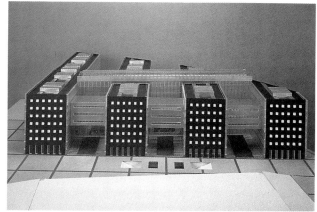

Grand Arch of La Tête Défense. The project is the result of a 1986 competition, and it provides insights into Buffi's overall urbanistic and aesthetic philosophy. A proper site strategy was crucial for him, as he did not wish to produce a building which would compete with the powerful and detached volume of the Grand Arch. His buildings had to be designed as a background for the Grand Arch, a difficult conceptual task for any architect. His solution features a series of perpendiculars to the Grand Arch, separated by narrow spaces of glass to maximize transparency, the penetration of light, and a good view of the Grand Arch. The Colline Nord is pierced diagonally by the so-called Grande Nef, a twenty-five-meter-high and twenty-meter-wide circular glass gallery which provides access to the offices. It is oriented parallel to the Grand Arch, which is slightly skewed in relation to the Champs-Elysées axis. The Colline Sud is bisected by another great circular gallery which contains technological exhibits. The architectural language of this project is one of great restraint and sobriety which speaks through essential volumes and spaces, reducing the visibility of detail to a secondary importance.

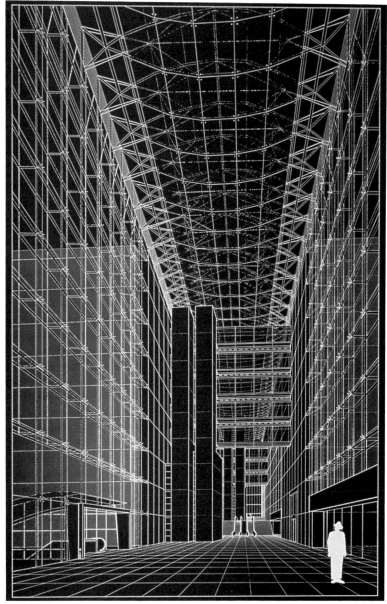

Interior perspective

IBM Headquarters • Lille • 1984–87

Buffi's two IBM projects show his concern with morphological issues. The IBM Headquarters for northern France in Lille is located on the wooded site of a former château. Buffi designed a semi-circular building to preserve as many trees as possible. The crescent-like shape is a strong visual form which organizes the site in a geometrical manner. A glass curtain wall on the concave side of the crescent creates a sense of the penetration of the greenery into the building itself. The convex side of the building holds the structure together physically with the help of arcaded, concrete forms that produce a dynamic visual duality between both surfaces of the building. Its thin shape allows light to travel through the building, creating effects of spatial transparency dear to the French modernists.

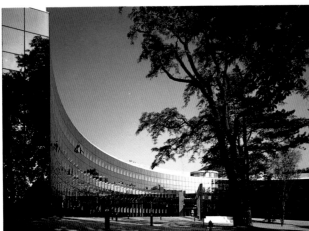
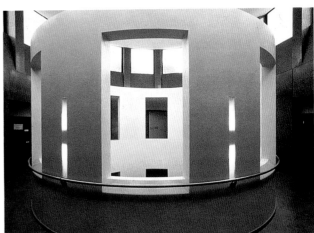

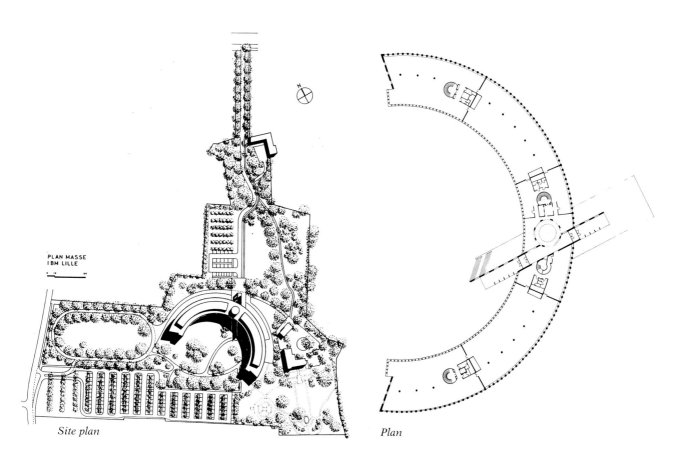

PLAN MASSE
IBM LILLE

Site plan

Plan

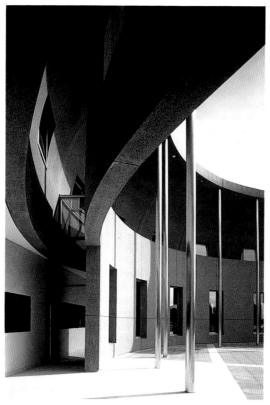

IBM Headquarters • Bordeaux • 1985–87

The IBM Headquarters in Bordeaux demonstrates how a banal and flat site can be structured in an imaginative way. Since a compact and simple building would not work on this site, Buffi opted for the combination of a tall L-shaped structure and a low pavilion with a semi-circular courtyard. This treatment gave the building volumetric characteristics which, on a site without any particular directional sense, resulted in a more picturesque quality.

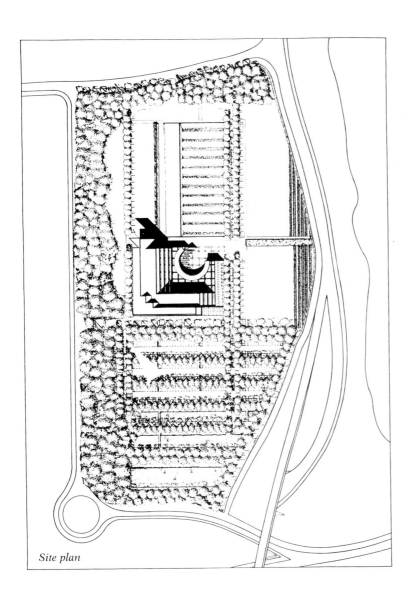

Site plan

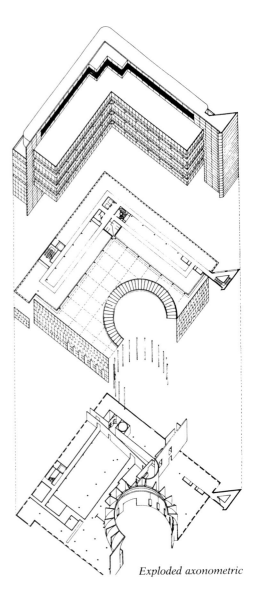

Exploded axonometric

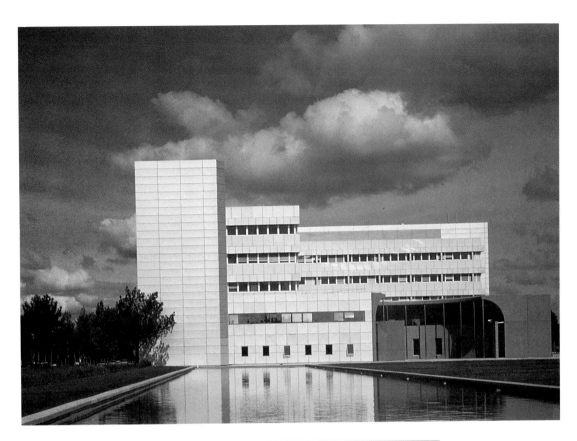

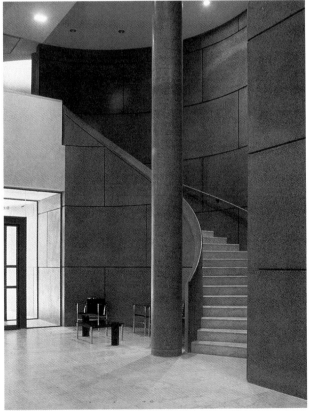

First floor plan

Buffi's Regional Information Center in Nevers can be described in terms similar to both of his IBM buildings. Located on a morphologically difficult and characterless site, the project demanded sophisticated compositional skills to create a structure of functional quality and strong architectural presence. Buffi designed a highly legible cruciform building which allowed him to distribute various components of the program in a clear and simple way. The materials used for this building—polished concrete, stone, aluminum, and glass—helped the architect to identify different components of the cruciform massing and emphasize its hierarchical arrangement.

French-Portuguese Cultural Institute · Lisbon · 1979–84

As more and more buildings are built on non-urban sites, a potential architectural ambiguity becomes a substantial issue. More often, however, French architects design within the context of old city fabrics and debate the issues of new impositions on existing orders. A good example of this conceptual dilemma is Buffi's French-Portuguese Cultural Institute in Lisbon, completed in 1984. The building, containing a complex functional program, was built on a dense urban block and involved difficult issues of building scale, stylistic expression, and materials. Buffi derived his facades from Lisbon's tradition of flat, non-articulated frontal elevations within which the window bays are slightly recessed. The result is another simple, sober, and entirely modern building which sensitively fits the overall context. Nothing is perhaps more difficult in design today than the satisfactory reconciliation between past forms and future needs. Buffi's work has met this challenge successfully and uniquely.

Site plan

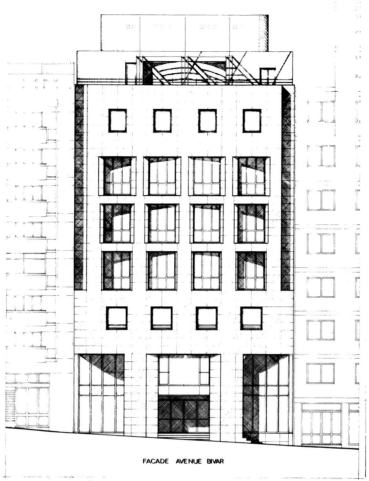

FACADE AVENUE BIVAR

Facade elevation

Perspective section

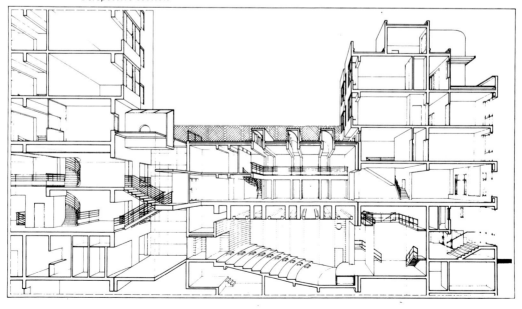

Le Manet Residences • Saint-Quentin • 1985–89

Buffi designed several housing estates in the new towns outside of Paris. His latest project is the housing complex in Saint-Quentin called Le Manet. Like his other residential projects, Le Manet demonstrates a rigorous urban character through the use of playful volumetric forms and a creative mixture of materials, textures, colors, and details.

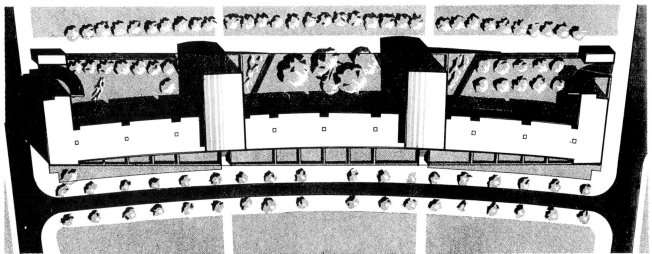

Site plan PLAN DE MASSE

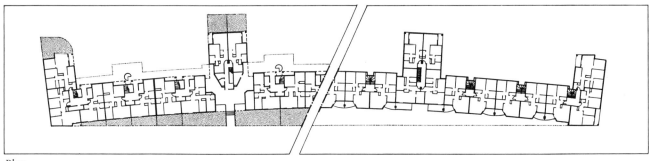

Plan

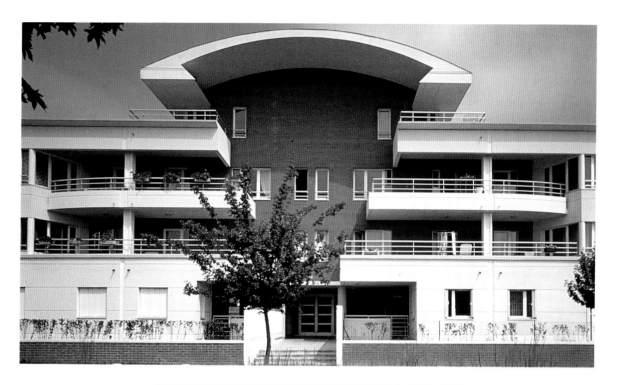

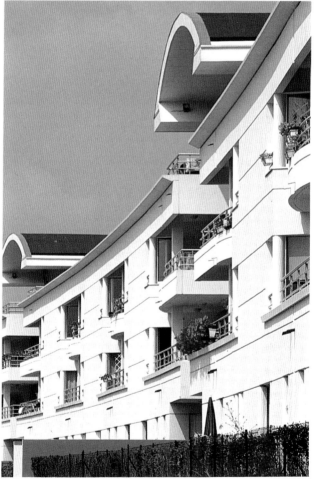

FRANÇOIS DESLAUGIERS

Regional Information Center • Nemours • 1975

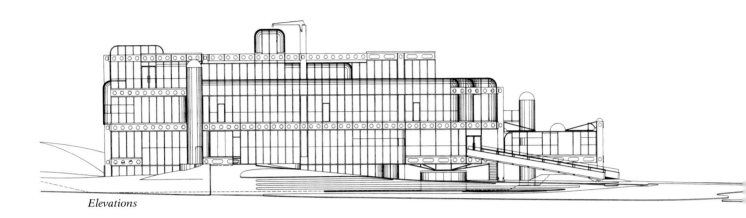

Elevations

"I have come to think of architecture as an exercise in precision engineering," François Deslaugiers once said. The statement, characterizing his approach to design, is embodied in his Regional Information Center in Nemours of 1975. At this time high-tech industrial architecture was far from the building standards of the day. Deslaugiers' building challenged these preconceptions by demonstrating that sophisticated, high-tech architectural designs could be produced in a country which had lagged behind other industrialized nations in building technology. The building was conceived as a three-dimensional kit of parts—including panels, partitions, a modular skeleton, and even the building's foundations—manufactured in the spirit of automotive assembly. It was planned on a thirty-five-inch grid, small enough to facilitate a great number of functional variants. Its system, as Deslaugiers explained, was not that of an umbrella or an outer skin, but a three-dimensional structure whose final volumetric form resulted from functional and internal arrangements. This building, after the Pompidou Center, directly contributed to the dramatic evolution of French architecture in the 1980s.

François Deslaugiers believes that the formal aspects of architecture are no longer an overall concern. Rather, the functional arrangement of particular spaces is of principle importance today. Deslaugiers does not believe in approaching architectural design from preconceived aesthetic points of view. The building's performance in a functional and structural sense represents the core of the design. His buildings are designed on the basis of material lightness, efficiency, component standardization, and sophisticated methods of assembly which, in the end,

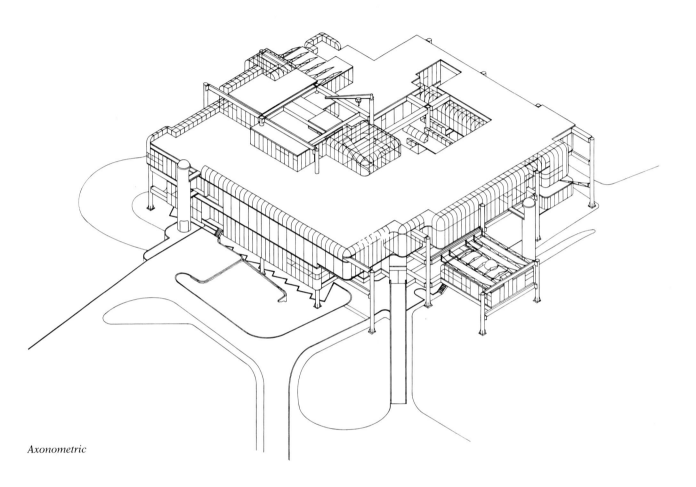

Axonometric

produce an architecture of an industrial character. In fact, the invention of specific functional and structural systems is the chief subject of Deslaugiers' work. He believes that metal, because of its lightness and flexibility, is the most appropriate construction material and he sees advanced architectural design in terms of automotive and aircraft assembly.

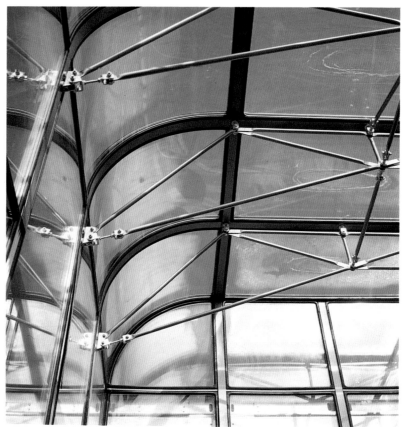

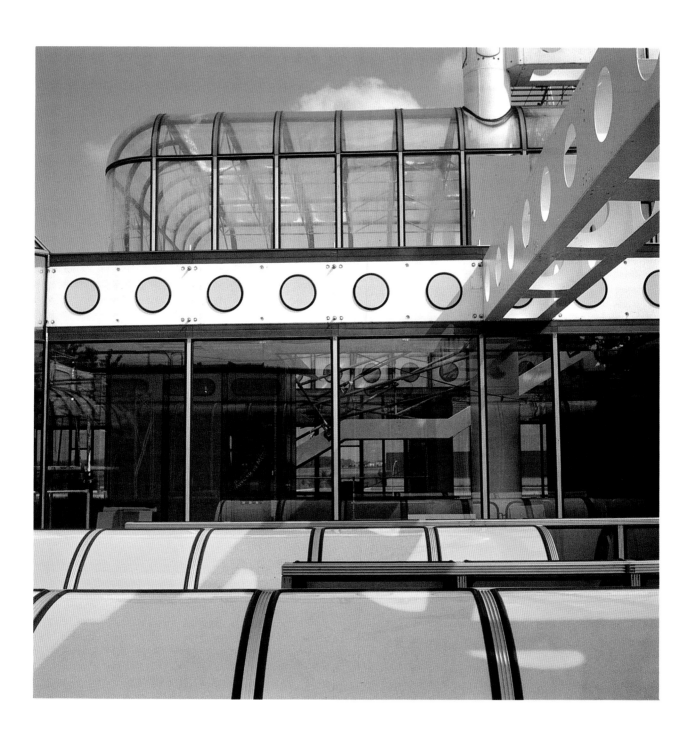

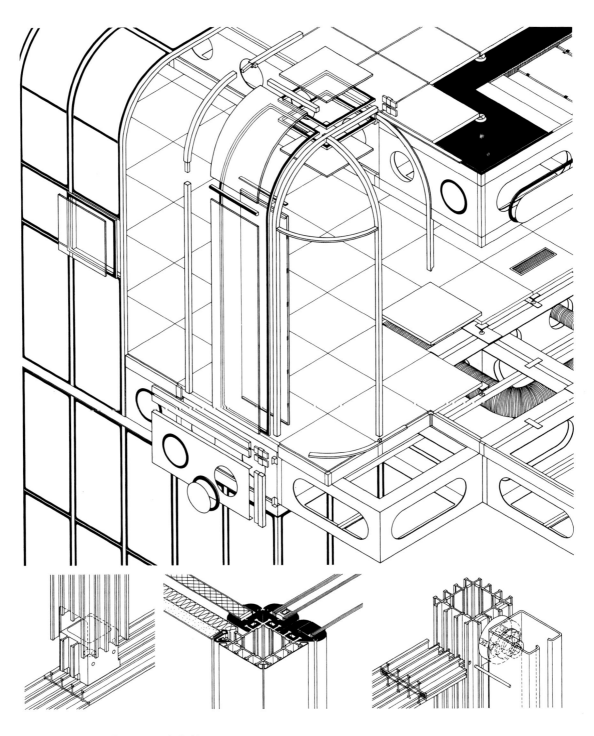

Axonometric of structural system and cladding

96 FRANÇOIS DESLAUGIERS

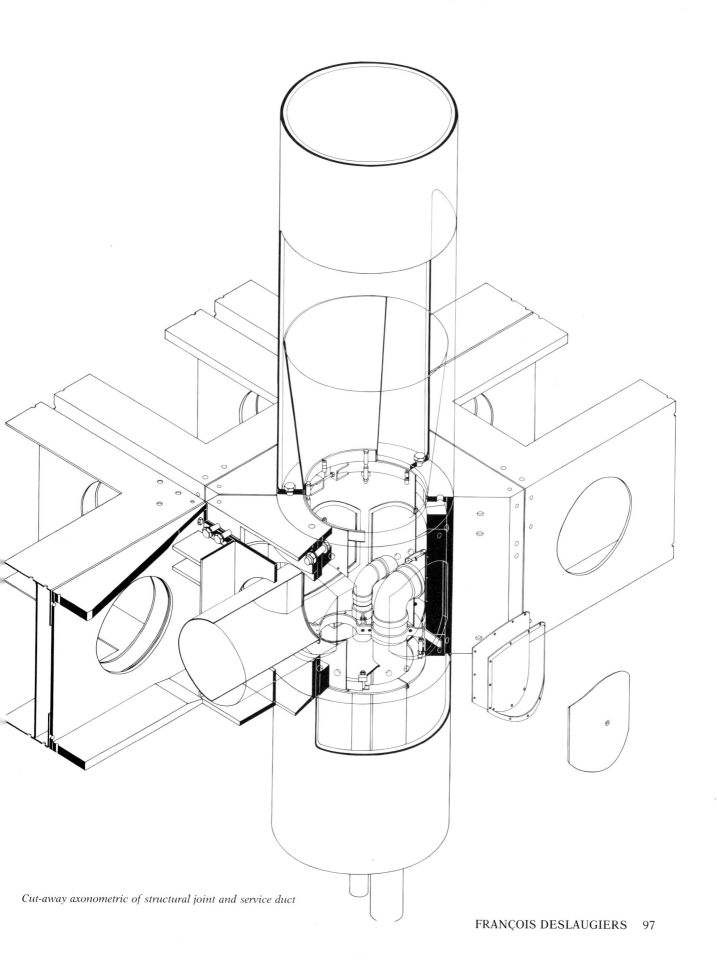

Cut-away axonometric of structural joint and service duct

Façades and Elevators • Grand Arch • La Tête Défense • Paris • 1987

Deslaugiers' contribution to the construction of the Grand Arch in La Défense brought him his recent fame and recognition. After the unfortunate death of Johan Otto von Spreckelsen the construction of the Grand Arch was awarded to the distinguished French architect Paul Andreau. He, in turn, asked Deslaugiers to collaborate on the project. Deslaugiers was put in charge of the construction of the façades and the now-famous elevators of the Grand Arch. In both cases, Deslaugiers invented a system of aluminum caissons, each of which cost the price of a small car. Over 2,400 window caissons were prefabricated and attached by bolts to the concrete megastructure of the arch. The building's five elevators were conceived in the shape of glass cylinders closed at both ends by glass half-domes. The glass for the elevators is comparable in strength and technical specifications to the windshields of Airbus passenger jets. The vertical shafts of the elevators are made of twelve tubes constructed of corrosion-resistant steel, within which high-tech elevators carry visitors on a spectacular ride to the top of the Grand Arch.

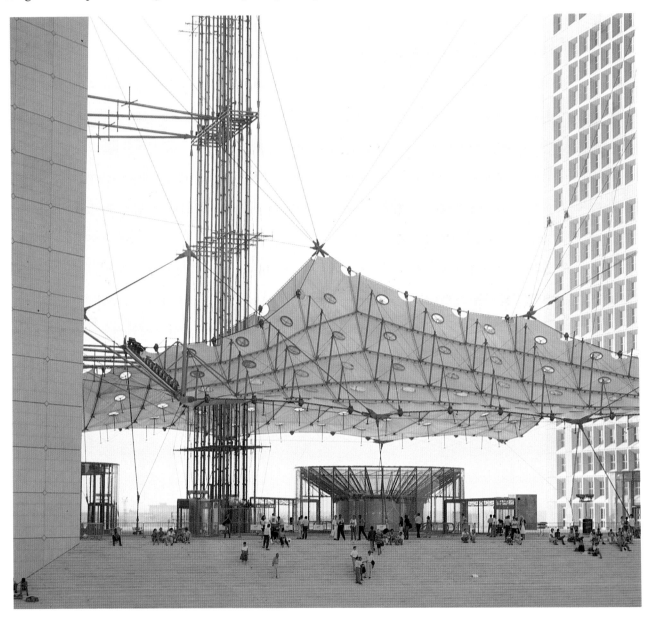

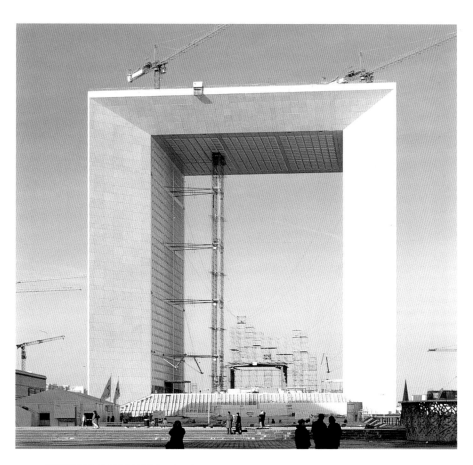

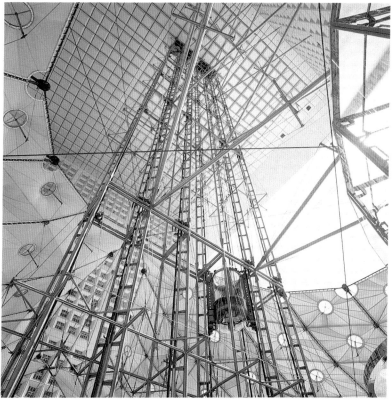

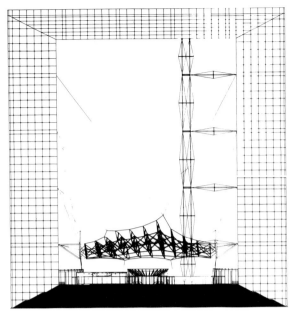

Elevation, interior of the arch

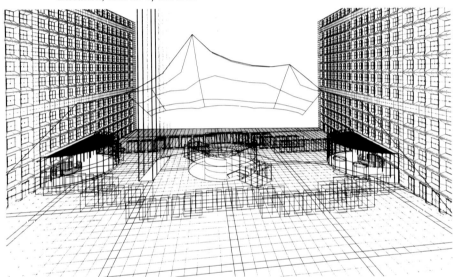

Perspective, interior of the arch

Perspective, circulation hub

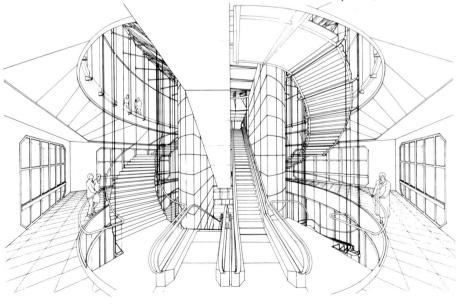

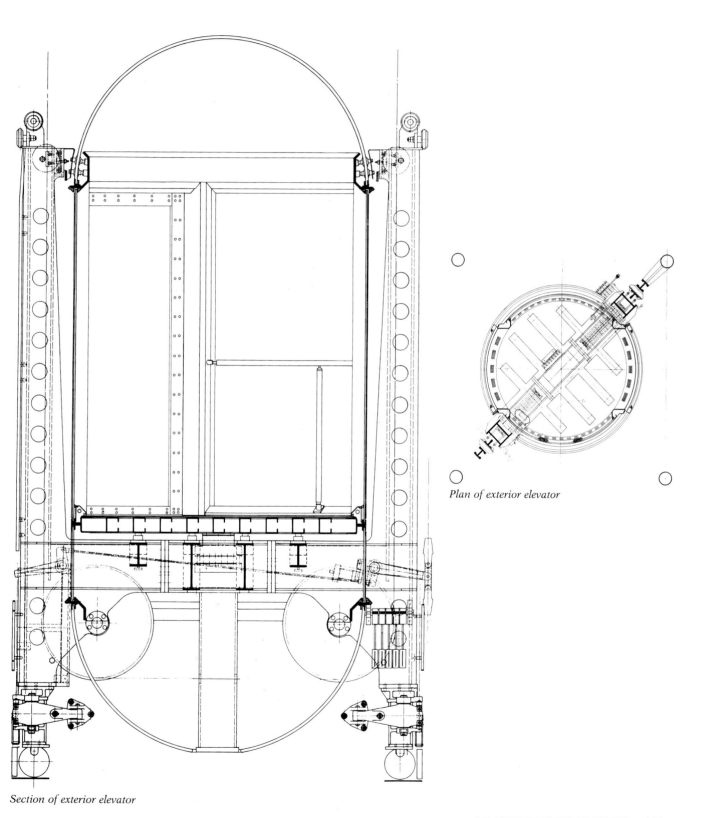

Plan of exterior elevator

Section of exterior elevator

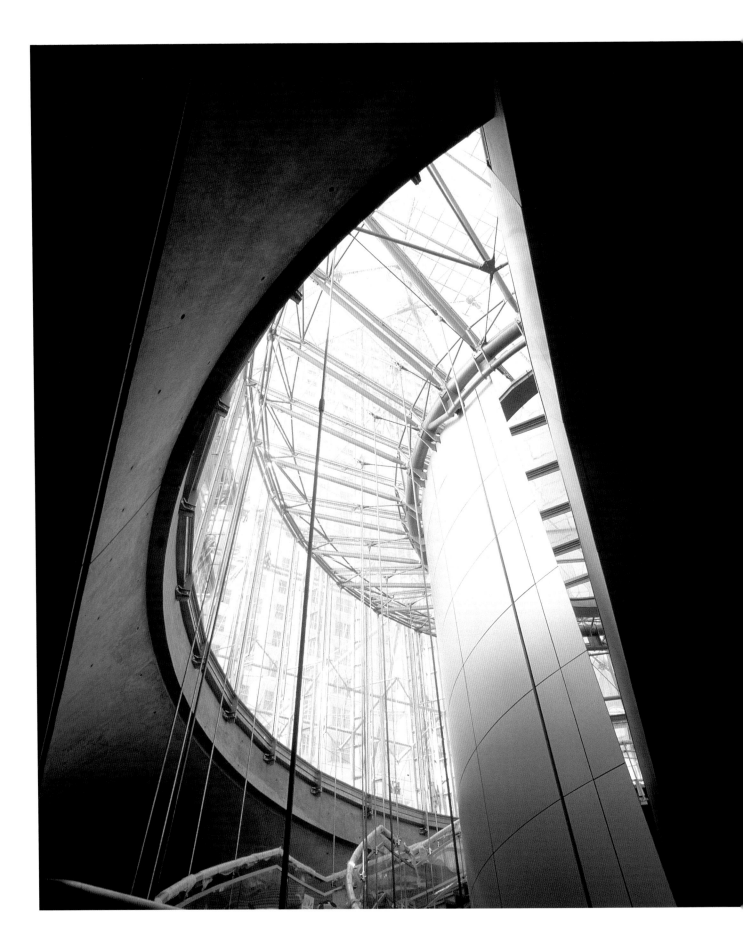

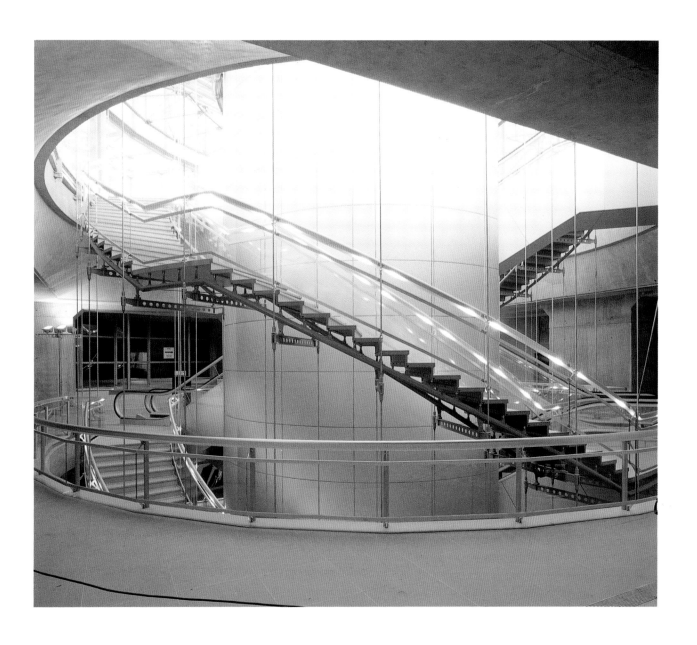

Congress Center • Toulouse • 1989

Section study

Deslaugiers could be defined as a constructivist, not in the ideological sense, but in a pragmatic technical sense that emphasizes the permanent and leading role of advanced technology in our lives. A number of Deslaugiers' projects have profited from this conceptual stance. These include his designs for the internal furnishings of the Center for Science and Industry at La Villette, his Renault Regional Center in Rouen-Baratin, his extension of the courthouse in Nanterre, and his proposal for the Congress Center in Toulouse.

CHRISTIAN HAUVETTE

Regional Chamber of Accounting • Rennes • 1985

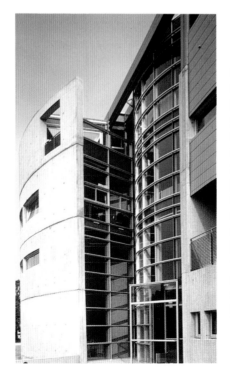

Christian Hauvette is the principal structuralist architect in France today. Preoccupied with the study of mechanical aesthetics, he believes that the structuralist movement in architecture was shelved too quickly. In the final account, architecture for Hauvette consists of the making of images which generate visual messages in two different ways—in the spirit of structuralism, for which there is a long historical tradition represented by the theories of Laugier, Durand, and Gaudet, and in the spirit of descriptive, literary motifs which serve to formulate "discovery journeys" for the users through-

out the building. Any complete conceptual image in architecture must take into account both aspects. It must express the functional parameters and, at the same time, imaginatively organize the spatial, light, and morphological conditions. The search for this conceptual clarity is associated with the search for tranquility and calm, which Hauvette believes architecture should always convey. The chief enemies of a tranquil and lucid architecture are romantic, stylistic, and ideological extremes.

Hauvette decomposes his architectural schemes into a series of layers—functional and

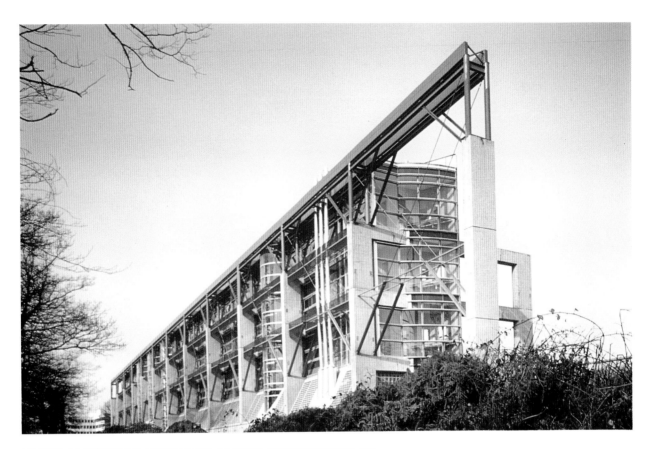

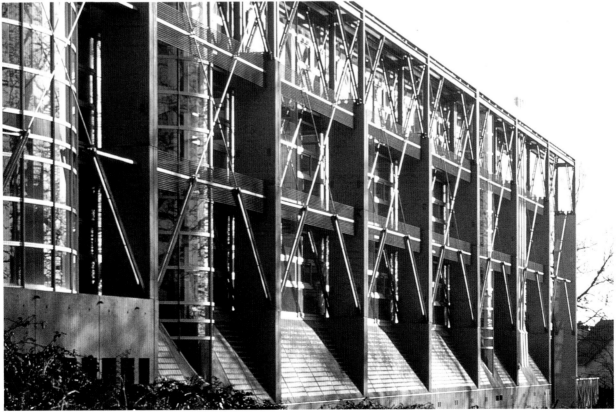

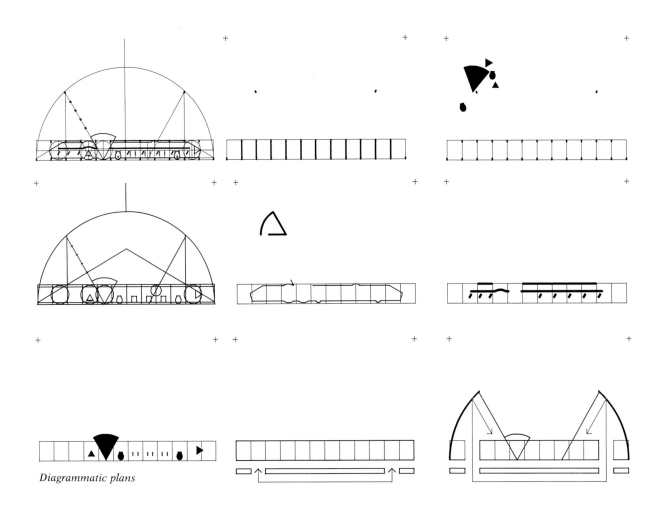

Diagrammatic plans

spatial zones, structural components, natural light, textures, and borders—and recomposes them to achieve tightly controlled, rationally-structured scenarios which simultaneously respond to artistic and functional criteria. Modern technology and materials play a chief role in his work. Hauvette sees a wealth of scientific advances being made today in fields, like aircraft design, of

which the architecture world is still ignorant. Hauvette believes that the time has come to find a better way of reconciling the artistic and the scientific, and that structuralism is the best method towards this end. The result of his efforts is a series of magnificent designs which address poetic concerns through applied building technology.

The sites of Hauvette's re-

cent building projects are generally characterless and without any great morphological or historical distinction. Yet, he is capable of enriching these poor sites with architecture of a grand character. His magnificent Regional Chamber of Accounting in Rennes is a classic example in this respect. Hauvette designed it as an isolated object on a site without any great physical dis-

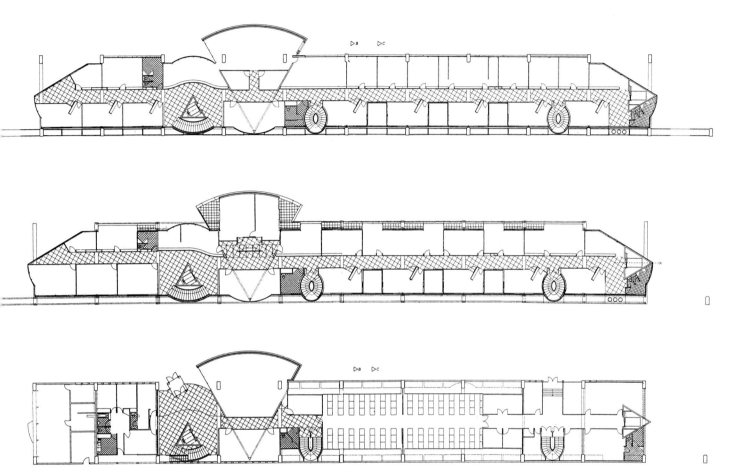

Top to bottom: Typical floor plan, first floor plan, basement floor plan

tinction. It appears as a long, narrow form in the manner of a passing ship. However, the richly articulated volume of this building, made of lightweight metal and glass, lends it a commanding presence. The interior of the building is extremely well-lit due to a series of transparent partitions and walls, necessary for the health of internal gardens which have been placed there.

Louis Lumière National School of Cinema • Marne-la-Vallée • 1987

At Marne-la-Vallée Hauvette built the Louis Lumière National School of Cinema in an unremarkable context. The building consists of a double bar, positioned parallel to an adjacent boulevard. Each bar has been formed into a series of functional and structural layers. Each layer is representative of a specific functional arrangement—corridor, deck, internal street, or bridge. The linear arrangement of the building strengthens its presence on the boulevard, contributing to the greater integration of the site into the overall urban context.

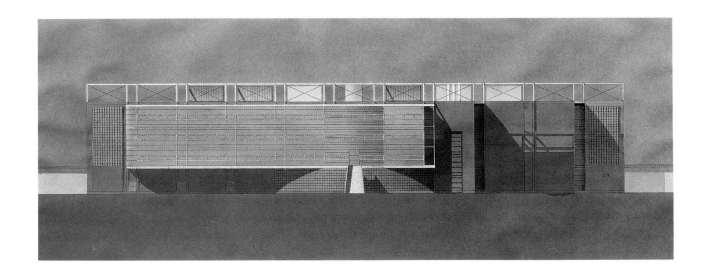

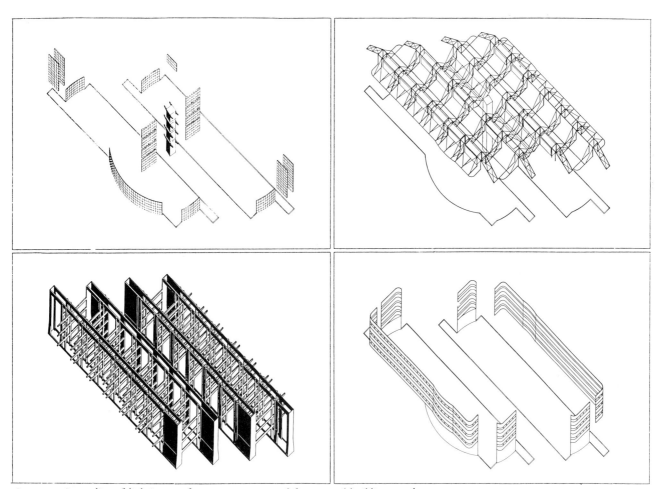

Axonometric studies of lighting, roof structure, structural frame, and building envelope

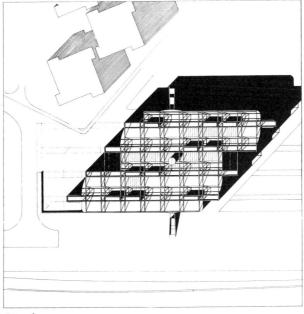

Site plan

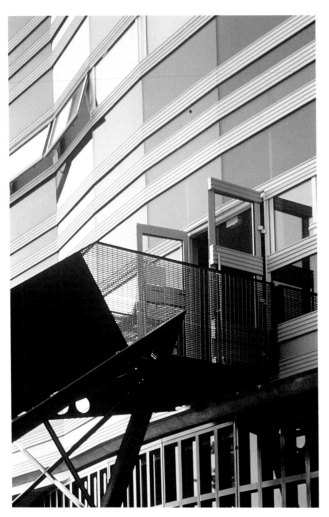

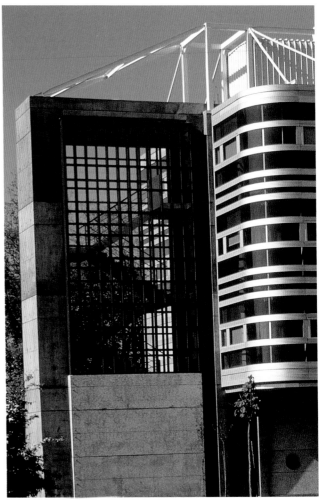

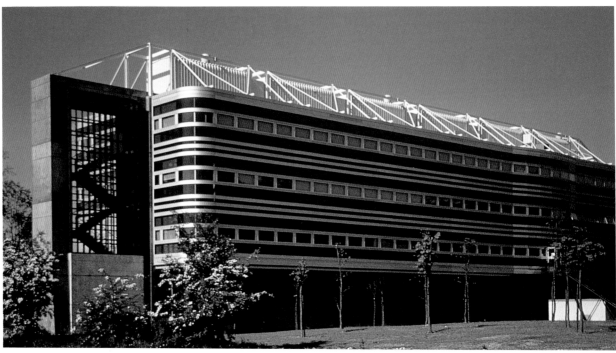

114 CHRISTIAN HAUVETTE

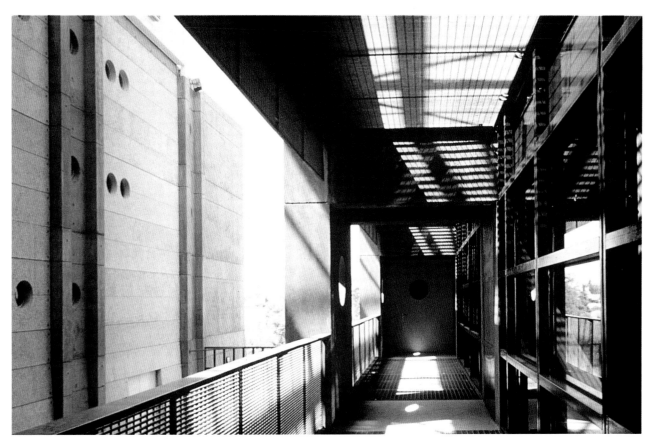

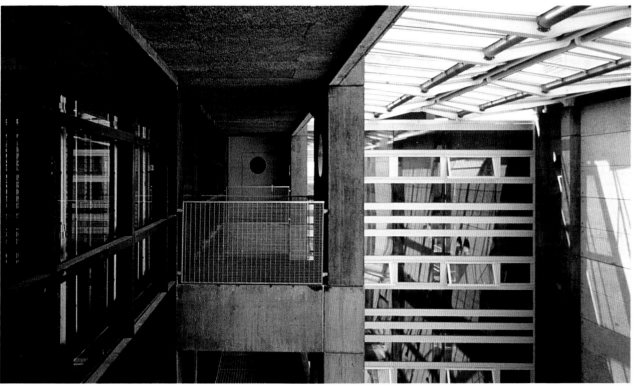

School of Law and Economics · Brest · 1982

A very well-known building by Hauvette is his School of Law and Economics in Brest. Located in the midst of a poorly planned collection of architectural objects, this building is distinguished by the sophisticated and clear compositional geometry that defines it. It is a typical example of Hauvette's rational, layered architecture within which each zone responds to a particular demand of the program. The northern side of the building, for instance, is smooth, enclosed, and contains functions requiring privacy and isolation—conference halls, administration, archives. Contrarily, the southern part of the building is open and reserved for spaces devoted to teaching and research. Its concave shape forms an embracing exterior space which is used for outdoor activities. Similar functional layering occurs vertically.

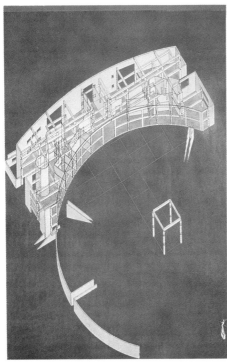

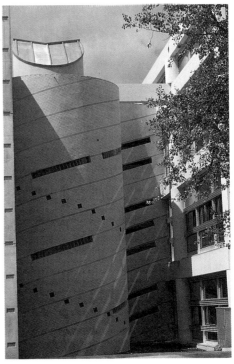

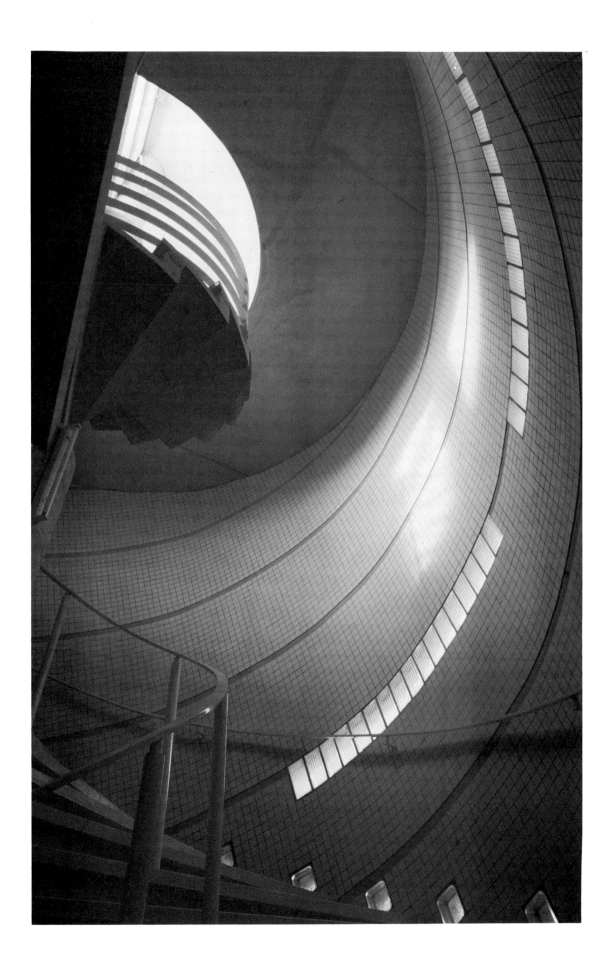

Technical College · Clermont-Ferrand · 1989

Hauvette's latest and largest project is the Technical College of Clermont-Ferrand. It features a striking combination of three essential architectural types—an arena, a central edu-cational center, and a cluster of small pavilions. All three components are kept in place with the help of a surface grid that imposes a rational structure on the site. Again, the project will be ex-ecuted in rigorously modern ma-terials and technology—metal and glass—which will provide it with an industrial aesthetic.

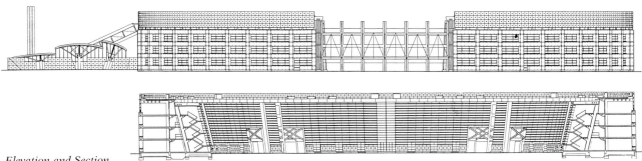

Elevation and Section

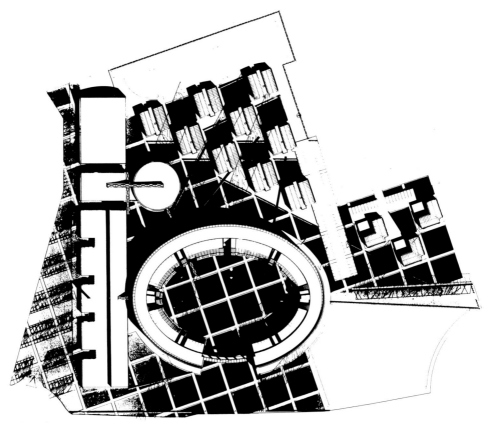

Site plan

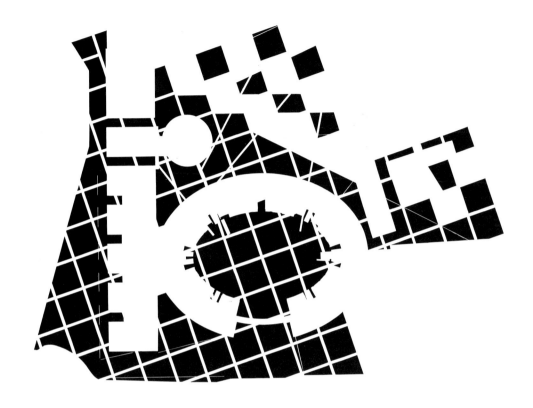

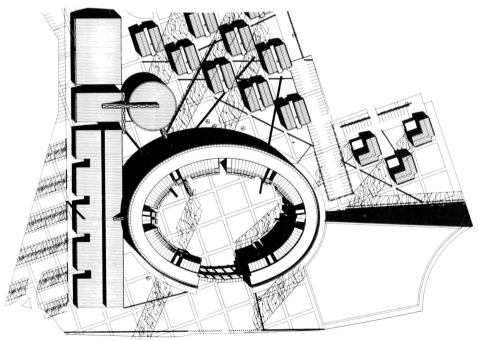

Site plan

JACQUES HONDELATTE
Town Hall and Park · Leognan · 1984

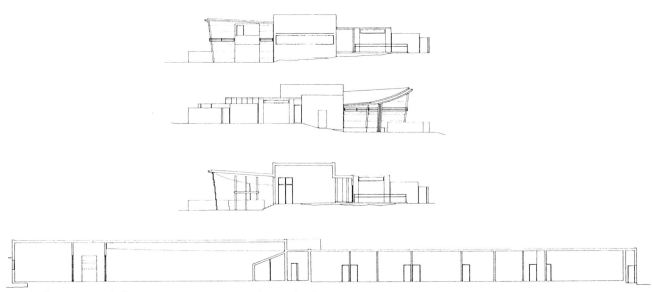

North elevation, south elevation, transverse section, longitudinal section

Jacques Hondelatte lives and works in Bordeaux. Although he considers himself somewhat detached from the Parisian architectural community he sees a potential advantage in being from a province. Intellectual independence is a prime virtue of living in Bordeaux, even if it has taken him longer to prove himself.

Ideologically, Hondelatte believes in architectural complexity, plurality, and ambiguity, which attract him because of the poetic possibilities that such conditions may generate. He begins every design process by investigating a wide range of notions—

sociological, literary, symbolic, technological, functional, and historical. Although his attitude toward technology is appreciative and he uses it in imaginative and futuristic ways, it is safe to say that the artistic aspect of architecture matters to him the most. Thus, he illustrates his projects with sets of evocative drawings for which he is well-known, while retaining a cautious and often skeptical attitude towards the excessive use of visual media. He believes that beautiful drawings are often deceptive and may provide a false impression of the product to be built. The art of drawing is im-

portant only in that it allows him to express his preliminary conceptual intentions in a stimulating and graphic way. Since all his projects are based on narrative themes and scenarios, it is necessary for him to capture his ideas in a painterly manner before he can proceed with technical designs. He sees his ideas and designs as efforts to regain conceptual freedom from academic theory, pragmatic functionalism, historical interpretation, and urban constraints.

The best example of Hondelatte's approach to design is his project for the town hall and park at Leognan, south of Bordeaux. In

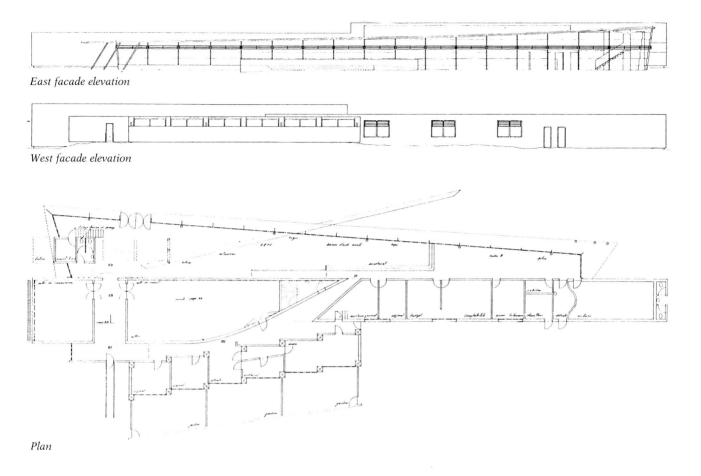

East facade elevation

West facade elevation

Plan

this village, which Hondelatte at first found quite ordinary, he discovered several elements such as old houses, an old church, and some ruins, to be of an extraordinarily picturesque character. Consequently, he decided to add on to this existing collection of fragments a new collection of invented elements. These objects include flags, busts of important personalities, and political inscriptions connected to the new town hall, all meant to enhance the surprising and mysterious quality of the park. The new objects, despite their intent to generate picturesque effects, have been conceived in their forms and materials as entirely modern. Neon tubes and aluminum and steel components create a sense of modern fragmentation, dictated not by nostalgia for historical images but by poetic interests. The town hall was designed to reflect a similar sense of casual and dynamic freedom. Its appearance is that of an aircraft wing, an object in flight related only temporarily to its site. Thus, the entire composition projects Hondelatte's typical sense of the modern through immateriality, airiness, and dynamism.

JACQUES HONDELATTE

Lechère Thermal Station • Savoy • 1986

The renovation of the Lechère Thermal Station in Savoy is another example of Hondelatte's high-tech poetic sensibility. Located in the industrial valley of Tarentaise in the midst of active hot mineral sources, the site was covered with existing residential and industrial structures. The context and its programmatic possibilities appeared to Hondelatte as a marvelous opportunity to introduce a series of stimulating poetic solutions and effects. He decided to combine the existing structures with a series of new ones. The plan includes the building of a new thermal station covered in a mirrored glass to reflect the surrounding mountain scenery, a frontal portico treated as a green pergola, a high-tech bridge suspended above the Isere River providing access to a glass enclosure containing the source, the cranes, and components of the pumping station expressed as machines surrounded by nature, and a series of sculptural objects to be spread liberally around the adjacent forests and mountains. The effect that Hondelatte is trying to achieve here is the presence of the sublime achieved through contemporary means—an object of technological romanticism.

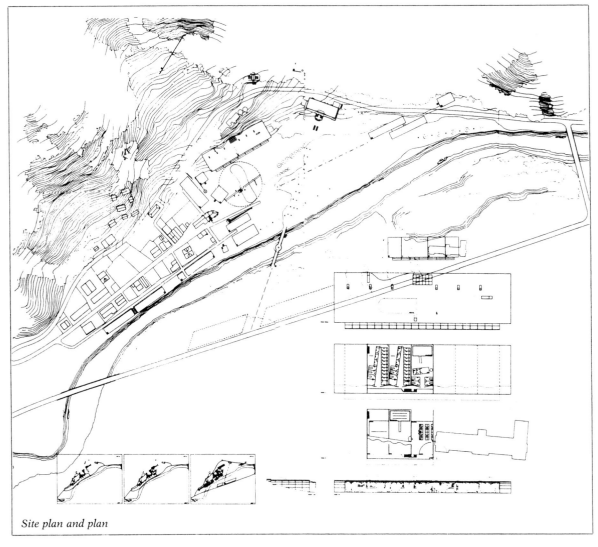

Site plan and plan

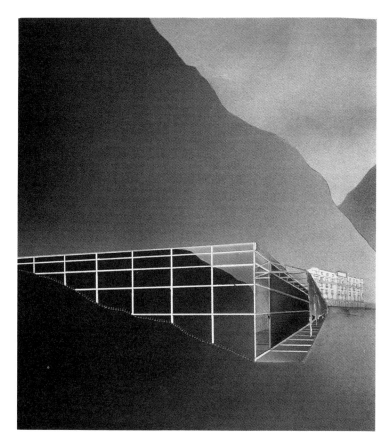

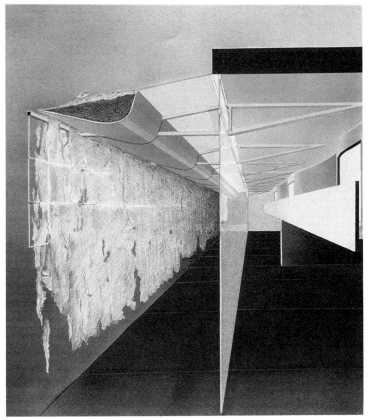

Housing • Coutras • 1984

Hondelatte's designs for public housing have not prevented him from exploring poetic themes and concerns. His housing for the small community of Coutras is a good example. Here Hondelatte employed a series of visual metaphors to structure the concept of the project. Among those metaphors are a number of variations on visual associations—stairs made out of textiles, bathtubs transformed into swimming pools, halls of machines corresponding to hygienic components in the dwellings, and duplex apartments suspended in the air to emphasize the need for openness and spaciousness. The design features buildings which consist of two elevations—a northern elevation that is plain, minimal, and closed, and a multilayered southern elevation made of panels of glass, aluminum, and steel to help filter the light into the interiors and to create a transition from outside to inside. The two-story interiors feature 'floating' sanitary and storage components that can be rotated and positioned at different angles. Such an arrangement was proposed to accomplish a greater internal spaciousness and a range of functional combinations in limited spaces.

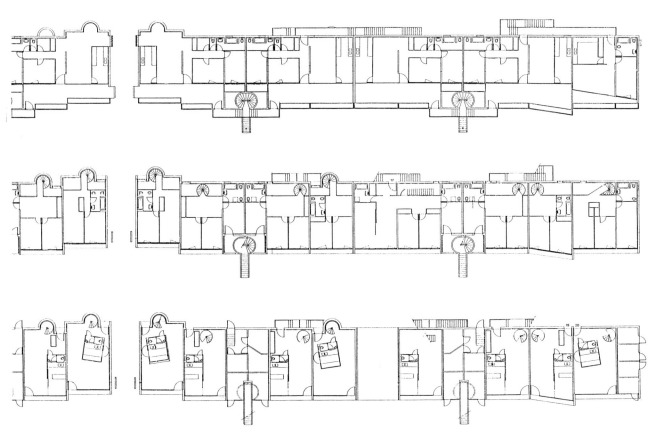

Building I: Third, second, and first floor plans (top to bottom)

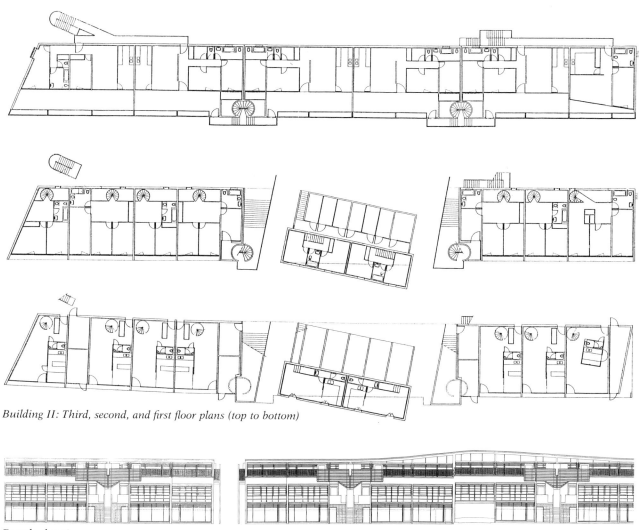

Building II: Third, second, and first floor plans (top to bottom)

Facade elevation

Le Foyer de la Gironde Housing • Bordeaux • 1987–88

Hondelatte's project for the Foyer de la Gironde Housing Co-operative in Bordeaux is another example of an attempt to introduce novel and imaginative design notions to the field of affordable housing. This particular project involves the creation of mixed-use housing for students and families next to the University of Bordeaux. Hondelatte's proposal features a single apartment type for each building in the interest of economical construction. The proposed dwellings are to contain two stories, each equipped with a system of floating sanitary and storage components and a system of translucent partitions to increase the feeling of spaciousness. The buildings themselves are simple, compact, and linear volumes, arranged in a free and spontaneous fashion around the site. The dynamic quality of the project is related to the "labyrinth" of interlocking aerial streets and decks where Hondelatte expects social activities to occur. These outdoor areas illustrate Hondelatte's belief that no matter how economically constraining a program may be, the freedom of movement, discovery, and exploration are fundamental and necessary components of our present architectural needs.

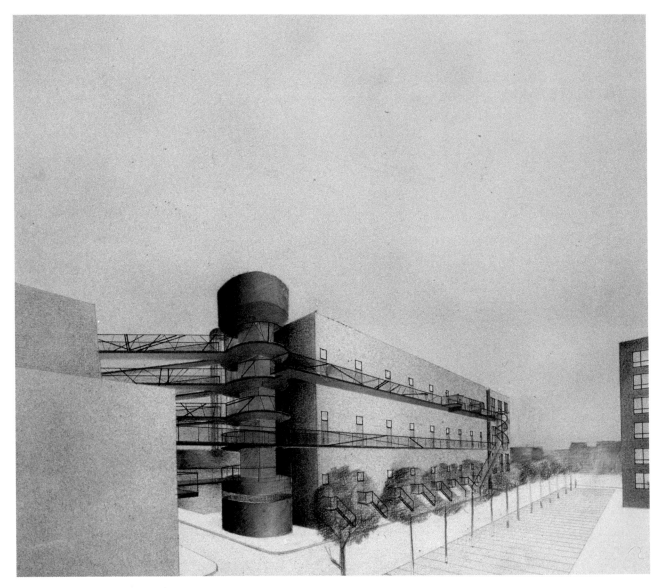

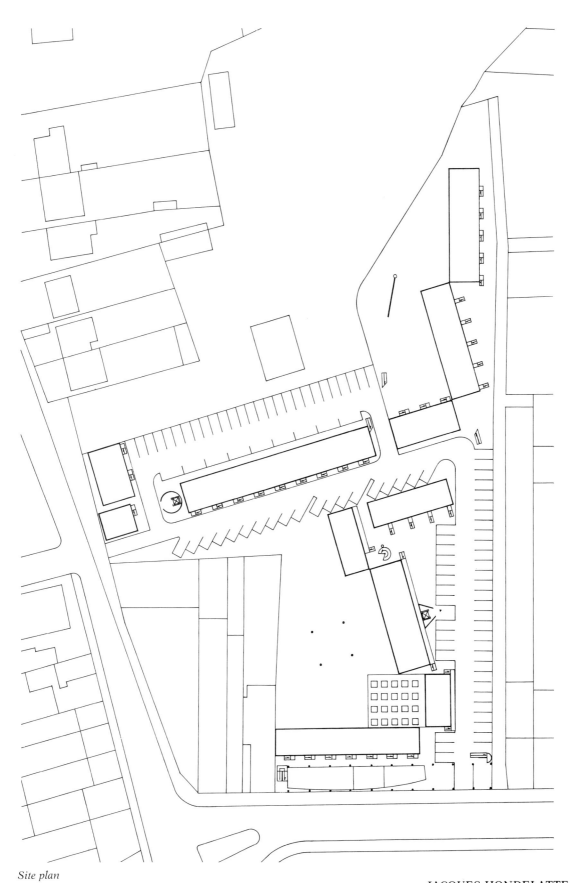

Site plan

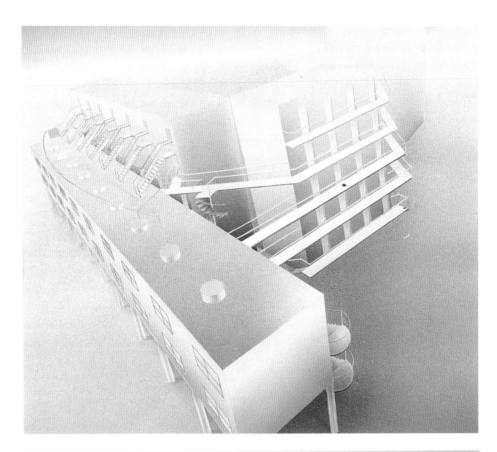

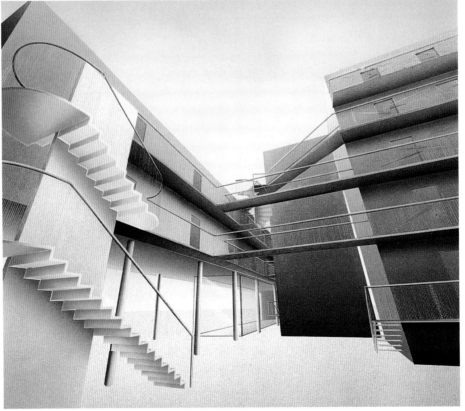

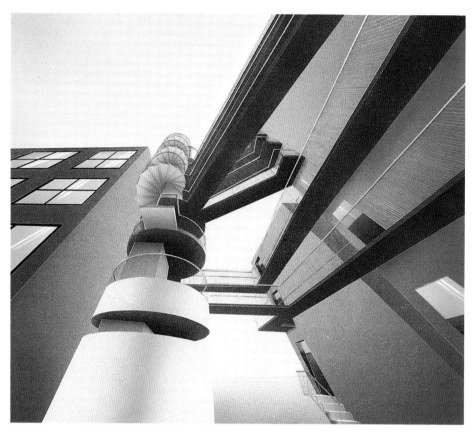

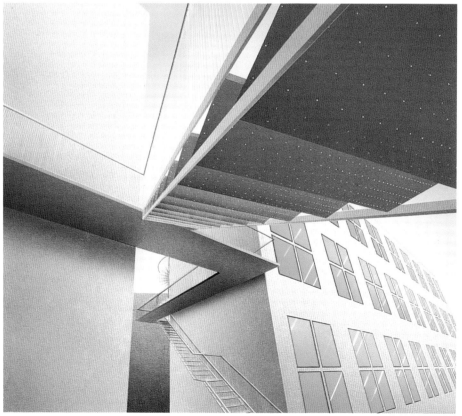

JOURDA AND PERRAUDIN

Individual House • Lyon • 1987

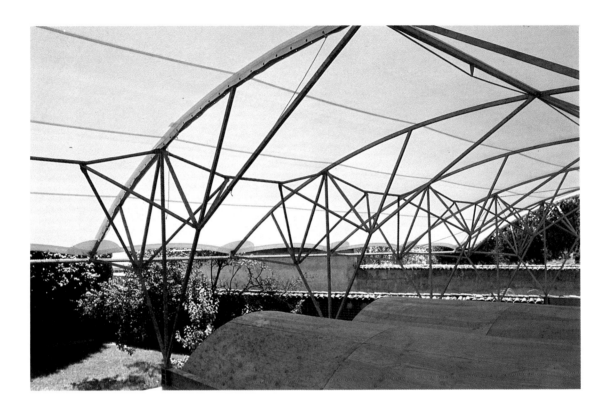

Variety, as it relates to essential archetypes in architecture, illuminates the work of François Jourda and Gilles Perraudin. The guiding principle of their designs is a tendency to rely on certain historical notions of order—hierarchy, symmetry, axiality, and functional and structural clarity. The architects often evoke the work of Louis Kahn in order to affirm that any language of architecture should be dictated essentially by functional and formal integrity. Upon an examination of their designs, one can quickly apprehend organizing principles behind each of their buildings.

A marvelously simple and powerful idea is expressed in Jourda and Perraudin's Individual House in Lyon. It is informed by the basic conceptual theme of Le Corbusier's Heidi Weber Pavilion in Zurich, which consists of a free-floating roof with a series of pavilions tucked under it. The house was designed around a linear structural system of metallic "trees" which support a transparent tent made of polyester. Under this umbrella a series of identical repetitive cells built out of wood are combined in a linear fashion. They contain a series of living spaces, subdivided with movable partitions which allow

a number of internal arrangements. The north elevation is entirely closed because of the site demands, while the south is entirely open, resulting in a Miesian spatial transparency which allows the visual penetration of the garden into the interior of the house.

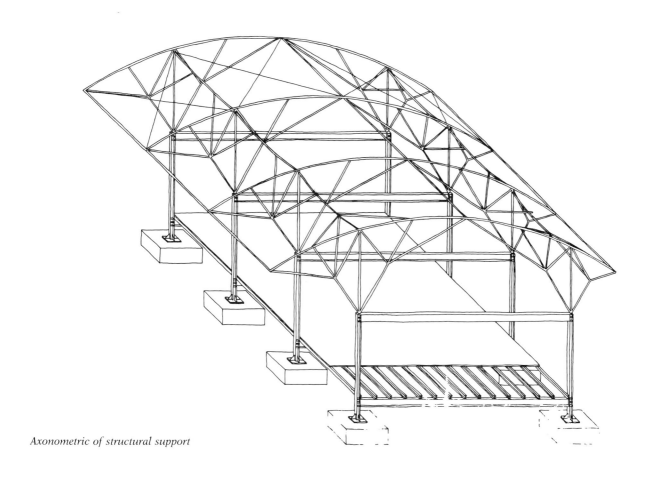

Axonometric of structural support

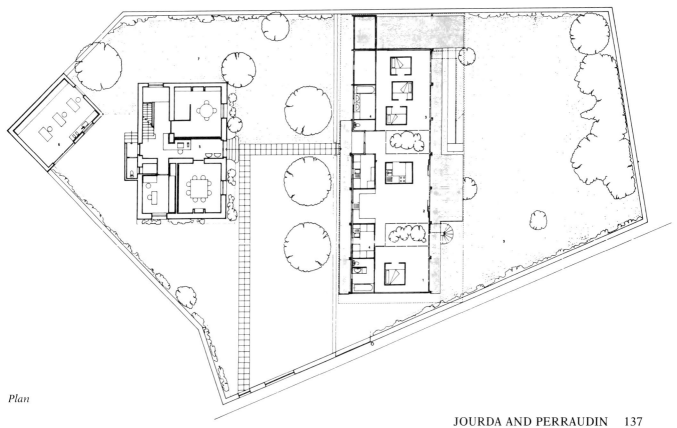

Plan

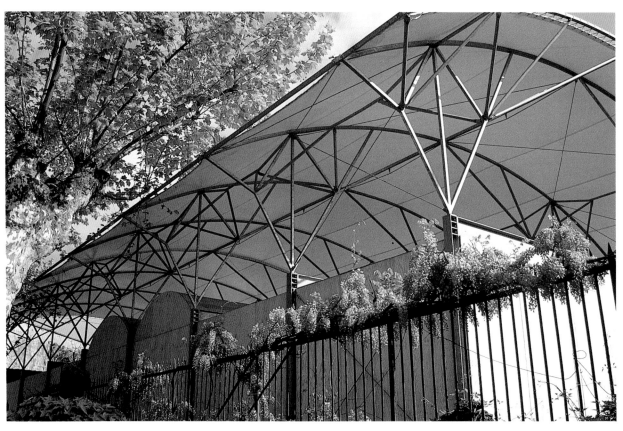

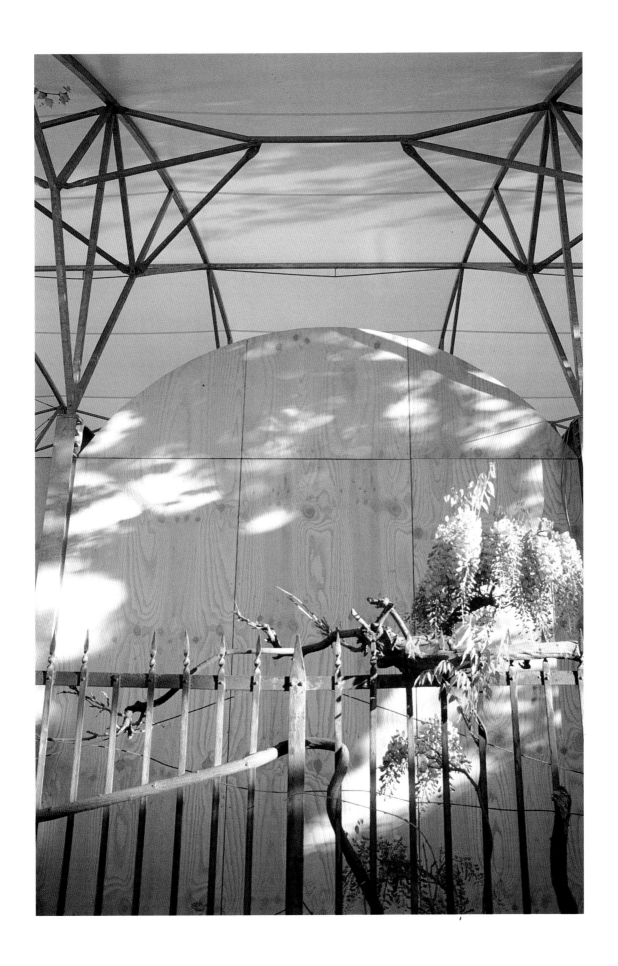

Elevation

Section

School of Architecture • Lyon • 1982

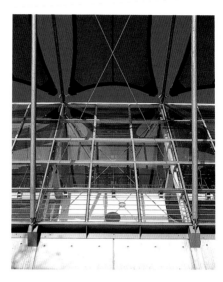

One of Jourda and Perraudin's best known works is their School of Architecture in Lyon, completed in 1988. Several philosophical, formal, and didactic principles have been clearly expressed in the design of this school. The overall concept was strongly influenced by Louis Kahn's formal vocabulary, and consists of two distinctly articulated volumes. A long volume contains teaching facilities and a half-cylindrical volume contains administration and faculty offices. Both volumes are connected by a central span that serves as an internal street for the entire structure. The long wing of the school has been divided into two functional and symbolic layers. The ground floor, expressed on the outside with heavy arches, contains classrooms, seminar rooms, and the library. The upper floors feature an ultra-light transparent superstructure within which open design ateliers are located. Here the mixing and development of design ideas is supposed to take place. The combination of functional, technical, and poetic metaphors within individually defined parts gives this building its wonderful combination of permanence and fluidity, heaviness and lightness, containment and openness, and firmness and flexibility. The overall concept of design, based on symmetrical, axial, and classical principles, gives the building great clarity and substantial presence.

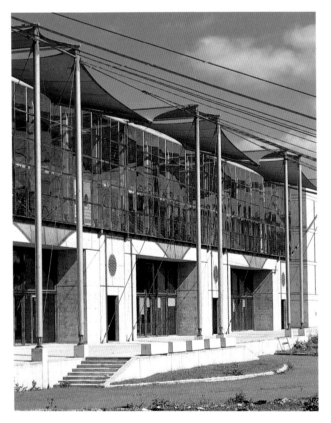

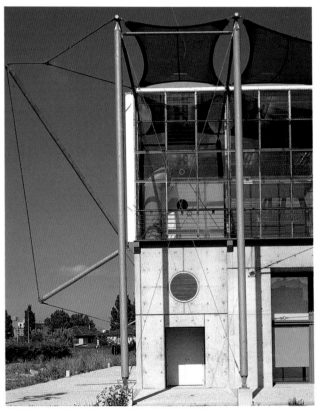

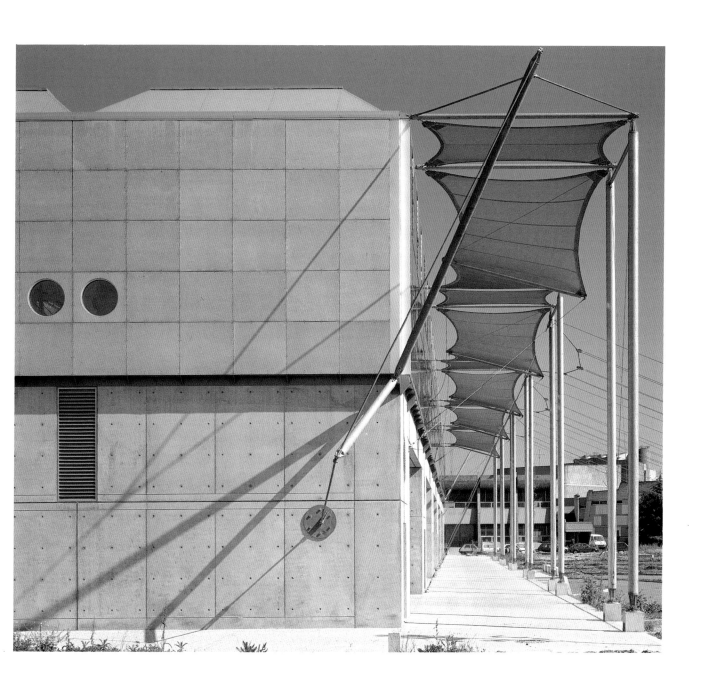

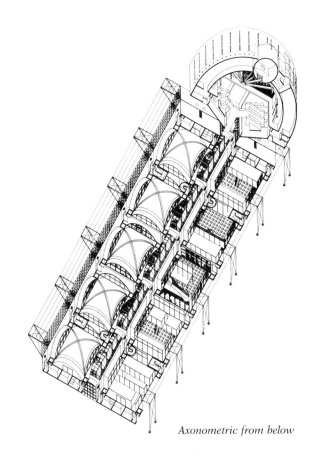

Axonometric from below

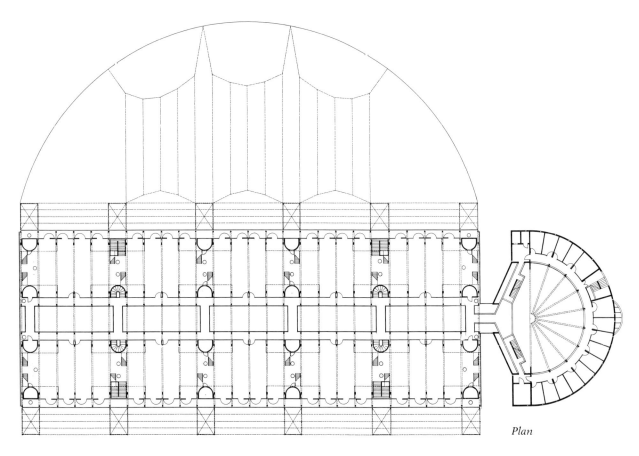

Plan

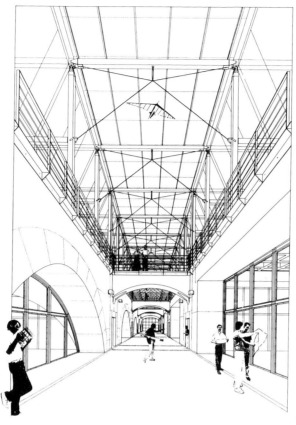

Interior perspective

nterior perspective

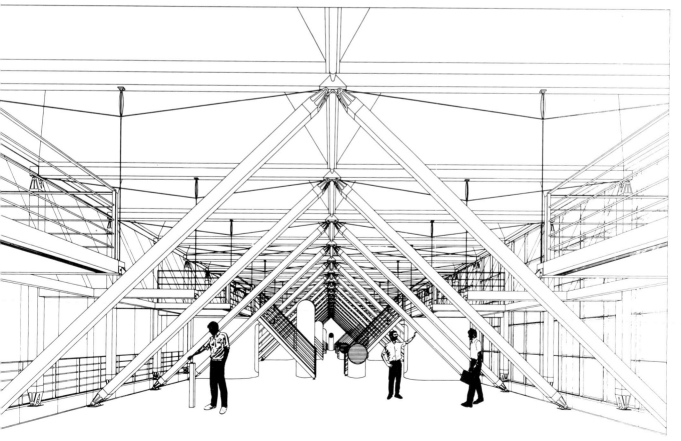

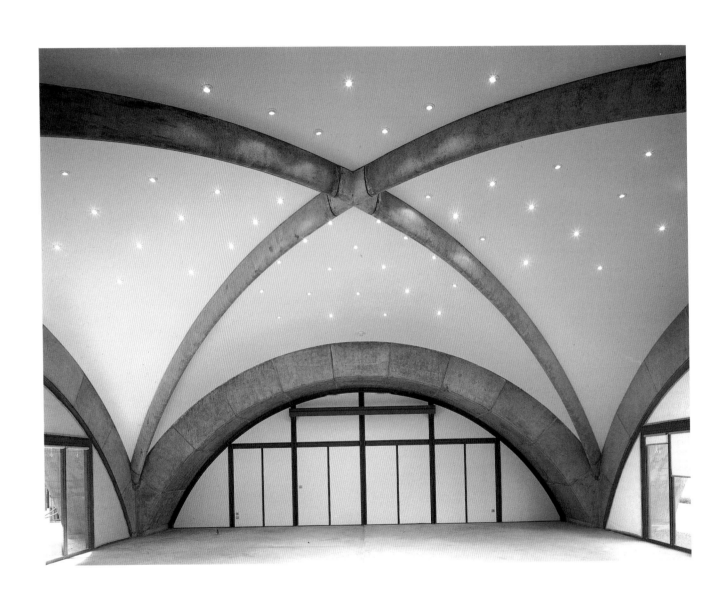

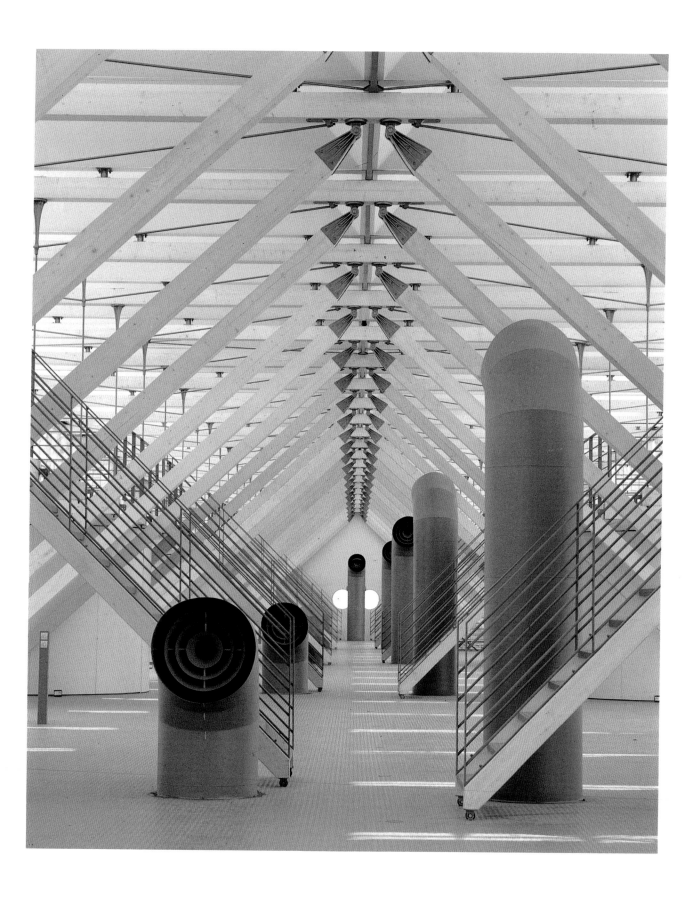

Memorial Exhibit • Lyon • 1987

Mies's influence on Jourda and Perraudin becomes evident in their Memorial Exhibit in the city of Lyon, erected as a temporary monument to commemorate certain events of the Second World War. This building, an austere Platonic cube, was made of two layers—a delicate external space frame and a plain internal skin which encloses the memorial courtyard space. A true monumental object, it is form reduced to a minimum and yet capable of expressing in a powerful way the poetic and symbolic function for which it was designed.

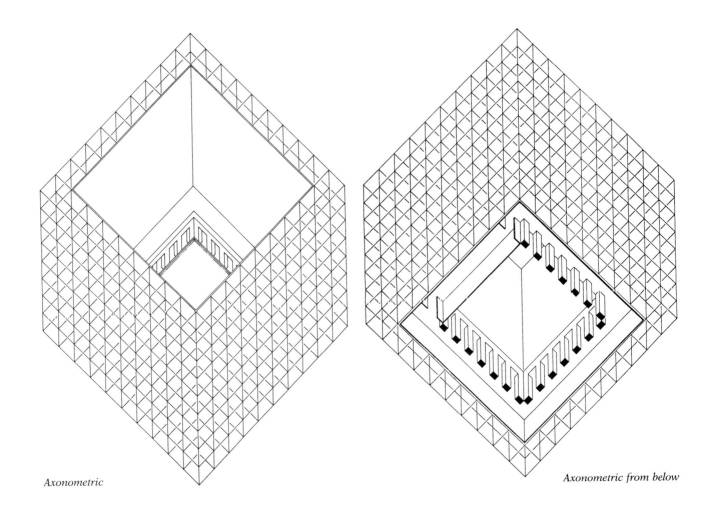

Axonometric

Axonometric from below

Parilly Metro Station • Lyon • 1989

Another work by Jourda and Perraudin that evokes distinguished historical sources is their Parilly Metro Station in Lyon. This underground cavity features molded concrete forms which recall the organic vocabularies of Antoni Gaudi and later-day organicists. The site includes a series of inclined columns intended to support an office building which will eventually be erected above the station, contributing to the overall effect of a space 'carved out' of the soil. Jourda and Perraudin have found a unique form of modernity in architecture, different from the methods which break with all past theoretical assumptions and traditions. They are able to handle the demands of modern functional design and advanced building technology by adapting past typological models to new conceptual possibilities. The result is a sophisticated traditionalism combined with refreshing novelty and originality, which all their projects communicate. Jourda and Perraudin have demonstrated that architecture, in order to be super-modern, does not have to rely on the heroic imagination. It can be made culturally continuous.

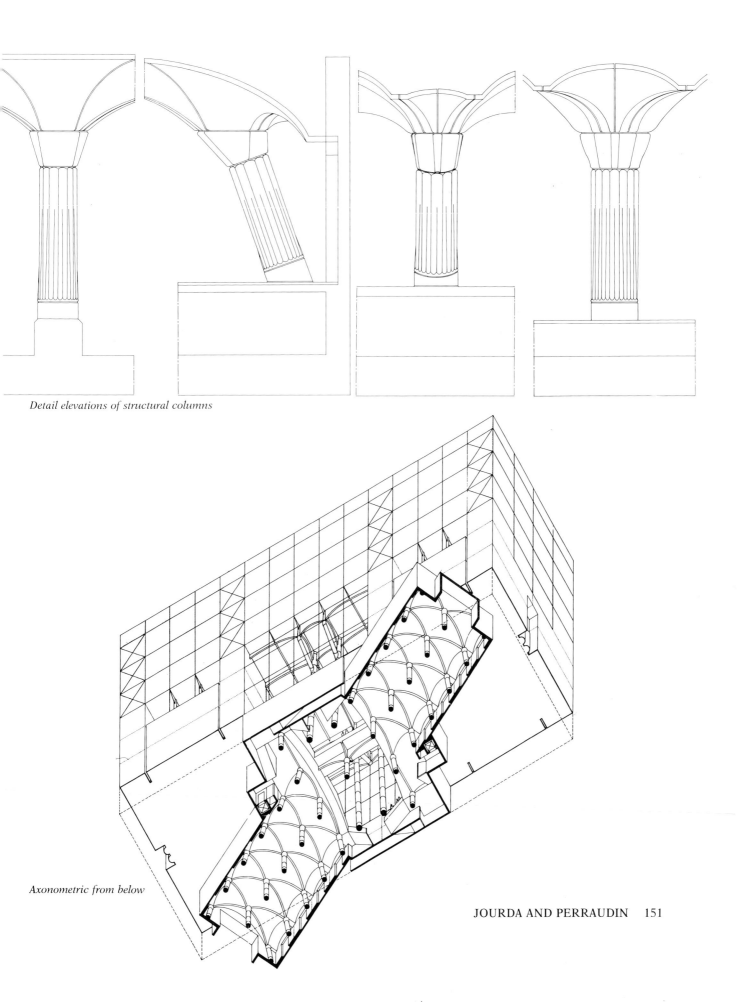

Detail elevations of structural columns

Axonometric from below

JOURDA AND PERRAUDIN 151

JEAN NOUVEL

Arab World Institute with Gilbert Lezénes, Pierre Soria, and Architecture Studio • *Paris* • *1981–88*

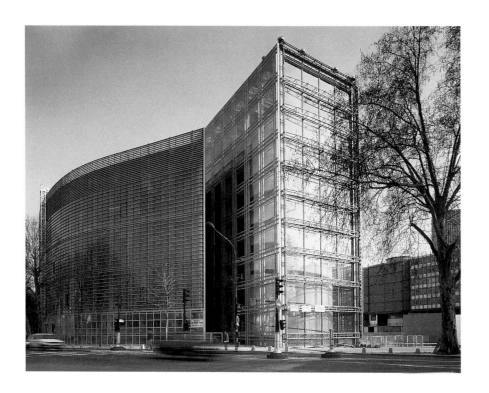

Jean Nouvel's name has become synonymous with the Arab World Institute in Paris, for which he received the Grand Prix of French architecture in 1987. This masterpiece of recent architecture reveals four concerns which have been essential for Nouvel—contextuality, urbanism, cultural imagery, and technology. In the case of the Arab World Institute, all these concerns are combined with a keen intelligence and architectonic precision. Nouvel and his associates demonstrated a quality that was unique at that time—the ability to achieve the formal integration of an ultramodern object into a site consist-

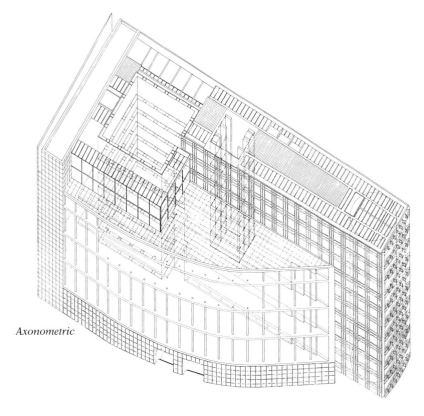

Axonometric

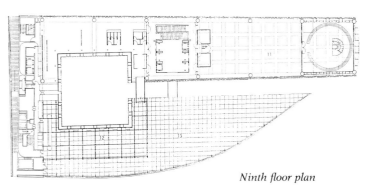

Ninth floor plan

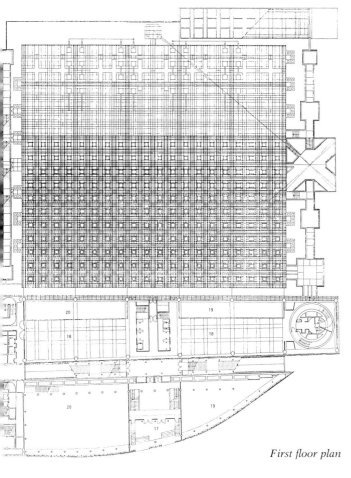

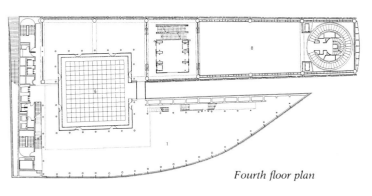

Fourth floor plan

First floor plan

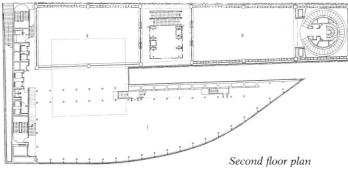

Second floor plan

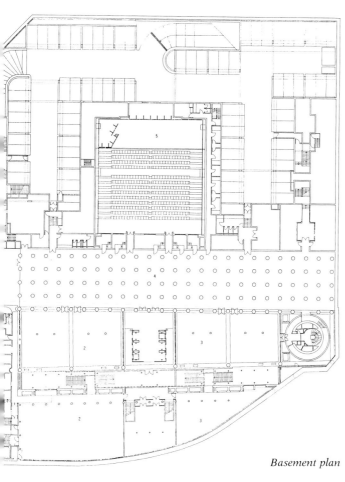

ing of many historical features. The Arab World Institute was the first truly successful solution to this dilemma since the Pompidou Center, which convinced many that technologically-inspired architecture may not be reconcilable with historical environments. The projects that followed the Arab World Institute reaffirmed that Nouvel's conceptual talent lies in his remarkable ability to create striking visual images which conform to their site.

Basement plan

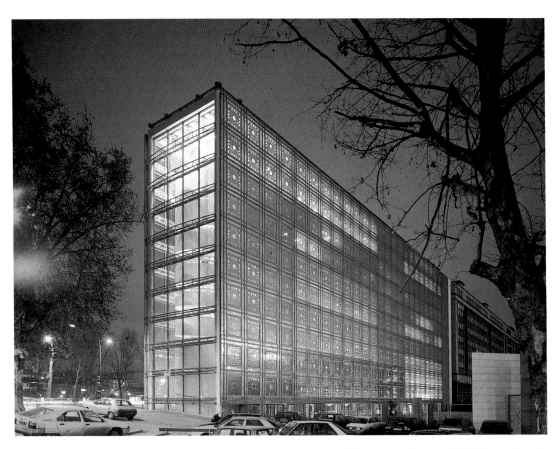

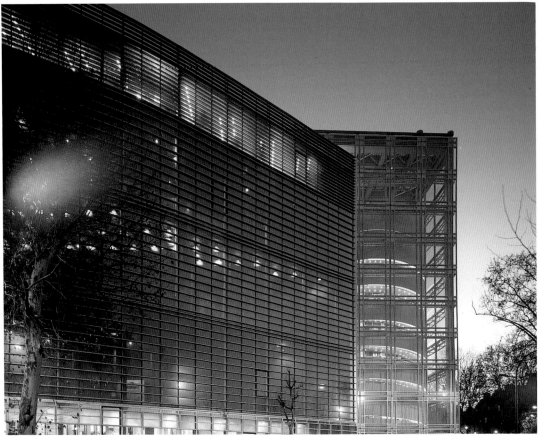

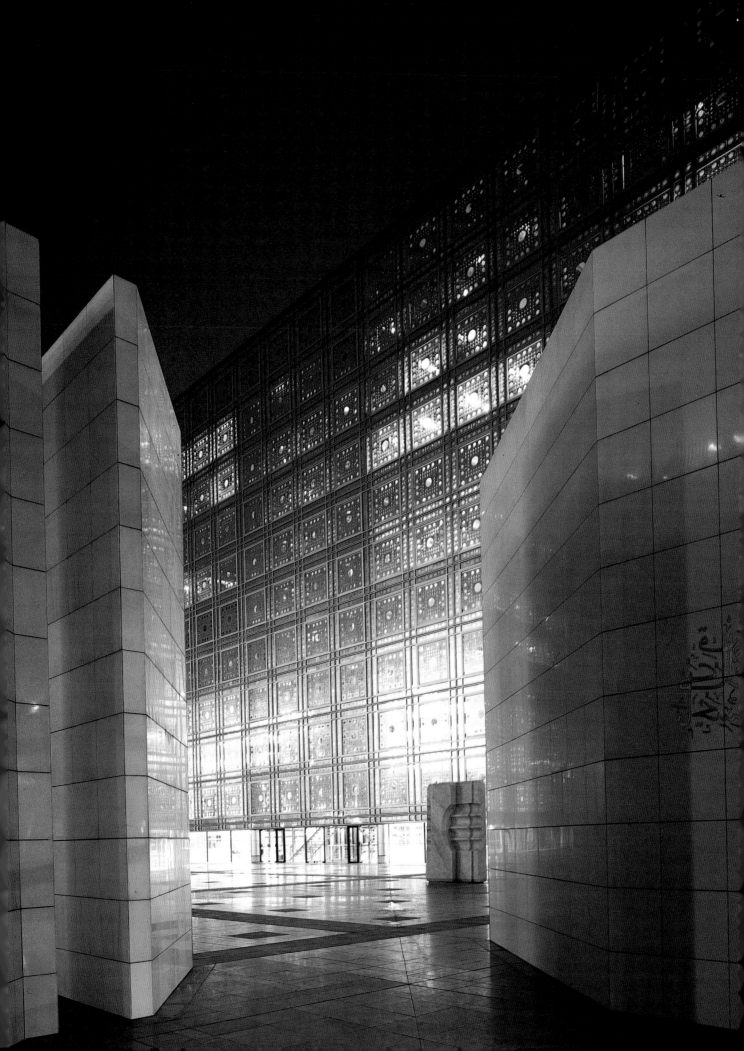

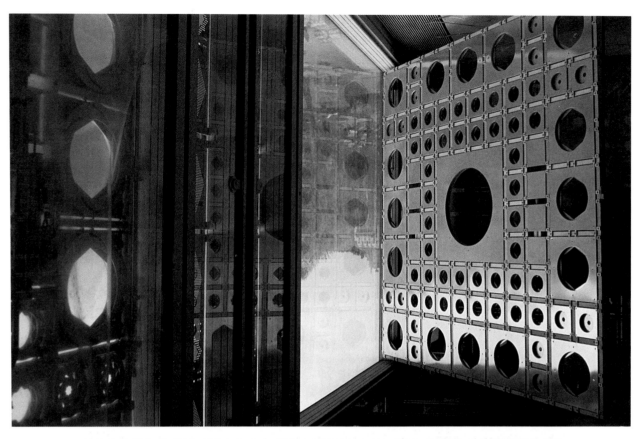

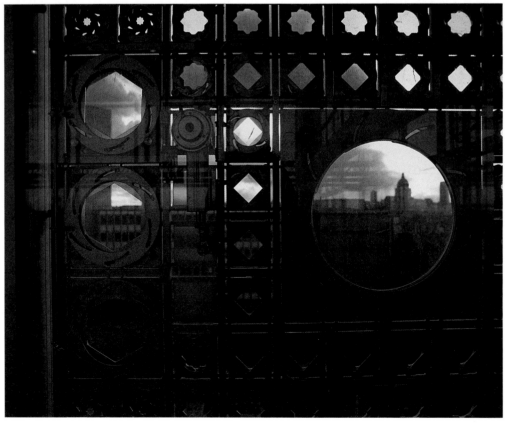

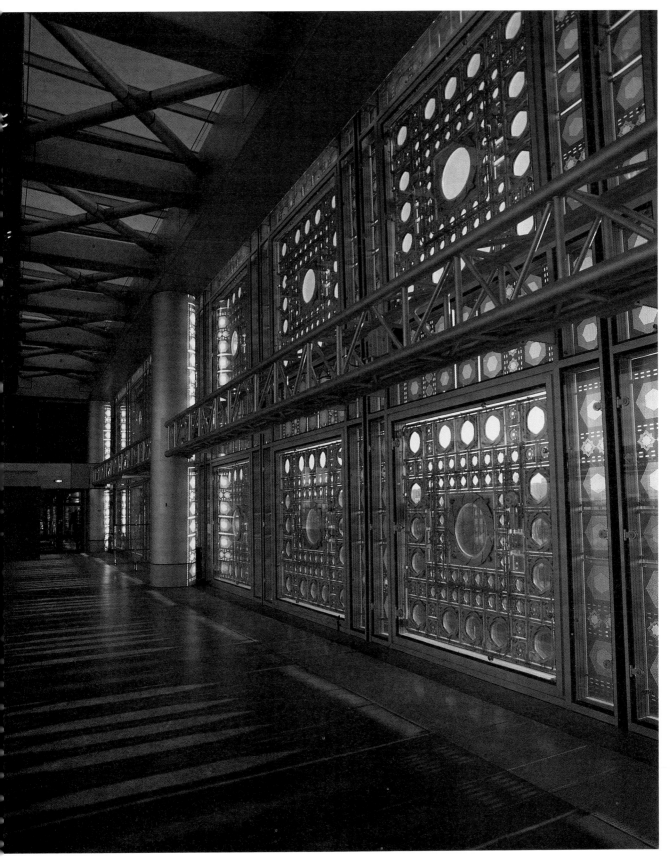

Health and Beauty Center • Vichy • 1988

Nouvel's project for the Health and Beauty Center in Vichy, the French town renowned for its mineral water and medical cures, is another example of a modern architectural object inserted into an old context—in this case, two converging city parks. An all-glass building (about thirty-five different types of glass are being used), the center will contain a hotel, medical facilities, and baths. It is shaped like a gigantic glass hangar which will allow greenery to thrive within it. The vertical walls of the hangar serve as a hotel and medical facility, while the baths are placed within the roof of the structure. The visual transparency of this building will help to integrate it into the site, and to express symbolically the shimmering nature of the place.

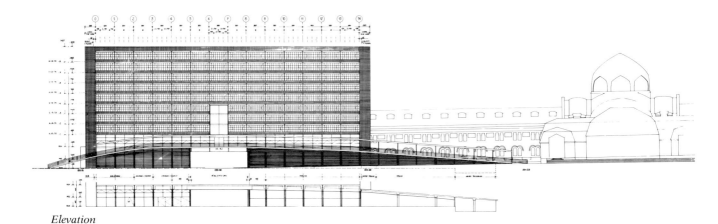

Elevation

Interior perspective

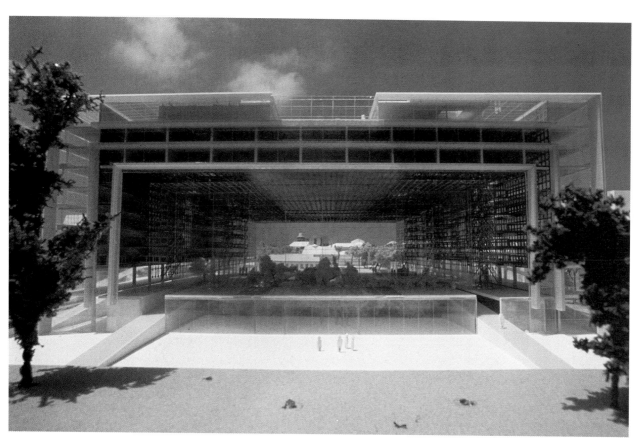

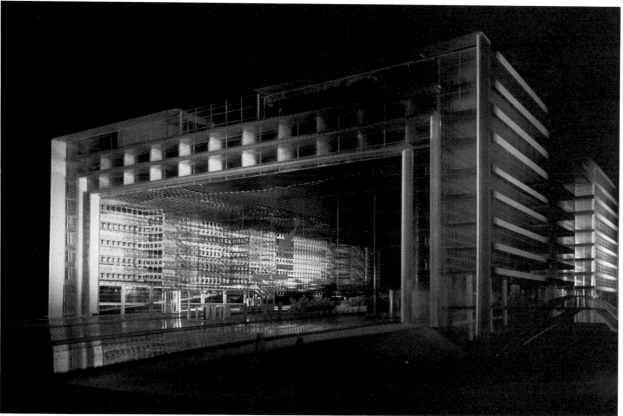

Nemausus Housing • Nîmes • 1987

Nouvel has applied his powerful modernism to a number of residential projects. Two designs, his Nemausus housing project in Nîmes and a housing estate in Saint-Quen near Paris, stand out. In both cases, the problem of creating the largest possible living surface was crucial for Nouvel. Simply by eliminating traditional internal staircases and replacing them with external circulation, Nouvel was able to increase the apartment surfaces by almost thirty percent. Otherwise, in structural terms, both complexes were designed as highly modern industrial objects; and many of their parts came from the catalogues of industrial metal manufacturers. The Nemausus housing project was conceived as a striking visual image—two parallel bars, raised on pilotis, float above the line of trees. Characteristic cantilevered roof screens act as sun shades for roof decks, bridges, and terraces. Its metallic surfaces and its transparency refreshingly perpetuate the image of a dynamic "machine to live in," an image which we are only now capable of fully realizing.

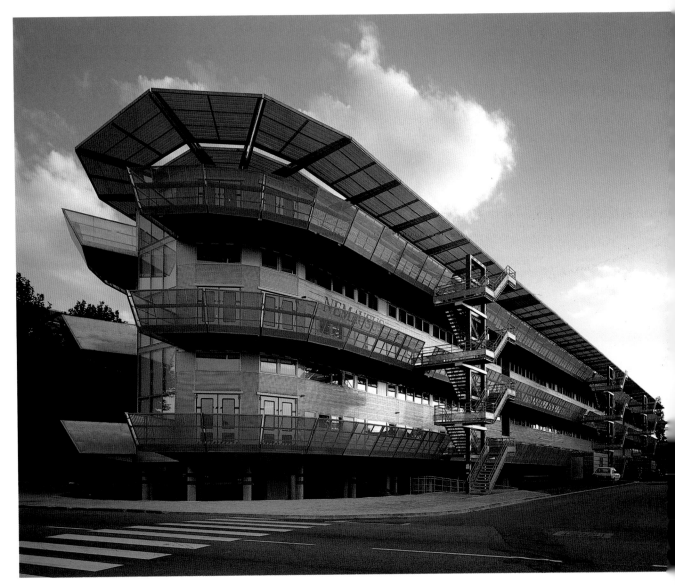

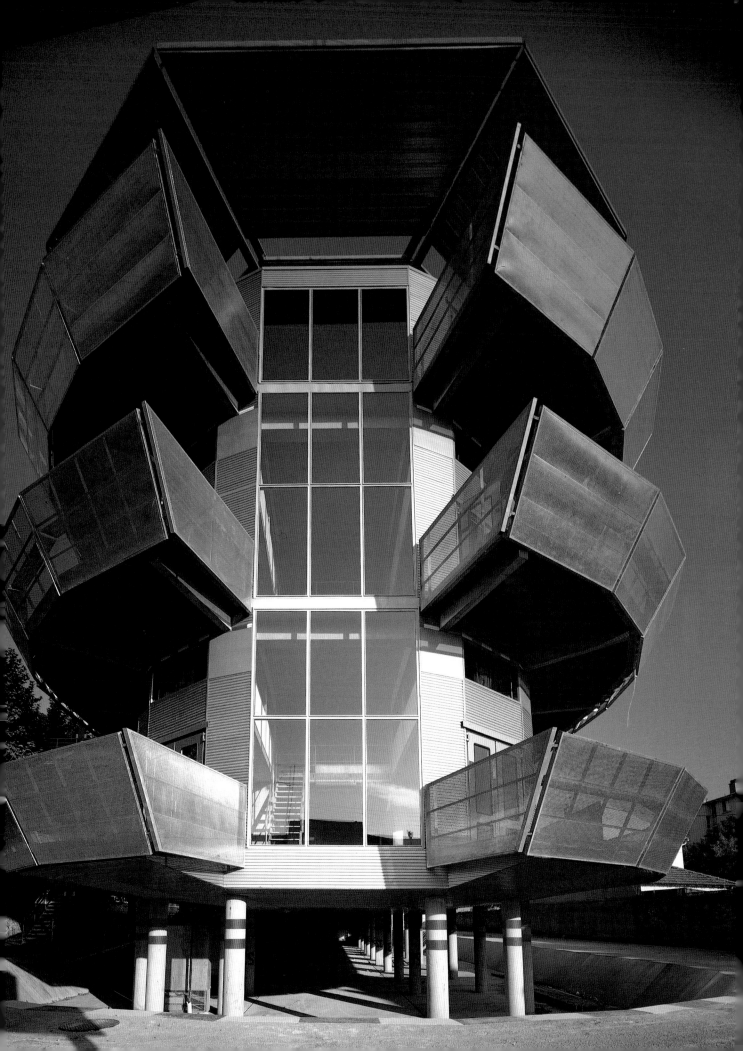

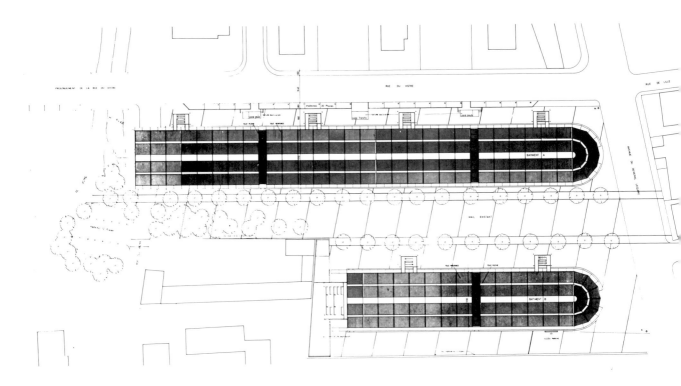

Site plan

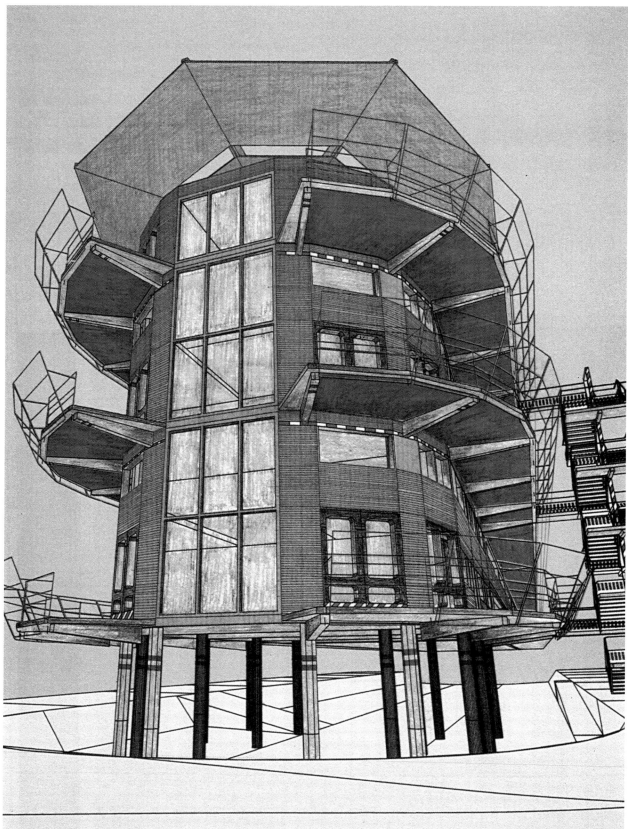

Exterior perspective

Triangle de Folie • Paris • 1989

Nouvel's latest project is for the Triangle de Folie, a 1,300-foot-high tower in Paris to be built on a tiny triangular site to the northwest of the Grand Arch of La Défense. It represents an attempt to design an object in the context of the entire city of Paris (it could be seen from all of the strategic areas of the city) and to resolve the functional and formal demands of an incredibly confined site. As in the case of the Arab World Institute, another great concept emerged—a thin, cylindrical, and poetically dematerialized tower. It springs out of a deep pit whose walls are clad in black granite, appearing to emerge from the center of the earth. It terminates in a 160-foot-high hollow cylinder through which the "clouds could pass." The changing textures of its surface emphasize the vertical movement of its cylindrical shaft in the direction of the skies. Typical of Nouvel, it is a poetic handling of a pragmatic task. When completed, it will become one of the most spectacular towers built since the Second World War and a monument of significant symbolic importance for Paris.

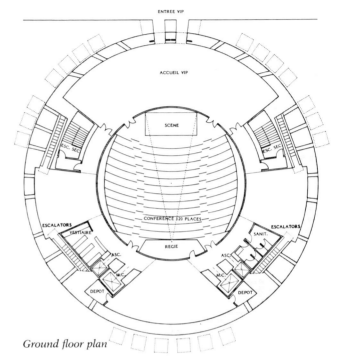

Ground floor plan

Transverse section

Longitudinal section

DOMINIQUE PERRAULT

Engineering College of Electrotechnics and Electronics (ESIEE) • Marne-la-Vallée • 1984

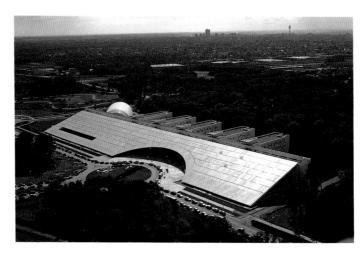

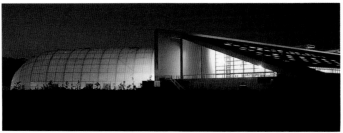

In 1987, a remarkable building called the Engineering College of Electrotechnics and Electronics (ESIEE) was completed. This building was designed for the prestigious Paris Chamber of Commerce and Industry, a client that cared very much about its modern image. The building is located in the industrial park Cité Descartes at Marne-la-Vallée. The architect chosen for the job was the young Dominique Perrault, for whom it was to be the first important commission of his career. Its creation marked an important step in French design towards an architecture based on high technology. The building was designed by Perrault as an inclined metallic plane, 1,000-feet-long, which resembles an aircraft wing design. Along its edge is the central circulation gallery to which a series of small pavilions are perpendicularly attached. The entire composition is highly luminous and reflective because of its white aluminum cladding, and its remarkable overall transparency creates the illusion that this building has no details. It appears to be so architecturally integrated and so lightweight that it evokes a sensation of smoothness, clarity, and brightness—a true machine aesthetic. This beautiful and elegant building represented a major step in Perrault's architectural development.

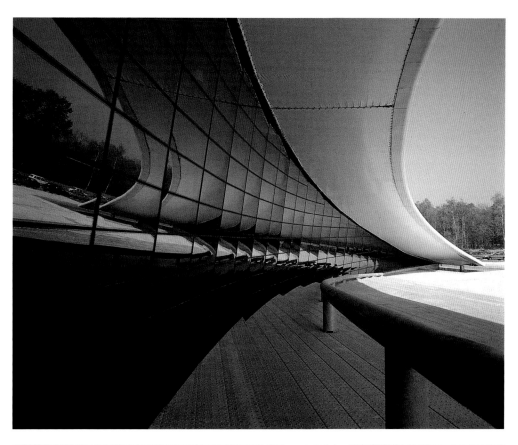

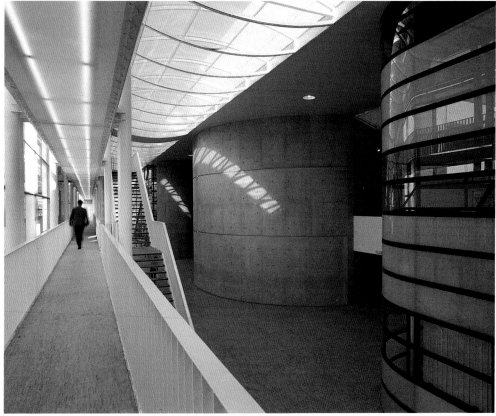

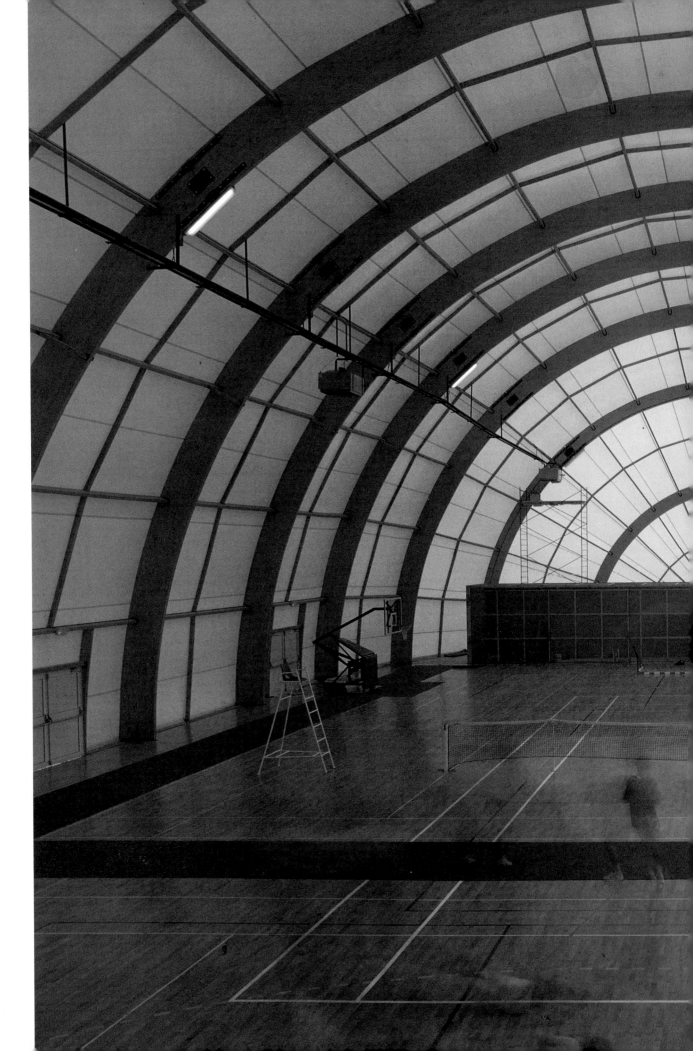

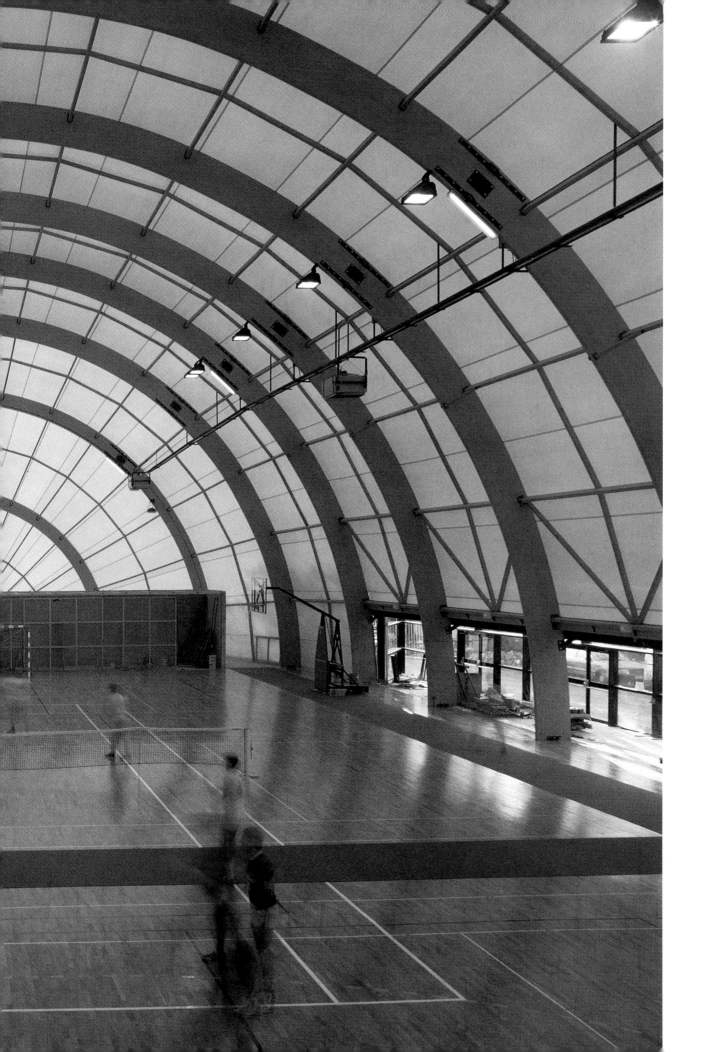

Bibliothèque de France · Paris · 1989

Perrault's sober, restrained, and refined approach recently earned him the first prize in the Bibliothèque de France competition. Here, more than anywhere else, his belief that buildings should be designed as vast, integrated landscapes is clearly evident. At the same time, his project for the library continues his previous design themes and displays an interest in the transmission and diffusion of daylight for functional and symbolic purposes. The glow of the building by night is also particularly important for spiritual and symbolic reasons. Glass architecture allows a great degree of openness and transparency which are vital to Perrault's themes and to the powerful symbol of the vast central courtyard, a container of living nature and the heart of the building.

In Perrault we find an architect who is instinctively and intellectually capable of expressing the best gothic and classical traditions in French architectural thinking by using modern technology without reaching for shallow historical pastiches. His clarity of vision demonstrates what technology can produce, even in an age of confused, rhetorical and arbitrary architecture.

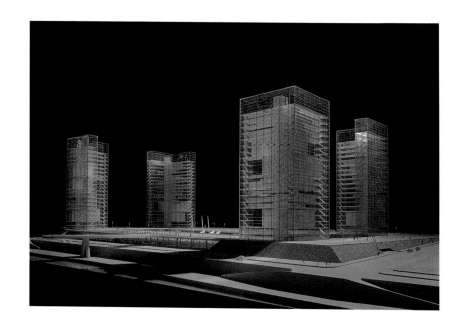

Section

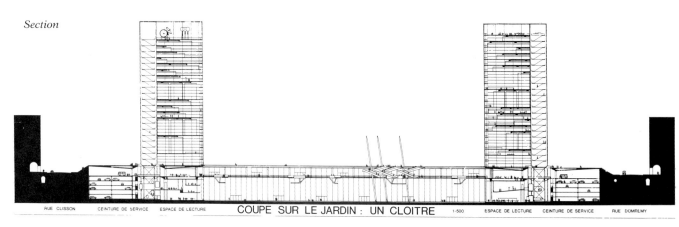

RUE CLISSON CEINTURE DE SERVICE ESPACE DE LECTURE COUPE SUR LE JARDIN : UN CLOITRE 1:500 ESPACE DE LECTURE CEINTURE DE SERVICE RUE DOMRLMY

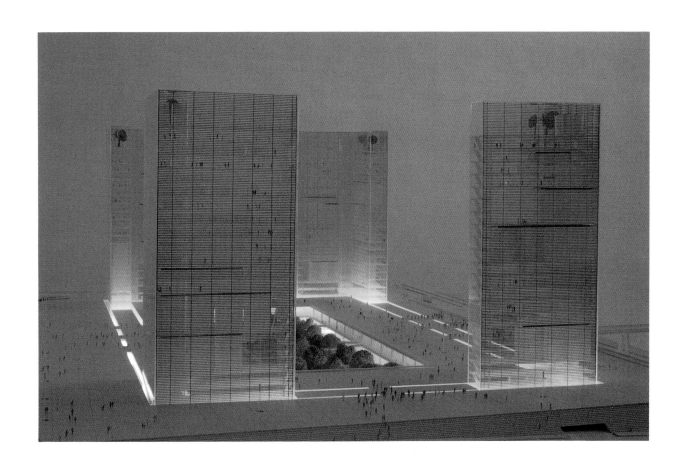

PLAN NIVEAU ACCUEIL - ENTRE SEINE ET JARDIN 1:500

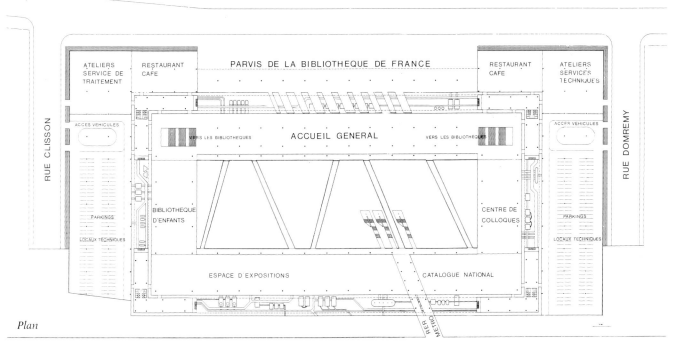

Plan

Industrial Hotel • Ivry-sur-Seine • Paris • 1986

Perrault has consistently applied the same conceptual characteristics he used in the ESIEE design to a multitude of other projects. Among them are the Industrial Hotel in Ivry-sur-Seine, the USINOR/SACILOR Conference Center in Saint-Germain-en-Laye, a water processing plant also in Ivry-sur-Seine, and the Siège de Canal administrative building in Paris. Aside from their simplicity, clarity, and rationality, these designs have demonstrated Perrault's "desire to produce the most beautiful buildings in the world," in his opinion the most fundamental duty of any architect.

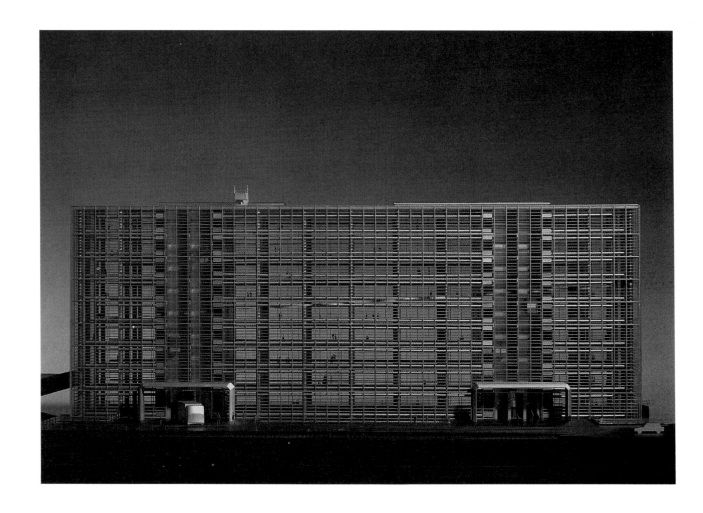

USINOR/SACILOR Conference Center •
Saint-Germain-en-Laye • 1989

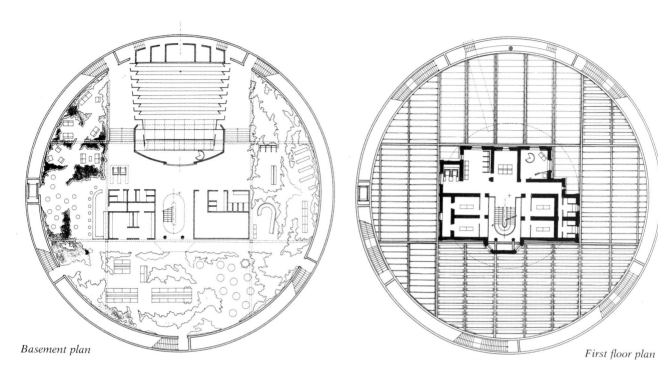

Basement plan

First floor plan

Water Processing Plant · Ivry-sur-Seine · 1987–91

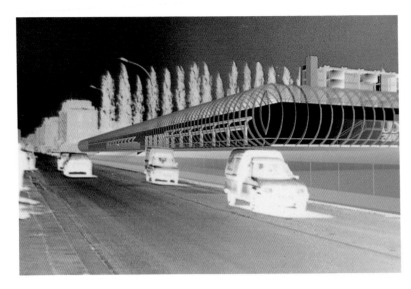

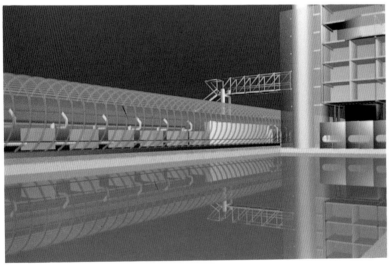

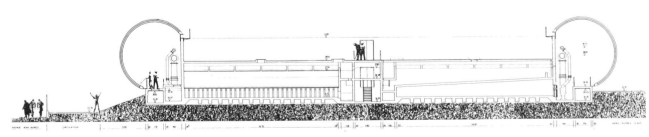

Section

Siège de Canal • Paris • 1988

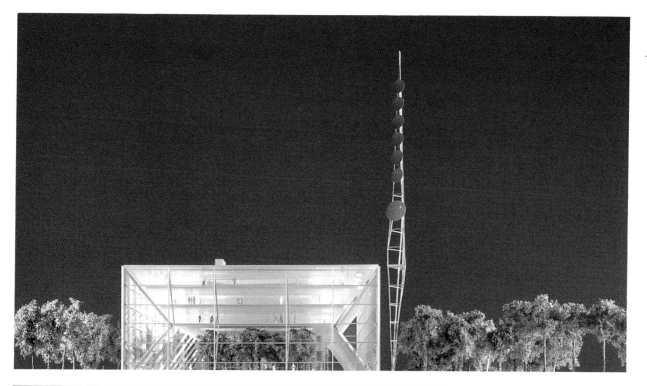

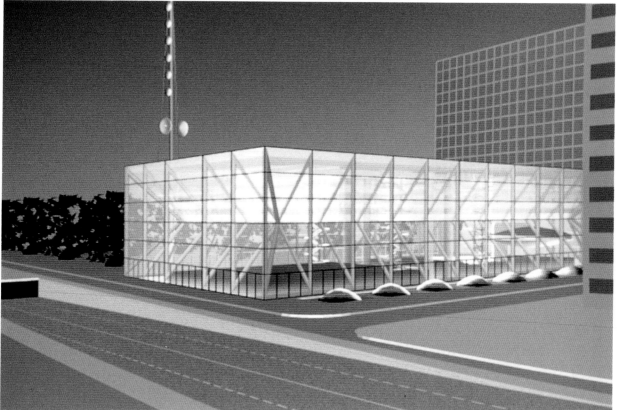

FRANCIS SOLER

Bibliothèque de France • Paris • 1989

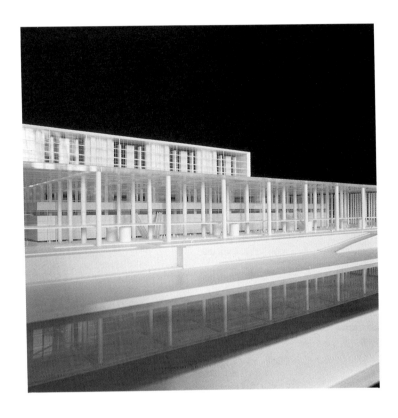

Francis Soler is an architect who, like Jacques Hondelatte, is capable of a delicate, imaginative, and sensual handling of architectural language. Soler sees architecture as a cultural object, although he worries about its present effectiveness. He is skeptical about the role of architecture today because, like Victor Hugo, he claims that architecture will never be able to generate cultural myth. It is clear to Soler that without greater social consciousness, architecture can only generate superficial images which will never be able to perform any deeper historical role. That is why Soler champions a

"combative" type of architecture. By combative he means a struggle against architecture as mere construction. He aspires to a higher image of architecture which can be reached only if other influences are brought to it—painting, sculpture, cinema, literature, and music, for instance. Technology, therefore, should always be in the service of architectural humanism. Technology ennobled by form-making is the most difficult architectural task today. Soler believes that we are still victims of the simplistic functional phase of early-modern architecture, which considered function and form as inseparable.

Such a rational mentality led us into the trap of sterile architecture. In poetic vitality, however, we find a state of mind which is the sole protection against design vulgarity. Architecture should consist of a combination of order and poetry, of principal and secondary arrangements without which human totality could not be adequately described and defined.

A recent competition entry by Soler demonstrates the importance of transparency and openness in his work. His project for the Bibliothèque de France competition involved a huge glass box of 130 columns which

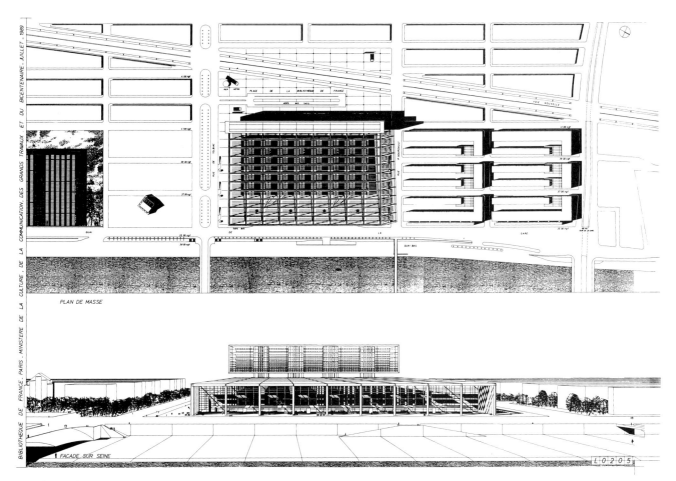

Site plan and exterior perspective

had book stacks located at its center. A simple volume, it relied on the effect of its luminosity, its reflection in the Seine, its crystal clear functional organization, and its technological bravura.

Pelleport Primary School • Paris • 1985–88

A wonderful example of Soler's combination of order and lyricism is represented in his Pelleport Primary School in Paris. Here the architect tried to render the spirit of immateriality which, he believes, corresponds to children's "unstructured mental universe." In order to achieve this, he introduced an interplay of static and dynamic components on the main facade. Using materials like metal and polished concrete in a direct and open manner, Soler adopted contemporary technology in a sensitive and compelling way.

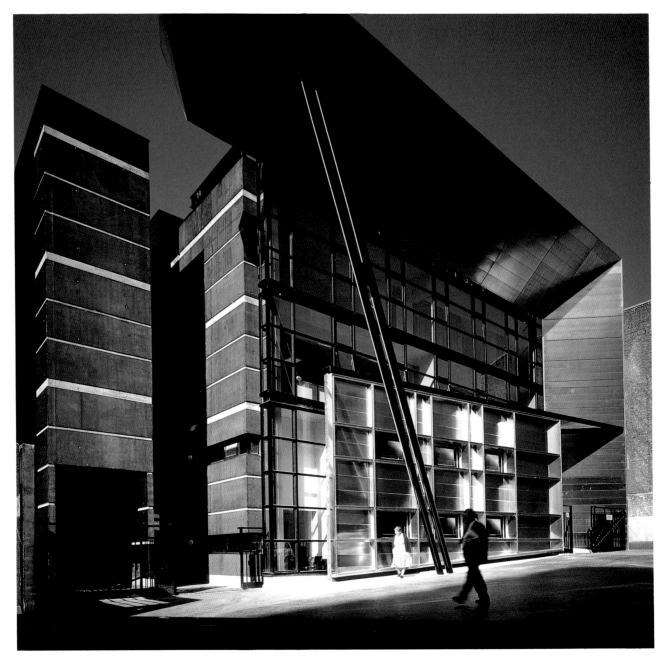

Facade layering

Facade elevation

Typical floor plan

First floor plan

Presidential Review Tribune • Place de la Concorde • Paris • 1983–85

Soler's themes of architectonic simplicity and symbolism were expressed in one of his earliest structures—the Presidential Review Tribune, placed in the center of Place de la Concorde on Bastille Day. Soler showed in this project that there was no need to be romantic about the site, and that modern technology and historical context can happily coexist. The tribune was a system of four mobile army cranes serving as a support for the suspended review stand. This simple solution showed Soler's imaginative ability to generate surprising architectural images with strictly modern means.

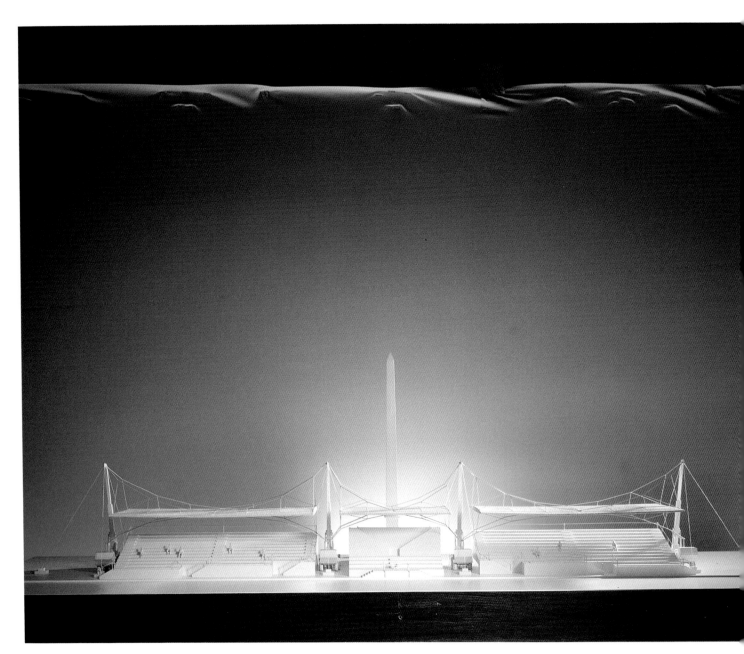

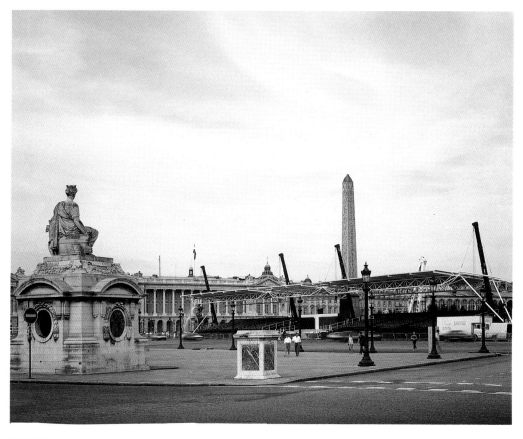

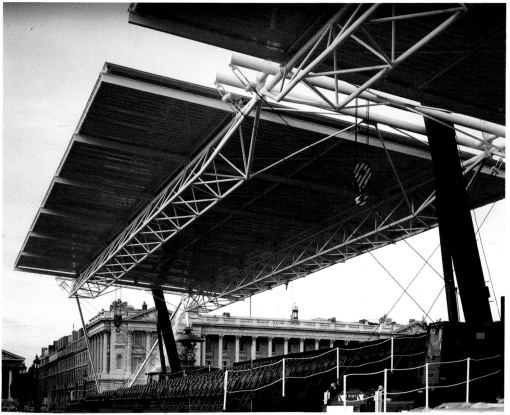

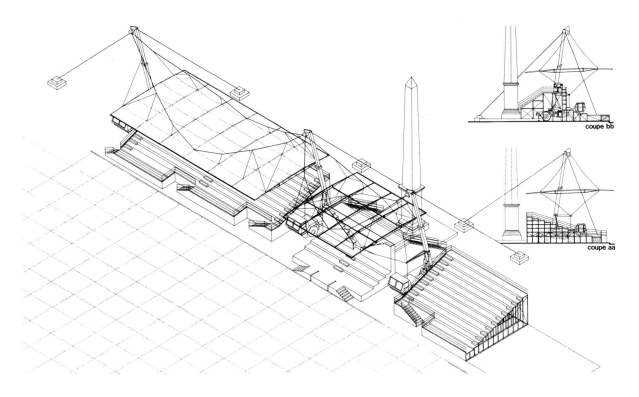

coupe bb

coupe aa

Axonometric

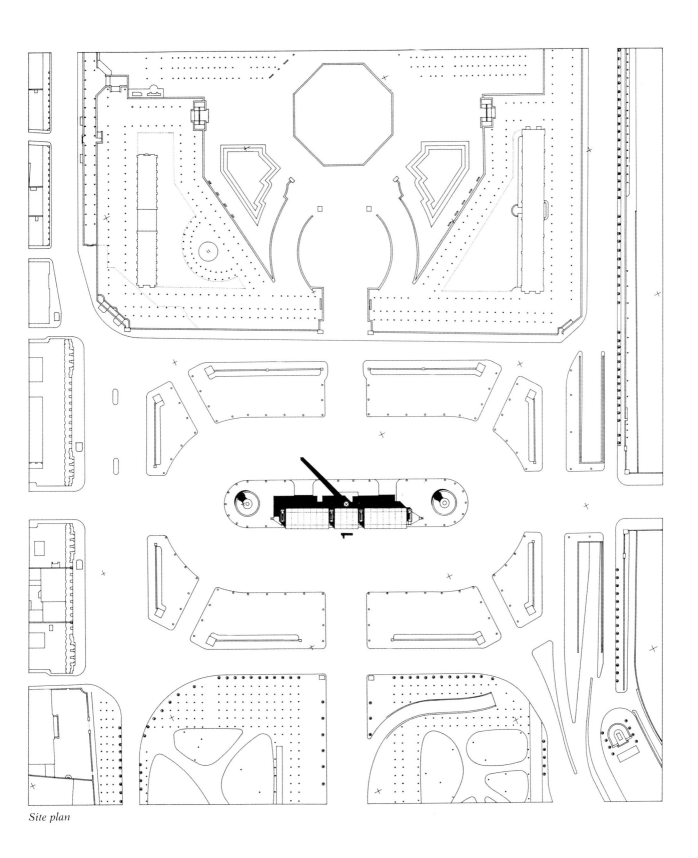

Site plan

Computer, Communication, and Image Research Center (C.N.R.S) • Marne-la-Vallée • 1986

Soler's C.N.R.S. building at Marne-la-Vallée, a research center for computers and communication, faces Dominique Perrault's ESIEE building. Sited on a narrow and constraining site, the building utilizes a linear form for the evocation of visual

movement. In addition, physical transparency, lightness, and the interpretation of interior spaces gives this structure an architectural image associated with a spirit of openness and communication.

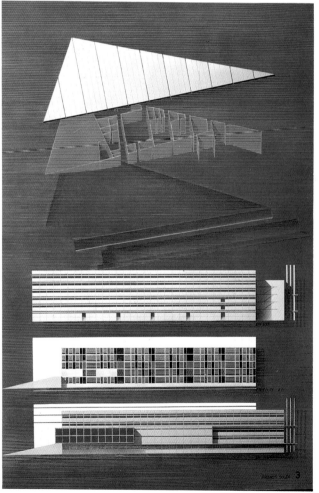

Elevations

School of Architecture • Paris-Villemin • 1987

Soler's project for the School of Architecture in Paris-Villemin, designed as a place of dynamic promenades and explorations, was conceived to foster a rich architectural dialogue. The building derives its overall form from the context of the surrounding city, calling for the use of dynamic linear sequences that benefit the vitality and energy of this design.

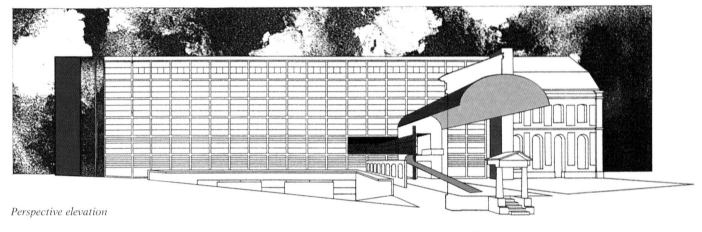

Perspective elevation

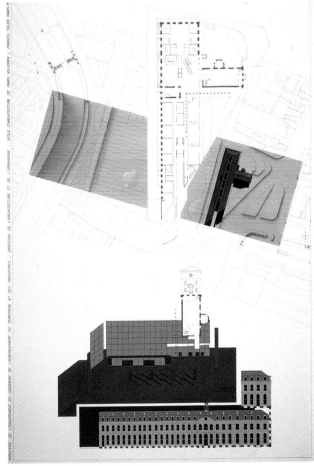

Plan and elevations

Triangle de Folie · La Défense · Paris · 1988

In a minimalist spirit, So-
ler's entry for the Triangle de
Folie competition in La Défense
features a simple glass building-
mirror which was to reflect every-
thing existing around it.

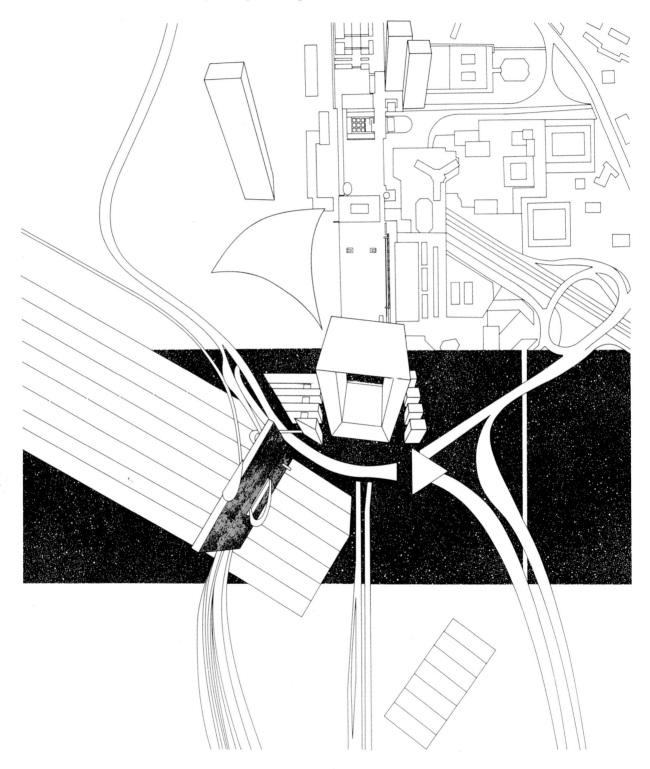

Axonometric and site plan

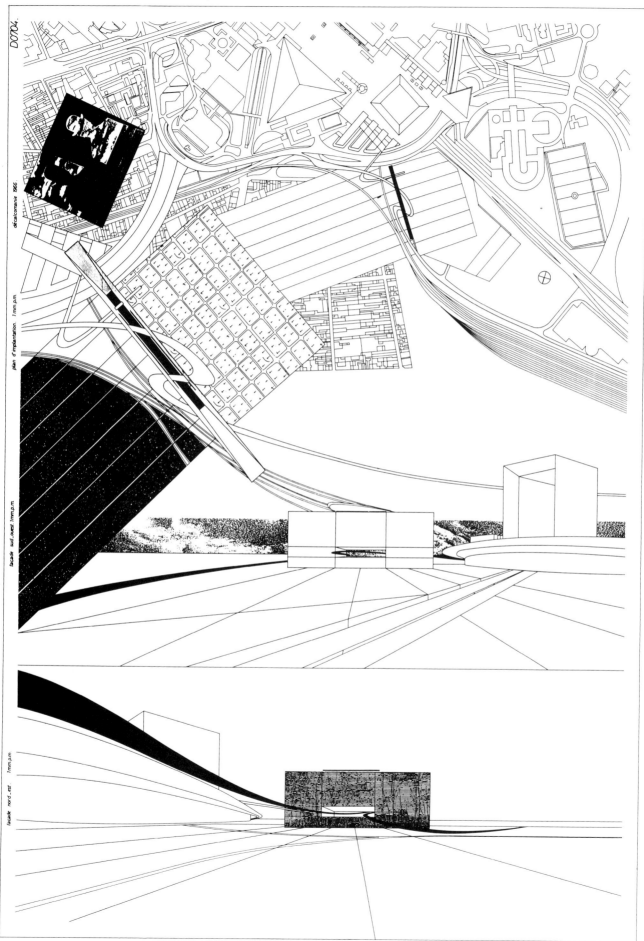

Perspective and site plan

BERNARD TSCHUMI

Parc de la Villette • Paris • 1982–83

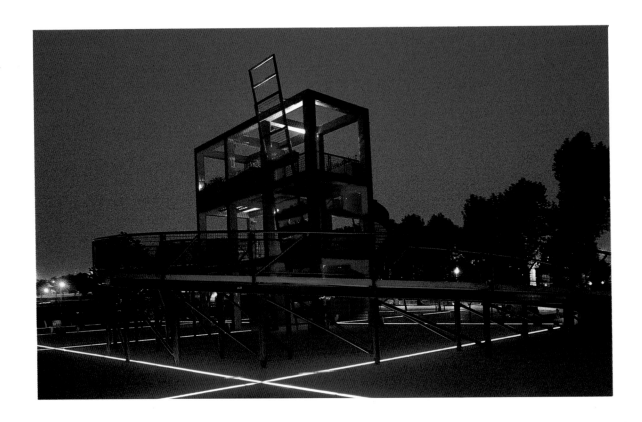

Bernard Tschumi is the most academically and theoretically inclined of the twelve architects in this volume. He is one of the principal exponents of the recent design movement known as deconstructivism, which Tschumi calls a "specific vision of post-modernism." The principle notions of deconstructivism were derived by him and other international architects from the philosophical, critical, and literary works of Derrida, Joyce, and Queneau, as well as from the nihilist notions of Nietzsche. The conceptual thrust of this movement is architecturally, politically, and socially anti-establishment, al-

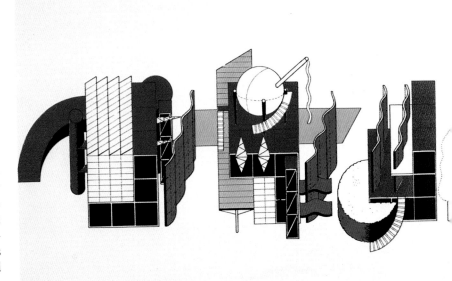

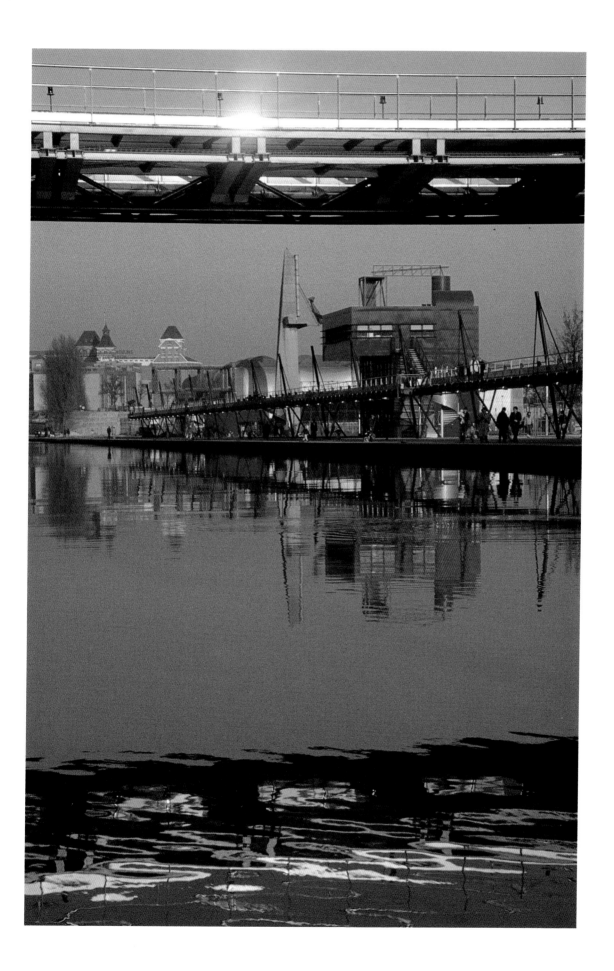

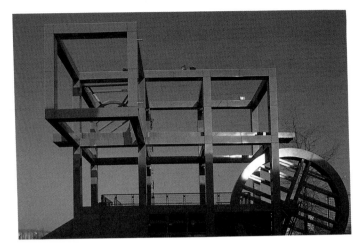

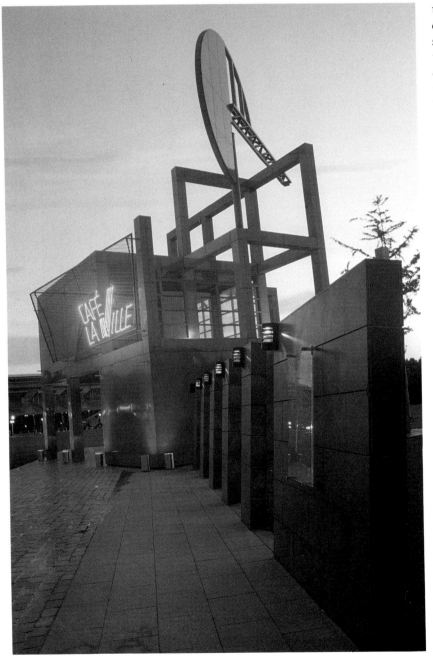

though its principles have been quickly absorbed into the mainstream. The representatives of the movement consider our present Western socio-political reality as lacking any cohesion, hierarchy, or consistency of view, therefore highly fragmented and contradictory. They consider hierarchical and stable cultural frameworks to be outdated and reactionary from the present point of view. The traditional architectural approaches, which Durand captured in his theories of functional design, are viewed by Tschumi as not corresponding with the present-day reality. He sees assemblage, fragmentation, and folly as modern replacements for historical notions of unity, hierarchy, and stability. Historical architecture, for the most part, emphasized psychological harmony, while present day architecture should respond to the conditions of psychological and symbolic disintegration.

In March of 1983, Tschumi won an international competition for the urban Park of La Villette, which constituted one of the presidential building programs for the city of Paris. For Tschumi, the project was an opportunity to express through the "biggest discontinuous building in the world" the many principles for which deconstructivism stands. The park was described in the competition program as an "ur-

ban park for the 21st century." This was the first time in the history of modern architecture that the notion of an urban park was introduced. The urban park was described as a sort of cultural center which, in its physical and symbolic aspects, was to represent a continuation of the urban morphology. An urban park was to become an extension of the urban environment rather than a place of refuge. Since Tschumi rejected the notion of grand compositions, judging them out of date, he opted for its antithesis—the deconstructivist notion of environment. The issue was how to organize anti-hierarchy architecturally, or how to give irrational conditions a rational, buildable structure. Tschumi's layered planning-point grid contains thirty-five "folly" structures which act as high-intensity reference points over which other functions are juxtaposed. This structural grid expressed all the issues with which Tschumi is so concerned. Anti-contextual, anti-historical, and anti-natural, it became a radical expression of pluralistic conflicts and oppositions rather than a single-minded, integrated conceptual synthesis. This radical deconstruction exercise proved to Tschumi that it is possible to construct complex architectural organizations without using traditional value systems.

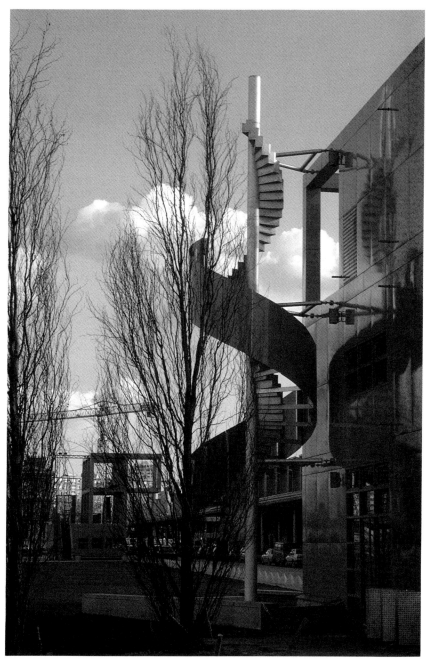

Kansai International Airport • Osaka • 1988

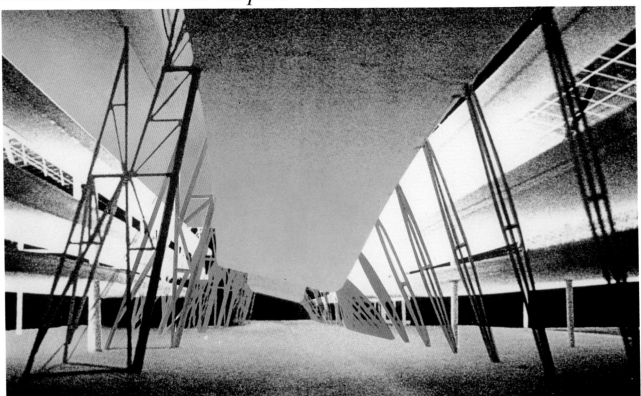

Interior perspective

ZKM Building • Karlsruhe • 1989

Tschumi's other projects, like his competition entries for the Tokyo Opera House, Kansai International Airport in Osaka, Bibliothèque de France in Paris, ZKM Building in Karlsruhe, West Germany, and the replanning of a vast stretch of land occupied by railroads in Lausanne, Switzerland, evoke the conceptually and stylistically recognizable deconstructivist features of his design approach. Tschumi's lack of built works leaves the development of his theories in question, and, for the time being, in the hands of the architectural community at large.

Exterior

Interior perspective

Ponts-Ville • Lausanne • 1988

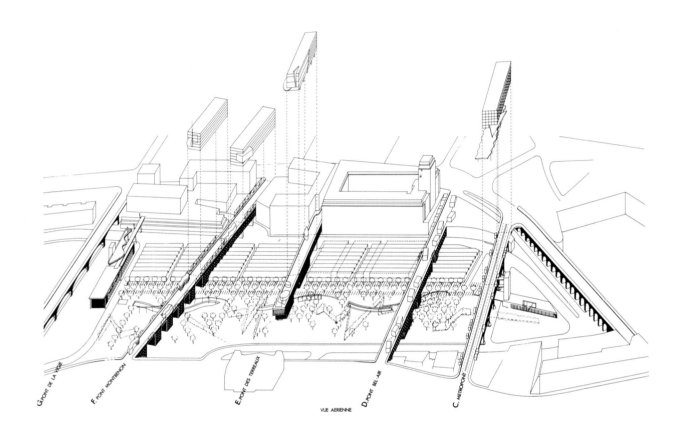

Exploded axonometric

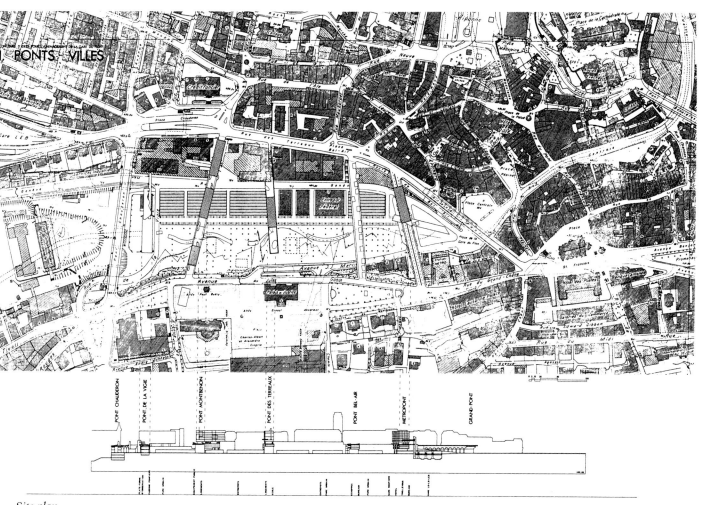

Site plan

CLAUDE VASCONI

Thompson Factory • Valeciennes • 1989

Claude Vasconi became well-known as the architect of the Forum Les Halles in Paris, which he designed in association with Georges Pencreac'h. He has since become one of the busiest architects in France. Two architectural issues are of particular importance to Vasconi. The first is the issue of comprehensive urban planning. "All architecture should be nothing else but an extension of urban ideas," he likes to say, and he looks for solutions to his designs in the context of specific urban conditions. The second issue about which he is passionate is the relationship of architecture to technology. Since he does not have preconceived formal ideas about what architecture should be, he derives his designs from a combination of site characteristics and from functional and technological demands. Within these two realms he looks for compelling visual images. Vasconi's life-long passion for modern technology is best illustrated in his recently completed Thompson Factory in Valeciennes. The wonderfully simple, elegantly flowing lines of this building in glass and aluminum point once again to the strong conceptual connection between present French architecture and the design of aircraft, cars, and trains.

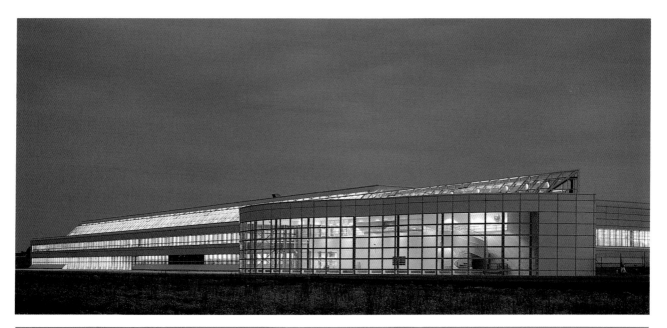

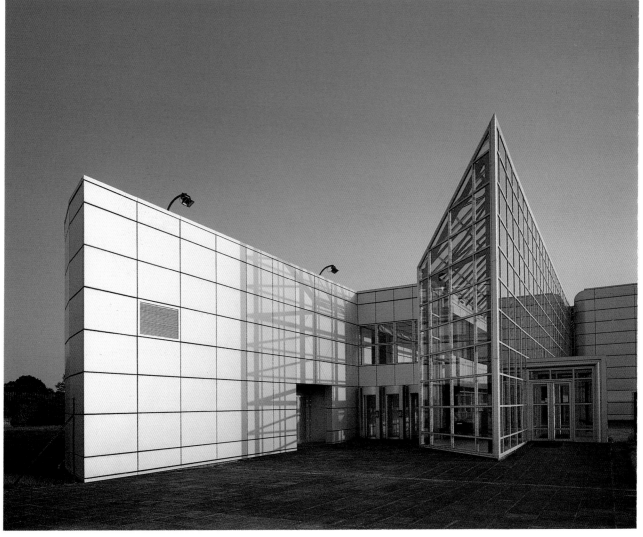

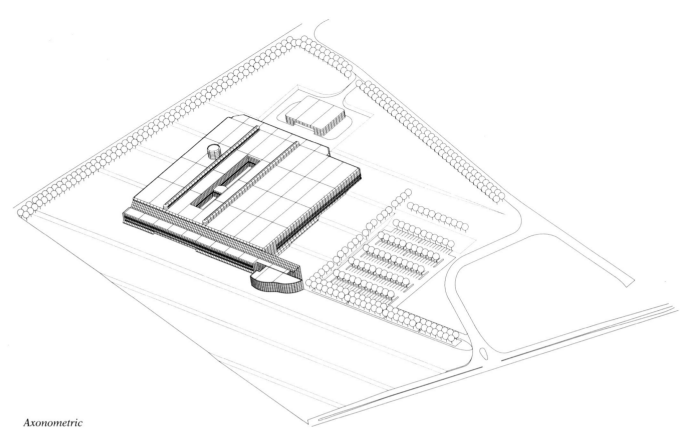

Axonometric

Sections

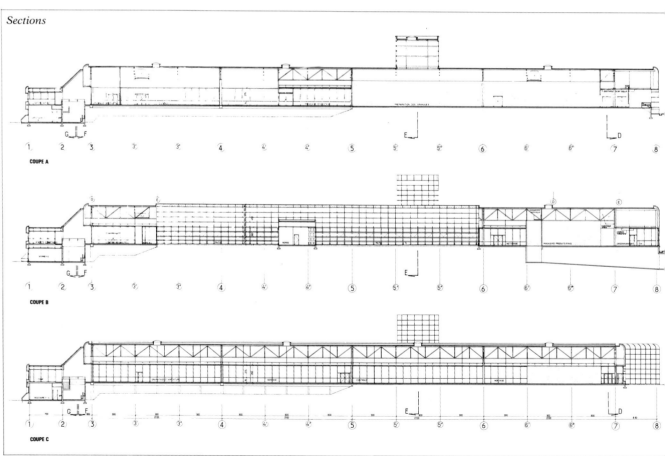

COUPE A

COUPE B

COUPE C

1 COUPE FACADE SUD

2 COUPE FACADE OUEST—BUREAUX

3 COUPE FACADE OUEST—LIVRAISON

2 COUPE—MUR—BUREAUX—VESTIAIRES

CLAUDE VASCONI 205

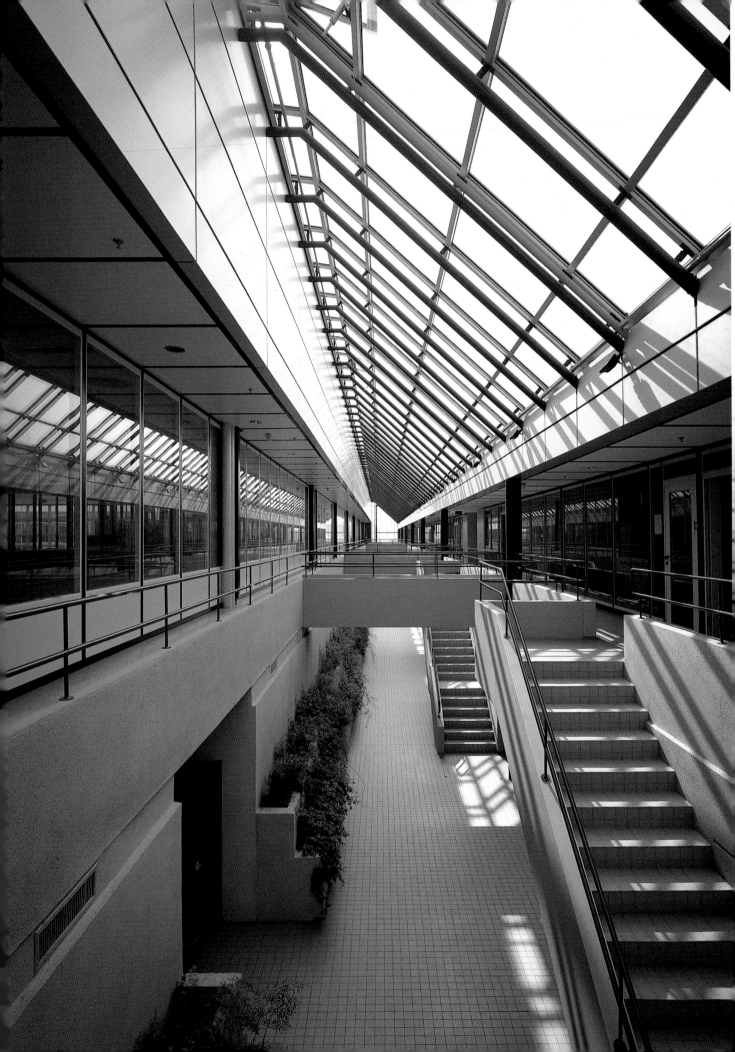

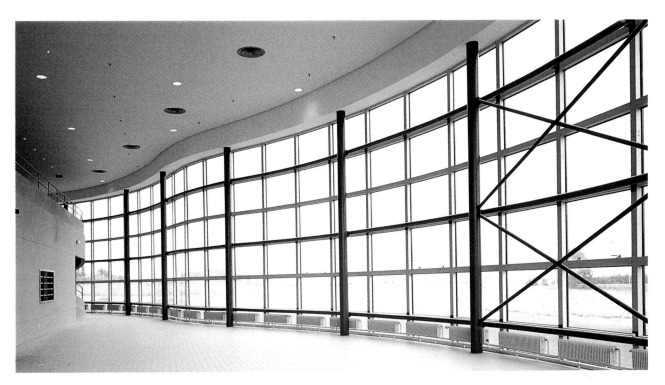

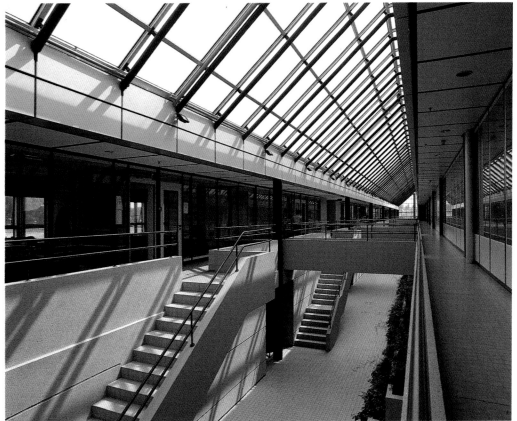

57 Metal • Billancourt • 1979

Vasconi's project for an industrial town called Billancourt, intended for the car manufacturer Renault, won him the Grand Prix of French architecture in 1982. Although the project was never realized, one structure was built—the 57 Metal tooling facility which Vasconi designed in a bold, plastic manner, more an object of art than an industrial facility.

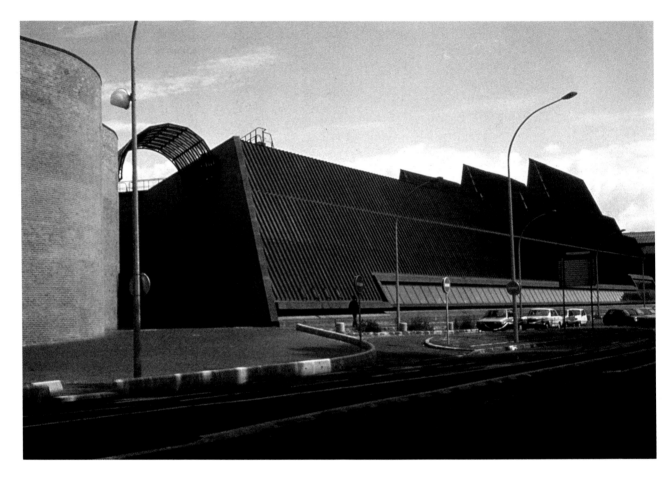

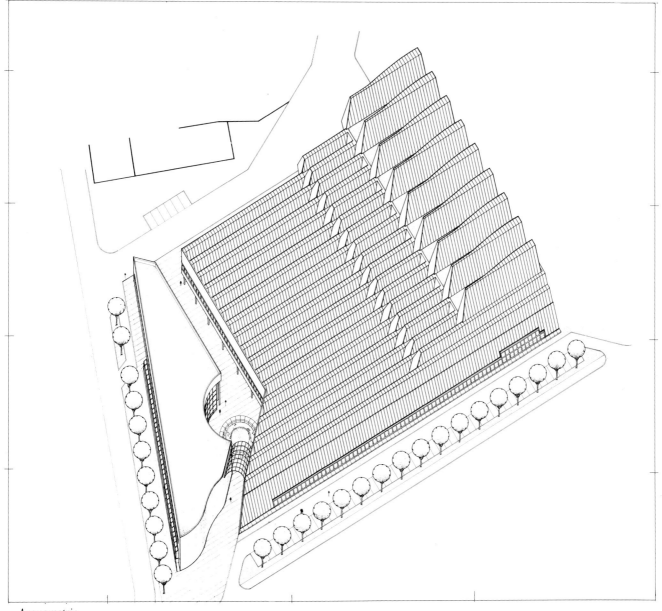

Axonometric

Plan

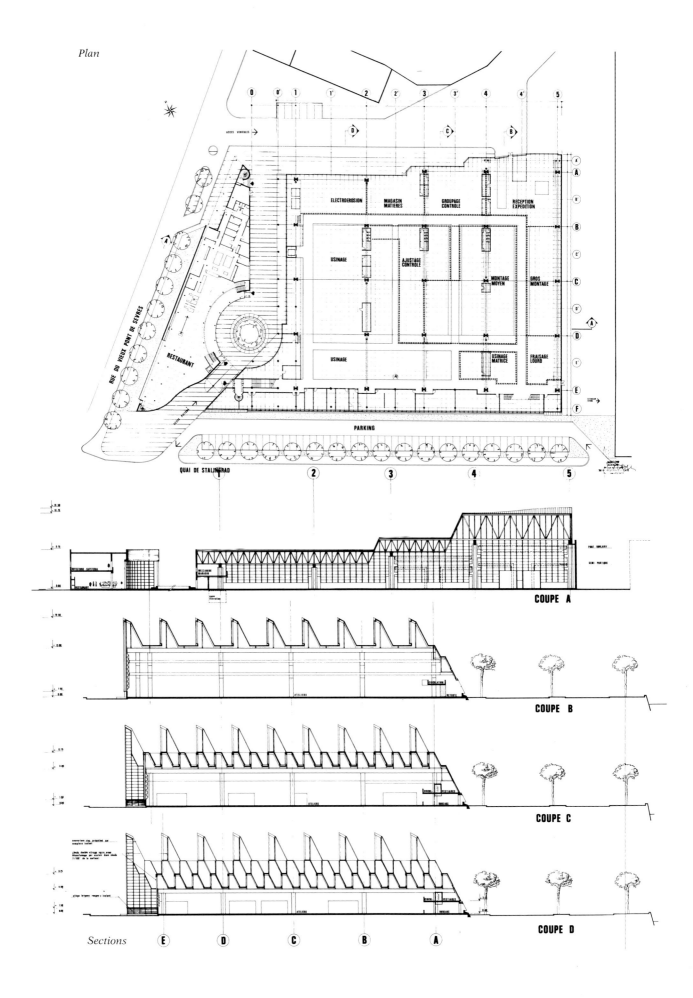

Sections

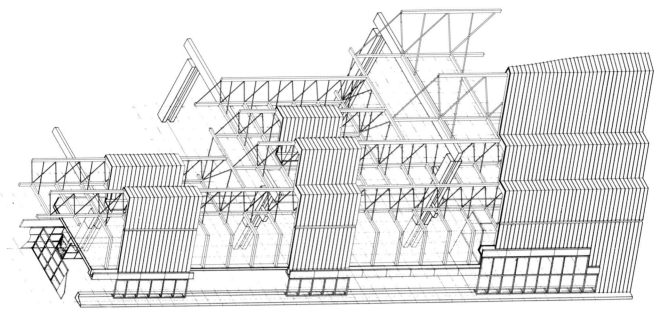

Cut-away axonometric

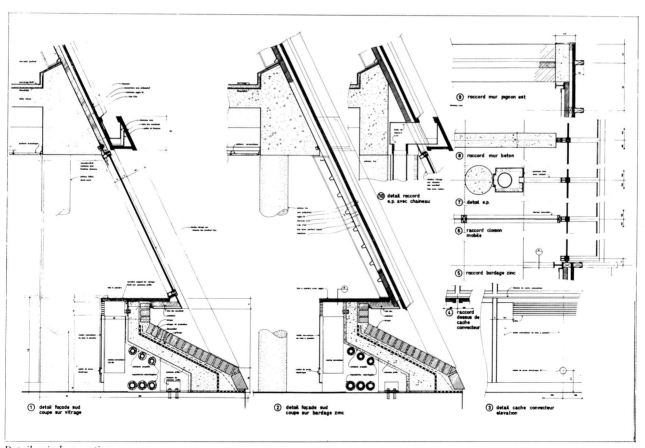

Detail, window section

Centre République • Saint-Nazaire • 1980–88

Vasconi is able to consistently maintain a respectful dialogue between his modern designs and historical or natural contexts. An example is his Centre République of 1988 in Saint-Nazaire, which features a mixed-use, all-metal shopping gallery at the intersection of two important city avenues. It is popularly referred to as "Le Paquebot" (The Ocean Liner), in recognition of the fact that Saint-Nazaire has been the traditional center for the ship building industry and where the famous ocean liner 'Le Normandie' was built. Its modern shape complements the surroundings, made up of 1950s reconstruction architecture, by maintaining good proportional scale and massing.

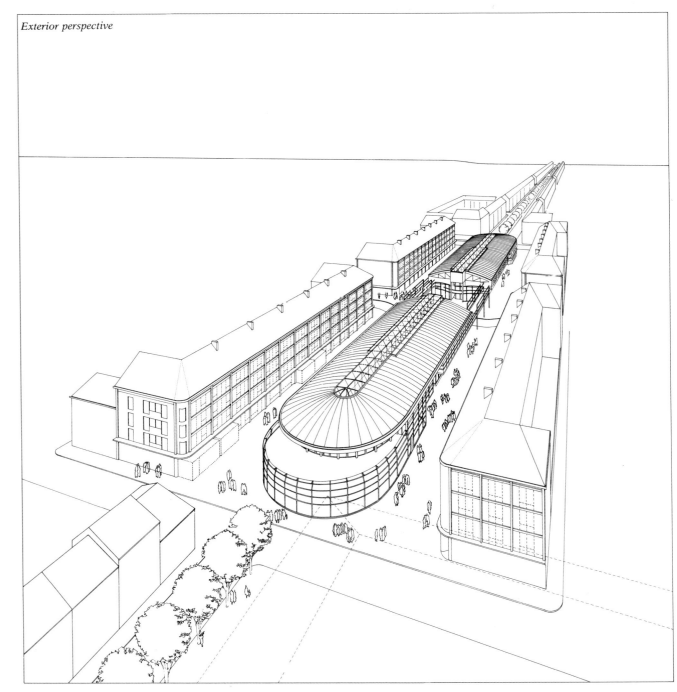

Exterior perspective

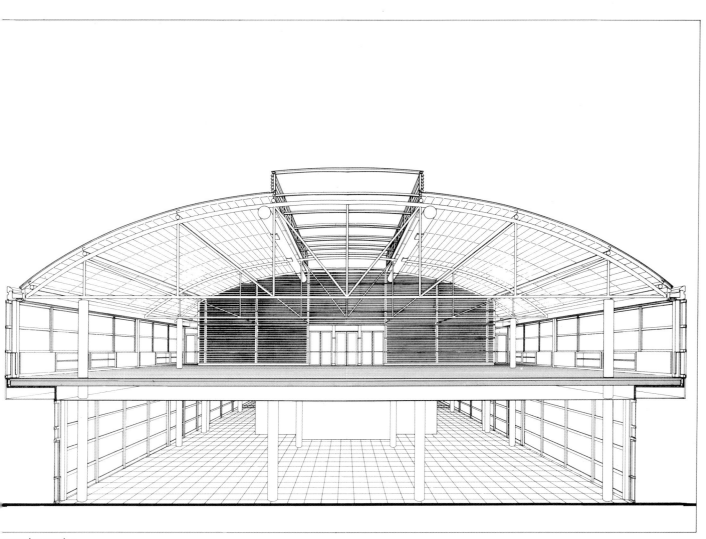

Perspective section

Transverse and longitudinal sections

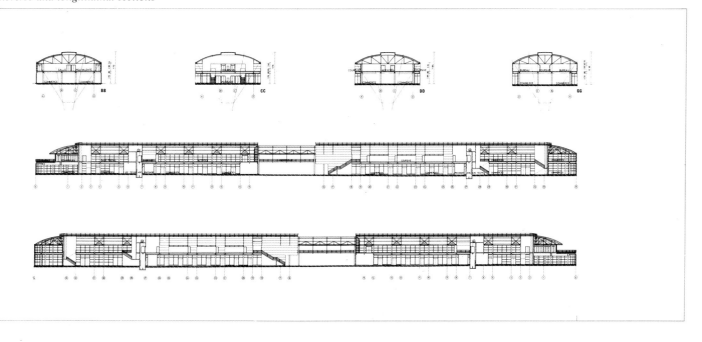

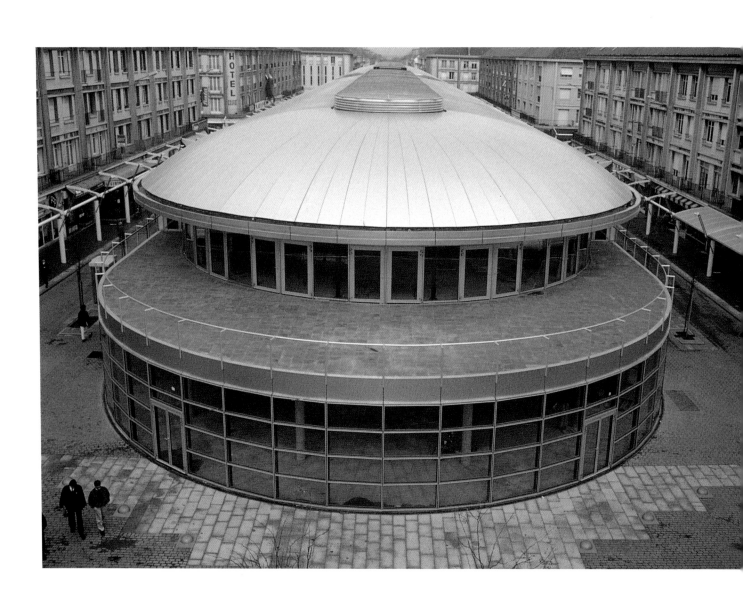

Le Corum Opera House • Montpellier • 1990

Complex contextual difficulties existed on the site for Vasconi's Le Corum Opera House in Montpellier. The project is located near a public promenade, which the architect judged to be too short and too near to the city's historical fortifications. To lengthen the promenade visually and to achieve better volumetric correspondence with the existing urban fabric, Vasconi designed the building as a series of terraces or roof gardens which visually bolster the presence of the promenade and allow the scale of this massive structure to be broken down.

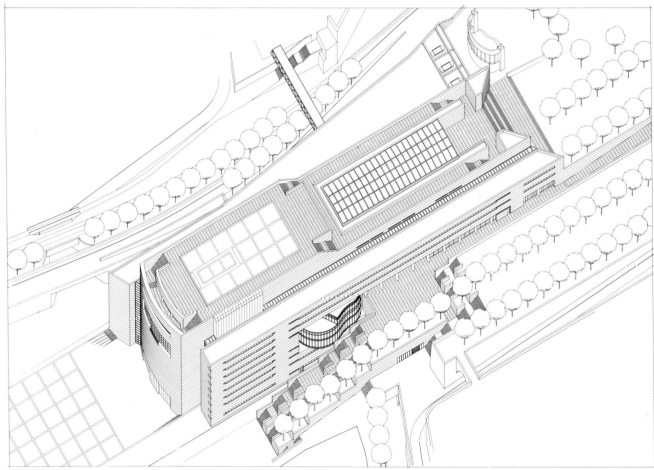

Axonometric

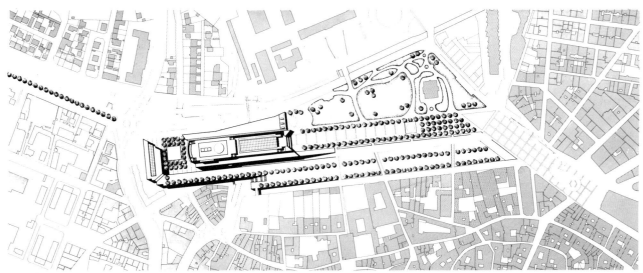

Site plan

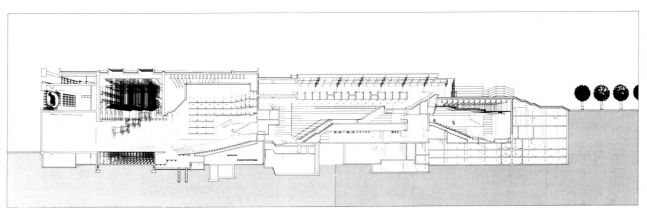

Perspective section

Olympic Village • Les Menuires • 1988

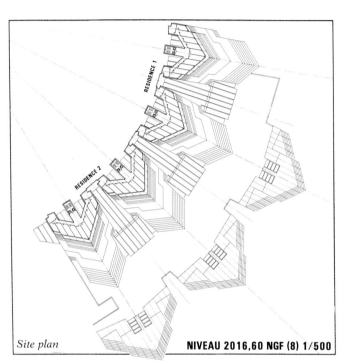

Site plan

NIVEAU 2016,60 NGF (8) 1/500

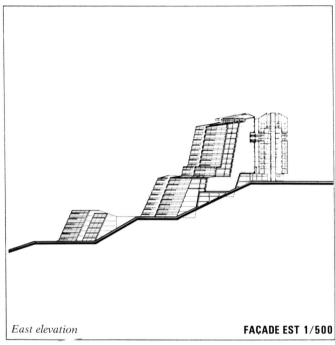

East elevation

FAÇADE EST 1/500

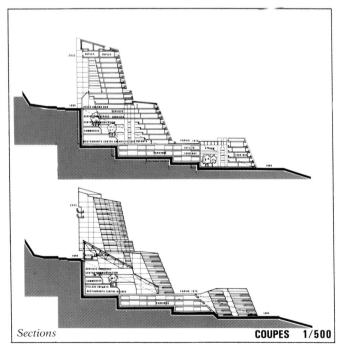

Sections

COUPES 1/500

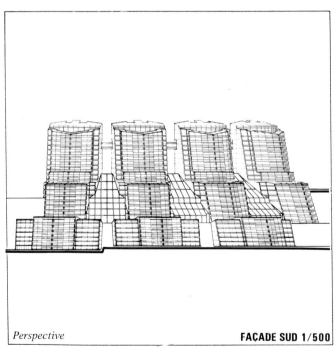

Perspective

FAÇADE SUD 1/500

Vasconi's most futuristic work to date is his recent winning entry for the Menuires Olympic Village, a series of tall, aluminum-clad volumes in the midst of the dramatic Alps. Vasconi did not choose to imitate the regional architecture; he remained strongly modern and yet sensitive to the physical needs of a difficult context. Through a contrast in imagery and careful volumetric handling, he arrived at a successful blend of the modern and the natural.

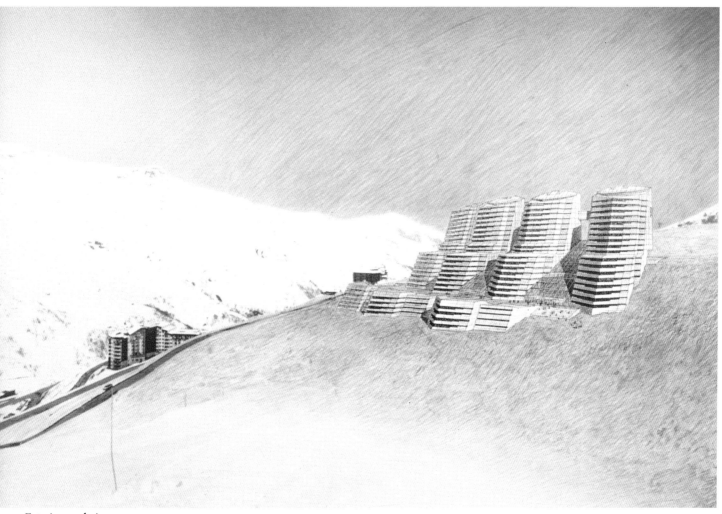

Exterior rendering

Bas-Rhine Administrative Center • Strasbourg • 1989

Vasconi's lack of preconceived formal ideas have led to a wide range of architectural responses. His project for the administrative headquarters of the Department of the Bas-Rhine in Strasbourg, for instance, is located on a site where the old and new parts of the city converge. Consequently, the building was designed as a symbolic junction between the old and the new, resulting in complex figure-ground arrangements and volumetric massing. Despite the existence of a strong historical context, Vasconi took a chance in designing this building in a thoroughly modern vocabulary. This modernism, however, did not prevent the architect from achieving an excellent urbanistic fit.

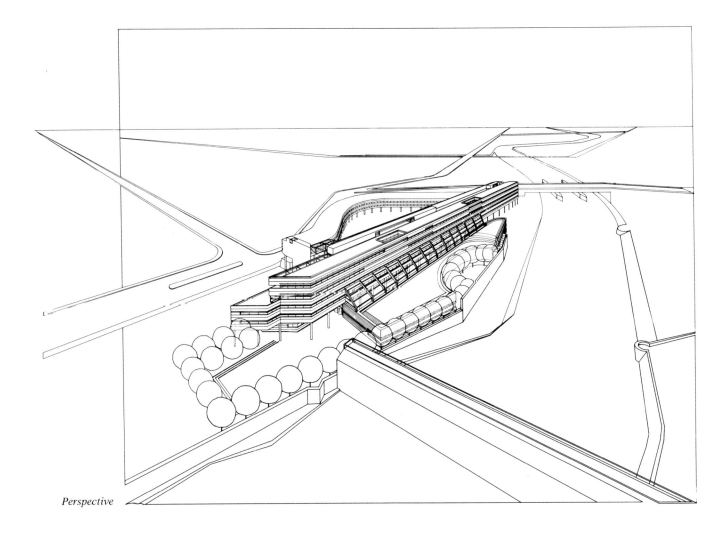

Perspective

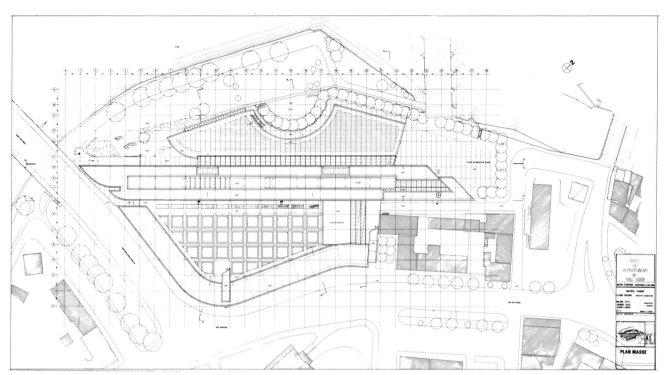

Site plan

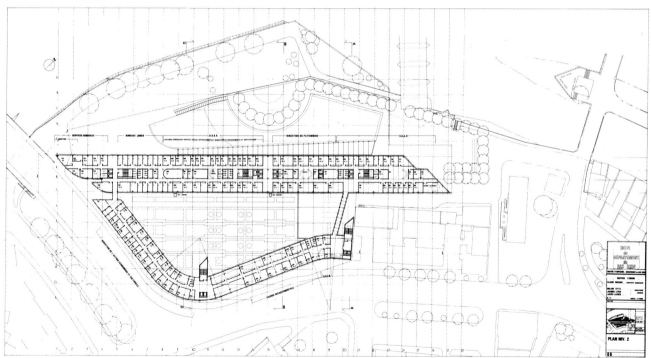

Plan

Architects' Biographies

Architecture Studio

Architecture Studio consists of four partners: Jean-Francois Bonne, Jean-Francois Galmiche, Martin Robain, and Rodo Tisnado. Jean-Francois Bonne was born in Paris in 1949, receiving his diploma in 1975 from the L'École des Beaux Arts. He received a separate diploma for his studies in urbanism in 1978. Jean-François Galmiche, born in 1943, graduated from the École des Beaux Arts in 1970. Martin Robain, also born in 1943, received his first diploma from the École des Beaux Arts in 1969, and a second one, in urbanism, in 1972. Since 1983 he has been professor of architecture at the School of Architecture in Bordeaux. Rodo Tisnado was born in Peru in 1940. He studied architecture in Lima, taking his diploma in 1964. After teaching architecture for a time in Lima, he pursued further study at the Institute of Social and Economic Development in Paris.

Gilles Bouchez

Gilles Bouchez was born in 1940, and he graduated from the École des Beaux Arts in 1967. He has participated in fifty-one national competitions and has been declared a winner fourteen times. Among his many designs, his proposal for the Hall of Popular Music at Bagnolet (1983) is well known. He has also built schools, public housing, office structures, medical facilities, and housing for the elderly.

Jean Pierre Buffi

Born in 1937, Jean Pierre Buffi studied architecture in his native city of Florence. Since 1967 he has been a practicing architect in France and a professor of architecture at the École des Beaux Arts. He is the architect of many public and private structures, among them the IBM headquarters in Lille and Bordeaux, the École Nationale d'Art at Cergy-Pontoise, and the French Cultural Center in Lisbon. He is well-known for his winning competition entry for the complex of buildings known as "Les Collines" surrounding the Grand Arch of La Défense.

François Deslaugiers

Born in Algiers in 1934, Francois Deslaugiers has spent most of his life in Paris. He obtained degrees in mathematics, philosophy, literature, and Latin studies from the Sorbonne. In 1954 he entered the École des Beaux Arts and obtained his diploma in 1966. He is a professor of architecture at the École Speciale d'Architecture in Paris. His Regional Information Center in Nemours of 1975 is well-known as the first high-tech French building prior to the Centre Pompidou. Since 1984, Deslaugiers has been the associated architect for the construction of the Grand Arch of La Défense.

Christian Hauvette

Born in Marseilles in 1944, Christian Hauvette has been a registered architect and town planner since 1969. In addition to his degree in town planning from the École Pratique des Hautes Études in Paris, he has also done research in the theory of the cinema and has taught at the School of Social Sciences in Paris. Since 1969 he has won eight major national competitions, among them the project for the French Embassy in Washington, D.C., the Technical College of Clermont-Ferrand, and the Louis Lumière National School of Cinema in Marne-la-Vallée. Hauvette is the author of many publications and the recipient of three national prizes for excellence in design.

Jacques Hondelatte

Jacques Hondelatte was born on May 10, 1942. Since 1967 he has lived and worked in Bordeaux. He graduated in 1969 from the École des Beaux Arts in Bordeaux and has since become involved in a large number of urban design and architectural studies, consultations, and projects, including public housing, private homes, health facilities, sports facilities, industrial and educational buildings, offices, and schools. Since 1985 he has been a professor of architecture at the School of Architecture in Bordeaux.

Jourda and Perraudin

Francois Jourda and Gilles Perraudin are partners in an unusual husband-and-wife architectural team. Jourda was born in 1955 and studied at the School of Architecture in Lyon. Since taking her diploma there in 1979, she has taught architecture in Lyon and is now on the faculty of the School of Architecture in Saint-Etiènne. Born in 1949, Perraudin graduated from the School of Engineering in Lyon in 1970 and received a diploma from the School of Architecture there in 1977. He taught architecture in Lyon between 1974 and 1981. The work of this team is international in character and includes many competition entries and realized projects. They are noted for their new School of Architecture in Lyon and for the Lyon/Parilly subway station. Their work also includes some joint ventures with Norman Foster and the English engineer Peter Rice.

Jean Nouvel

Born in 1945, Jean Nouvel studied at the École des Beaux Arts in Paris and received his degree in 1971. The author of a number of important projects and competition entries, Nouvel has exhibited an extraordinary ability to generate synthetic conceptual images resulting from his many interests and involvements. He is active in theater, stage, cinema, interior, furniture, and industrial design.

Dominique Perrault

Born in 1953 in Clermont-Ferrand, Dominique Perrault obtained his diploma in architecture from the École des Beaux-Arts in 1978. In 1980 he received another diploma in history from the School for Advanced Studies in Paris. His project for the Engineering College of Electrotechnics and Electronics at Marne-la-Vallée brought him early recognition. Recently, he won the international competition for the Library of France in Paris. Among his other projects are the headquarters for the Paris waterworks at Ivry-sur-Seine, an extension of the town hall in Bar-le-Duc, and a number of urban studies concerning satellite towns around Paris.

Francis Soler

Born in 1949 and educated at the École des Beaux-Arts in Paris, Francis Soler received his diploma in 1976 and is currently a professor at the Tolbiac School of Architecture in Paris. He is the recipient of two national awards for excellence in public design. Soler is known for four recent projects in particular: the presidential review stand at Place de la Concorde; two schools, one in Cergy-Pontoise and the other in Paris; and a project for the School of Architecture in Paris-Villemin. He is the author of many other projects, including the technical college in Guadeloupe and the so-called "Mirrors of Osaka," a monument to communications between France and Japan. His work has been widely published and exhibited in Paris, Bordeaux, New York, and Kyoto.

Bernard Tschumi

Born in 1944, Bernard Tschumi studied at the Federal Institute of Technology in Zurich, where he received his degree in 1969. Since that time he has taught at the Architectural Association in London, the Institute for Architectural and Urban Studies and the Cooper Union in New York, Princeton University, and presently at Columbia University in New York where he is Dean. Tschumi has been known internationally since he won the competition for the Parc de la Villette, currently under construction in Paris. He has also participated in a number of other international competitions. He was a finalist for the Osaka International Airport, and won second prize for the National Theater and Opera House in Tokyo.

Claude Vasconi

Claude Vasconi was born in 1940 in Rosheim and studied architecture in Strasbourg. After graduation in 1964 from the École National Superior des Arts et de l'Industrie in Strasbourg he established himself in Paris where he began his design career. Since the realizations of two early projects, the Prefecture in Cergy-Pontoise (1969) and the Forum Les Halles in Paris (1973–1979) he has become one of the busiest architects in France, building in Strasbourg, Saint-Nazaire, and Montpellier. He acquired an international reputation in 1979 with his project for an industrial town in Billancourt for the car manufacturer Renault, and for the only built structure from that project, the 57 Metal tooling facility, for which he won the Grand Prix of French architecture.

Illustration Credits

Numbered illustrations indicated in italics.

Claude Vasconi, study sketch for the Olympic Village, Menuires, 1988